The Challenge of Watercolour

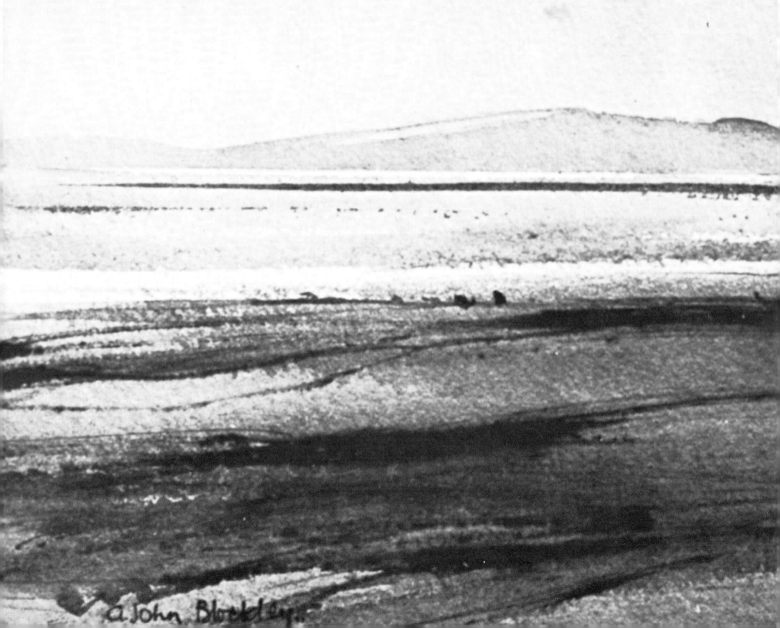

THE CHALLENGE OF

Watercolour

JOHN BLOCKLEY

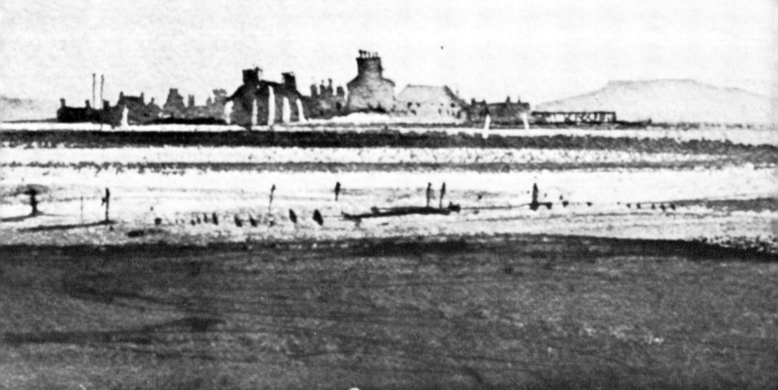

ADAM & CHARLES BLACK · LONDON

Reprinted 1983, 1985, 1989
A & C Black (Publishers) Limited
35 Bedford Row, London WC1R 4JH

ISBN 0–7136–2371–3

Originally published 1979
Pitman Publishing Ltd.

Text set in Monophoto Photina
by Filmtype Services Ltd., Scarborough

Printed and bound at The Bath Press, Avon

Contents

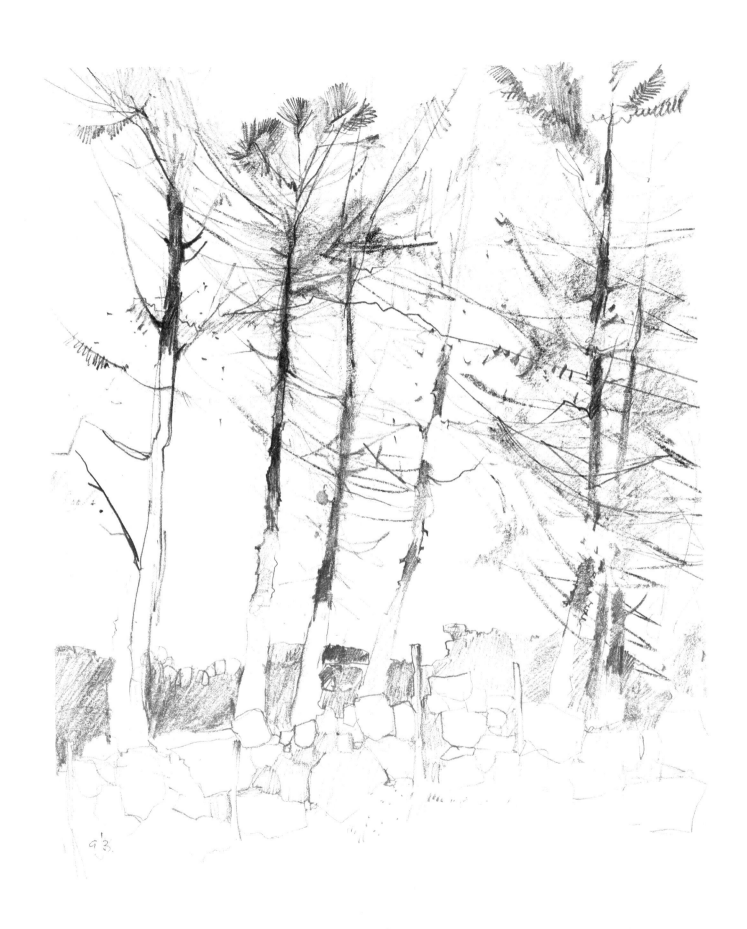

Colour Plates

Plates 12, 13, 14, 15, 16 are repeated
in black and white with fuller captions.
See Figures 136, 137, 139, 138, 122.
Plate 2 appears on the jacket.

Introduction

In my early years of landscape painting I always worked out of doors and it seemed to me that this way of working directly from the subject demanded a direct way of painting. I chose watercolour and I used it in the traditional manner, painting with broad washes of transparent colour.

The procedure is to brush pigment, mixed with water, over the whole of the paper, varying the colour to represent the landscape but without any attempt at definition. The first stage registers the lightest colours of the landscape and then darker detail is gradually added to complete the painting. The charm of this way of working is that light falling on the painting is reflected back through the thin washes to give a luminosity which is unique to watercolour.

My painting *Coastal Landscape* illustrates this traditional method. The sky and the water were painted with one light wash, starting at the top and continuing to the bottom of the paper. The clouds and their reflections were painted into this damp wash and the boats and buildings added last. It is important in this conventional process to work from light to dark leaving a large amount of the first wash uncovered in the final painting so that luminosity is not destroyed by layers of paint.

The best paintings made in this way suggest a seemingly effortless quality which comes only from considerable experience. The light and dark tones of the subject have to be determined, clinically, and painted with first-time assurance. Correct timing is vital. If clouds are painted too early into a first wet wash they will disperse and disappear, but if painted too late they will dry with the edges too hard. There is an optimum time for every operation and this gives a nail-biting fascination which is special to watercolour painting.

I painted mostly in mountain or hill

Figure 1 **Coastal Landscape.** 150 × 250 mm [6 × 10 in.]

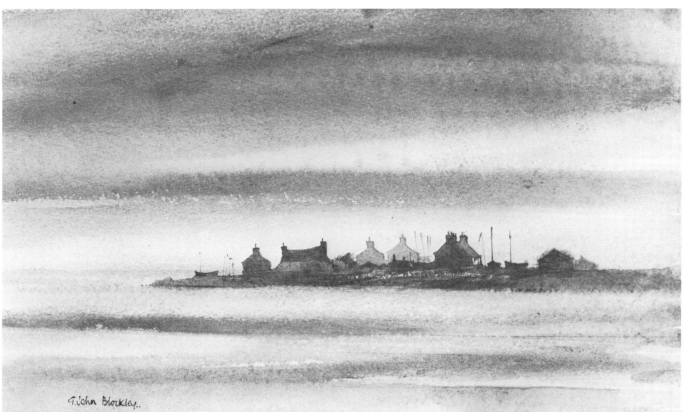

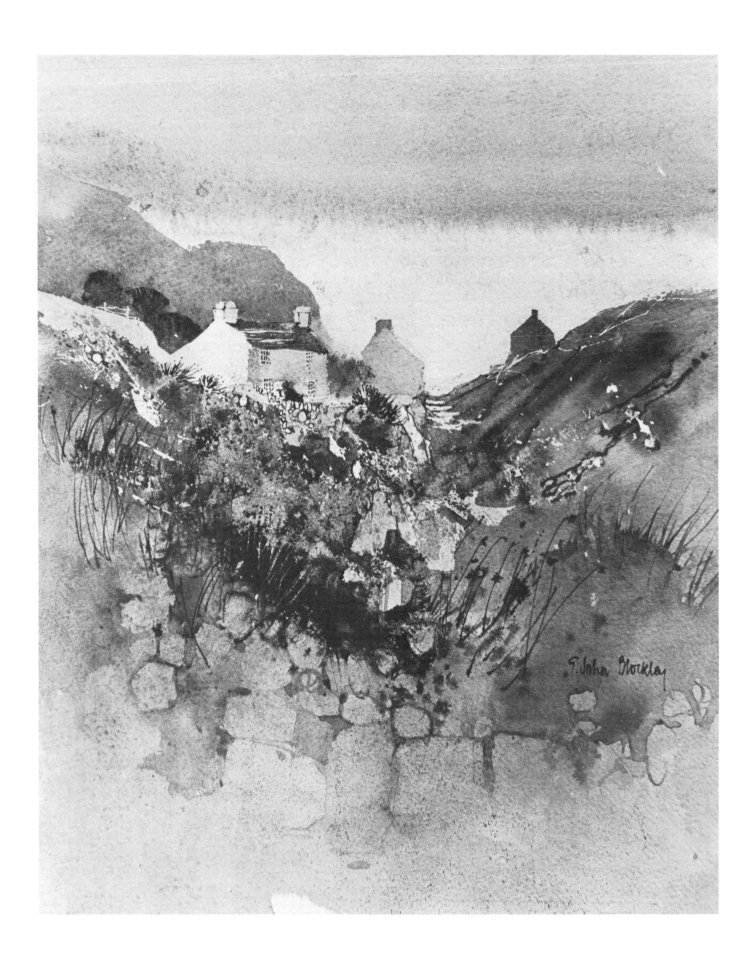

country, and watercolours, flowing and blending together, seemed ideally suited to express the dramatic changes of light. Mountain country is also rich in texture and I began to be particularly intrigued by changeable light on rock faces, sometimes large slabs, sometimes fragmented into smaller boulders and scree, glinting in sunlight. The plant life is often roughly textured, spiky gorse and brambles interlaced and inseparable, the bark of trees frequently twisted and deeply grooved as though etched by the weather. The man-made features are built with local materials so that everywhere there is a unity of texture. Lichen clings to eroded stone, and everything contributes to a countryside of sparkle, with light falling on the crystalline surface. I looked at these crumbled surfaces and I considered different techniques for painting them, but I rejected these as trickery, unacceptable to watercolour painting.

I think differently now, and feel free to try any process which I think will express my interest. My general practice is still to wash colour all over the paper and then work into it during its varying stages of drying, gradually building up to the final drawing. But I combine watercolour with ink, and frequently break rules of timing. I dry parts of a wash with a hairdrier, and wash the rest away under a tap. I obtain textures by painting over wax, by scratching, by scraping the paint away with a razor blade. There are no barriers now. Sometimes I still complete a painting entirely by conventional processes, and often I use them in association with experimental techniques. The idea leading to the painting dictates the methods used. I am now concerned with surface qualities, roughness, smoothness, and with even less tangible qualities. I have an ambition to paint the fluffy ball of a dandelion clock, poised, just before a breath of wind floats the seeds away. I have sat in the field plucking them, blowing and breathing on them, and my studio floor has been covered with

abandoned watercolour attempts ' have tried day after day. I+ ' feeling of suspensio: of time, that I canno looks too solid and sti colour with a damp br clumsy. The challenge i techniques to express the form.

This book is really about painting. I am not absorbed techniques, with being a tech nor with being an innovator. the processes which I shall des may sound difficult or chancy, b are no more so than conventiona techniques, on which they are bas They rely in the same way on judgement and timing.

I now paint mostly in the studio with the advantages of its facilities, a big sink and a water tap, a warm stove and a hairdrier; but the main advantage is that I am free to pick up an idea and work at it at any time. I can leave it and pick it up first thing next morning, or just before bedtime. I leave work lying around, perhaps for a week or more, and on the floor where I catch unexpected glimpses of it. Sometimes I put it away in a drawer. I have sessions at intervals of a few months when I go through the drawer and think again about the unfinished work. It has been said to me that watercolour is a facile medium, because unlike oil painting it cannot be worked at, pushed around and reworked to a considered conclusion. It either 'comes off' or it fails. Just chance. I disagree with this attitude: I do consider each stage before committing the brush to paper, and if at any point I am in doubt about the progress of a painting, I put it aside and come back to it with a fresh eye. I often destroy a painting and start again. Sometimes I make a number of attempts and regard this as a progression to a final considered result.

I do spend a lot of time out of doors, to keep the feel of it: I know about wet ploughed fields, brittle winter plants; and I sketch. I regard the landscape as

Figure 2 **North Wales Textures.**
300 × 250 mm [12 × 10 in.]

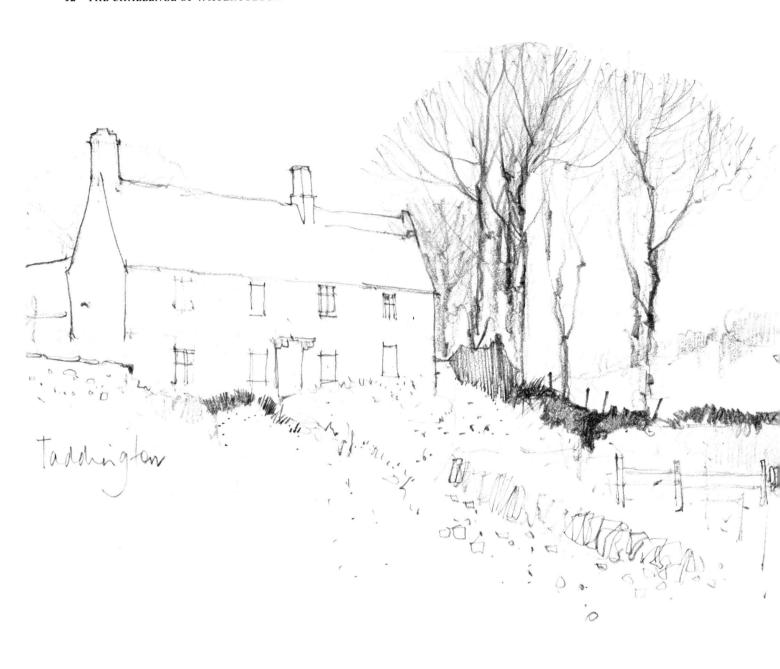

Taddington

a fund of information from which to select items and adjust them to my personal wishes. We should look for and paint ideas and impressions, not exact copies of the subject. A painting should reflect an emotional reaction to a specific interest in the subject, which might be a very obviously interesting feature, a lighting effect say, or a less obvious attraction which comes with a trained way of looking. The adjustment might amount to little more than an emphasis on some interesting quality and deliberate understatement elsewhere. I think that the habit of making sketch-notes is important. The very fact that they are made with only a pencil and a piece of paper helps towards a concentrated interest. The physical process involved is reduced to drawing a line, so that the mind is free to take a searching look at the subject.

In Chapter 5 I shall discuss the actual process of making sketch-notes, with the intention of relating the process to a way of looking at the subject. I have planned this book around my own sketches and paintings, some of them unfinished, some of them just jottings. I want to indicate the reasons for making them, the initial thinking, and the working processes.

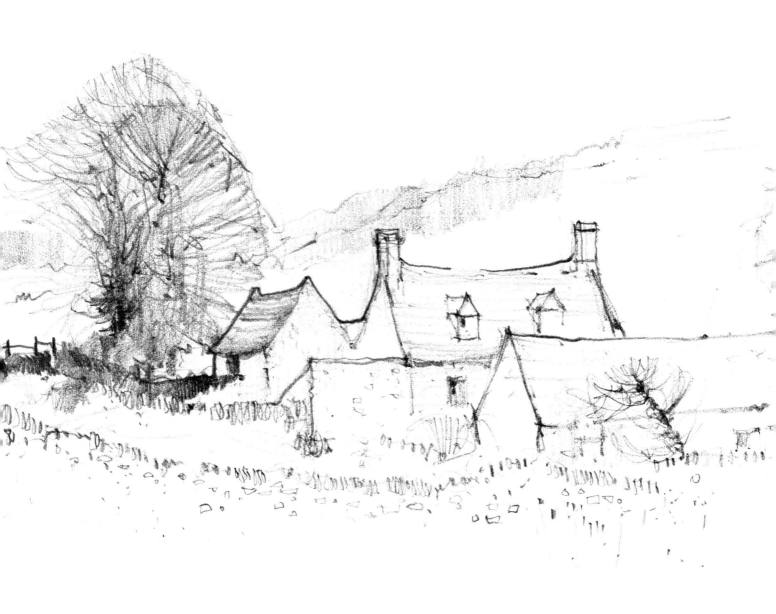

Figure 3 Cotswold farm. Pencil sketch,
175 × 380 mm [7 × 15 in.]

My own responses derive from a long association with textured landscape and with stone buildings. I am interested in, and have some knowledge of, the methods and form of construction of these buildings, enough to recognize the characteristics of various parts of the country so that I can paint them convincingly. My large Cotswold studio was once a hay-barn, stone-built nearly 400 years ago, and I often ponder about the man who built its rubble-filled stone walls, and joined together the oak timbers with wooden pegs which still exist. From certain positions in the studio the busy pattern of intersecting roof-timbers is seen through an open timber screen, and the combination of screen and roof provides exacting material to draw. Each hand-formed piece of timber differs with subtle curvature from its neighbours and although the open spaces of the framework are similar in shape, each one is slightly different and calls for searching comparison. This interesting interior may be seen in terms of either disciplined drawing or impressionistic painting. There are so many fascinating qualities: the geometry of the timber; pale oak against darker stone; the texture of the stone. The window frames an old apple tree with branches crisp and angular against the sky. Their angular direction is echoed by the slope of an old barn roof beyond. We look for such properties, light, texture, echoes. Each one is the source of a painting.

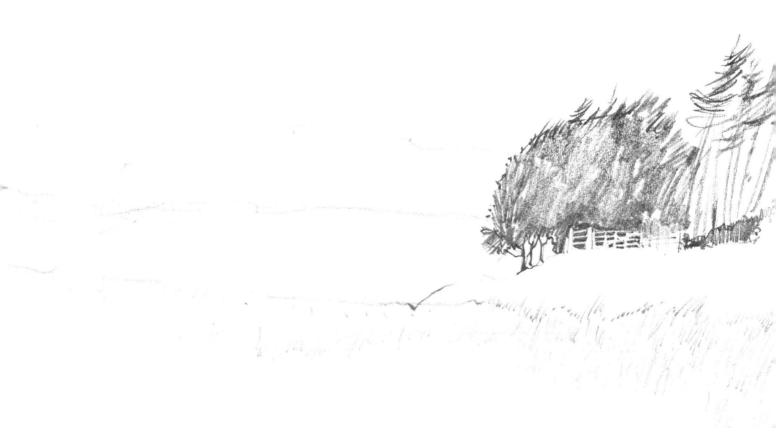

Figure 4 Northumberland farm. Pencil sketch, 175 × 380 mm [7 × 15 in.]

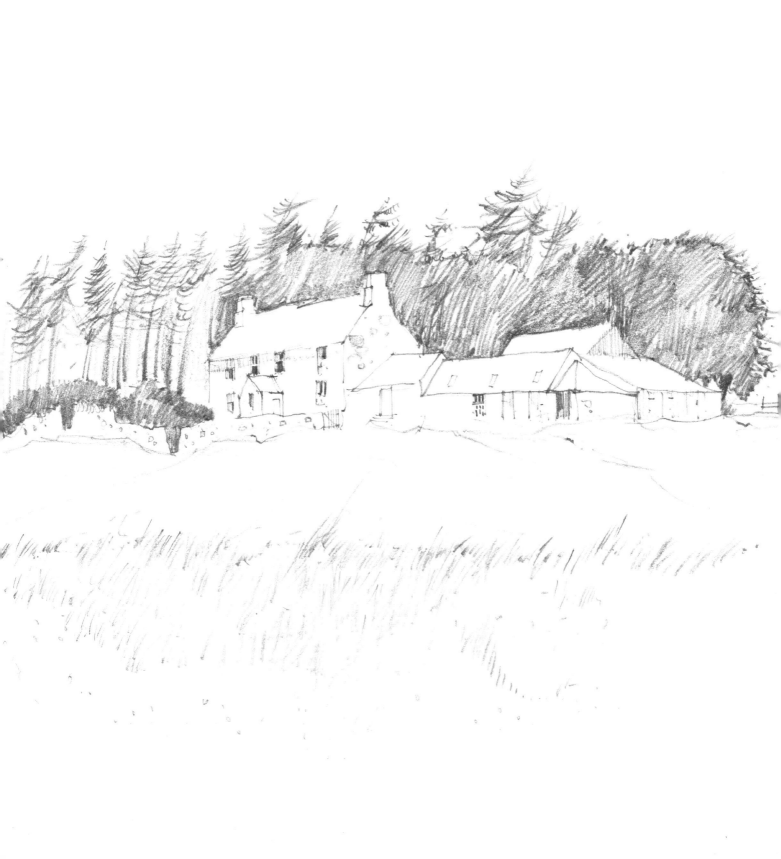

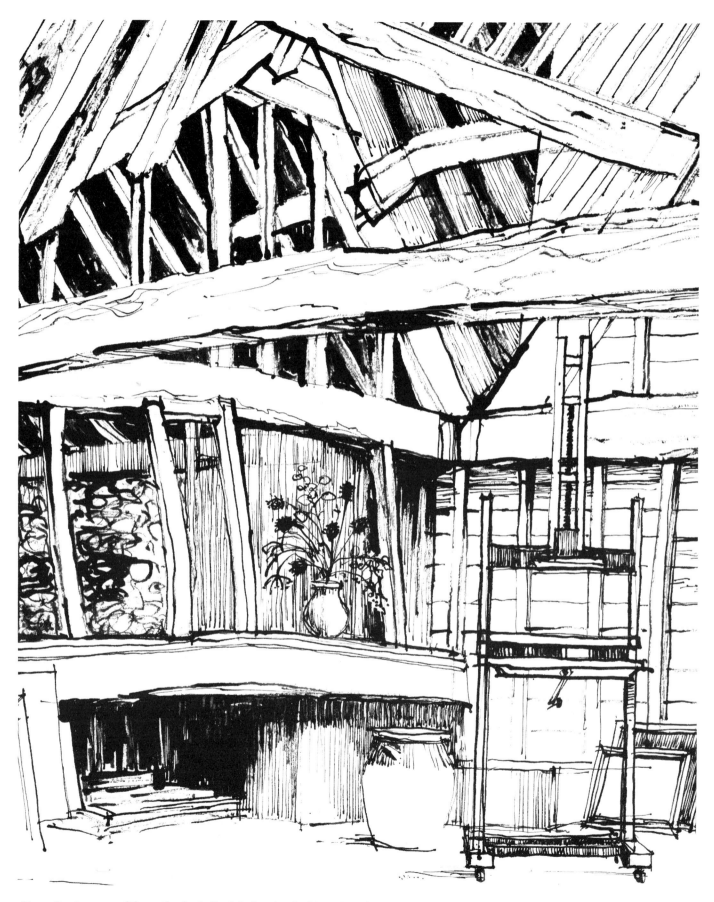

Figure 5 A corner of the author's studio. Ink drawing by Moira Huntly, 225 × 190 mm [9 × 7½ in.]

1
Watercolour
Processes

In this chapter I shall describe some of the painting processes I employ and explain my reasons for using them. I have selected those processes which will best illustrate my approach to landscape painting, and I shall develop these further as the book progresses.

Painting in the studio

When painting out of doors it is convenient to use an easel and I fix the paper to a piece of rigid board, with spring clips, but my indoor painting processes have led me to work in a very different way. I work with my paper lying flat on a table, instead of having the paper slightly tilted in the more usual way.

I just take a piece from the storage drawer and place it on a flat table. This seemingly casual approach gives me flexibility in handling and enables me to have more than one painting in progress at any time. I hope this does not sound like a production line, it is far from that. Indeed, I rarely finish a painting in one go: sometimes the brush seems to take over and the painting rushes along to rapid conclusion, but I often take longer to consider the work, even putting it aside for long intervals. This method of working is impossible if each paper has to be stretched or fixed to a supporting board, and so I use a paper heavy enough to lie reasonably flat when wet

without such preparation. I mostly use 140 lb. or 200 lb. (295 or 425 gsm) NOT paper.

Another reason for using a loose piece of paper is that by lifting the corner of the paper I can make the paint flow in interesting patterns. I like to drop a pool of colour from my palette into a still-wet wash and then tilt or bend the painting to steer the colour in the desired direction. It is fascinating to watch the paint trickle down the paper and one is constantly poised ready to tilt the paper in a different direction just before the travelling bead of paint breaks away to run uncontrolled. When a satisfying pattern is achieved, in order to give meaning and form I draw from it with a pen, or my fingernail, or a fine brush.

This is typical of the processes I use and which I describe in this chapter. They are best done without the restriction of an easel.

Sketching

Most of my experimental processes can be carried out more conveniently indoors, so I tend to paint in the studio from sketches which I have previously made outside. Some of the sketches, I really prefer to call them notes, are made in watercolour but most of them

Figure 6 Abereiddy, Pembrokeshire. Pencil sketch, 150 × 200 mm [6 × 8 in.]

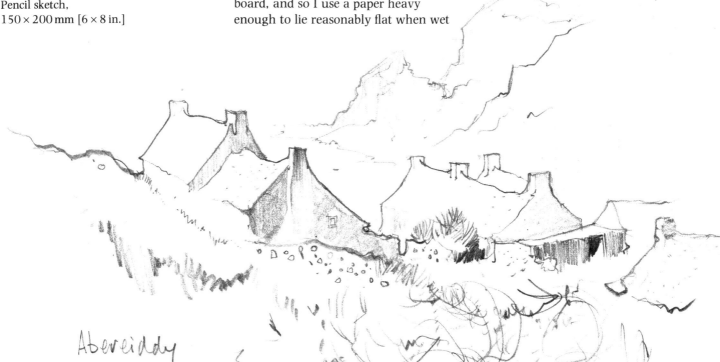

Abereiddy

are in pencil. I like to call them notes because this is really what they are, jottings for record purposes. Often a sketch is just a quick impression of an interesting detail which catches my eye and might stimulate an idea for a future painting; sometimes I will spend more time and enjoy making a more complete pencil statement. All these sketches are intended as information for paintings. I have included some in this book to show my working notes, but they were made purely as personal data, with no thought of publication. In many of them the accurate drawing content is concentrated on specific characteristics which interest me, such as the profile of a building, and in other parts of the sketch I rely on my own symbols to remind me. A few dots will indicate a slightly textured stippled surface, random small circles remind me of stone-covered ground or a wall, broad strokes of the pencil scribbled sideways on the paper will indicate tone or foreground grasses; but within this free treatment I draw the principal items with care and precision. I use a B-grade pencil, which is capable of bold black line and which may be sharpened to produce a taut, crisp line.

Interpretation

My drawing process is in keeping with my general approach to painting. I do not inquire closely into the precise nature of every part of the subject area, I am concerned with its over-all impression or the general sense out of which my principal statement emerges. I do not wish every part of the painting to be immediately apparent and yet I recognize that every part must have validity. I argue that this requirement is met if I convey the essential character of the landscape, its nature, its texture, which in itself is abstract but is meaningful in relation to the completed painting. I think this is true of what we see in the landscape. If we concentrate our view on one part of the landscape, its surroundings lose

focus; we might be especially interested in the features of a building, its shape, its colour, or its age, and so we are only just aware of the surrounding countryside. It becomes an amalgam of spattered forms, smudges, dots, soft shapes not detailed or explained, yet meaningful in the context of the whole.

This attitude will be apparent in my paintings, where large areas are spattered and textured, gradually assuming identified shapes as they approach the main interest. If the principal object in these paintings is covered with a finger, the surrounding painting is seen to be abstract in treatment. I do not want to make a literal statement of each part, I prefer to compel the viewer to look at my chosen interest and then invite his eye to wander around the painting, and even make his own interpretations of the various parts, before returning to the principal statement. Occasionally when looking at one of my own paintings I find myself examining and reconstructing the thinking behind some part of it that intrigues me and analysing the methods I used to paint it.

The Cotswold stone where I live has weathered to an intriguing pattern of deep purple and ash-grey blotches with ragged, convoluted edges and pale lemon centres. In representing these patterns I combine many processes, such as pouring paint into nearly dry paint, washing away still-wet parts, dribbling and spattering paint on the paper, and I thumb-print into the paint to suggest the textural qualities. The landscape is a larger edition of this patterned surface. The woods on the hill appear to me as strong, blot-like shapes which are connected together by a network of walls, and I like to work in a contrasting tonal range with dark tree shapes against lighter grass. The dark warehouses and mudbanks lining the river Thames also appeal to me, with their dark tones contrasting with the light tone of the silvery-green water. On some parts of the Atlantic

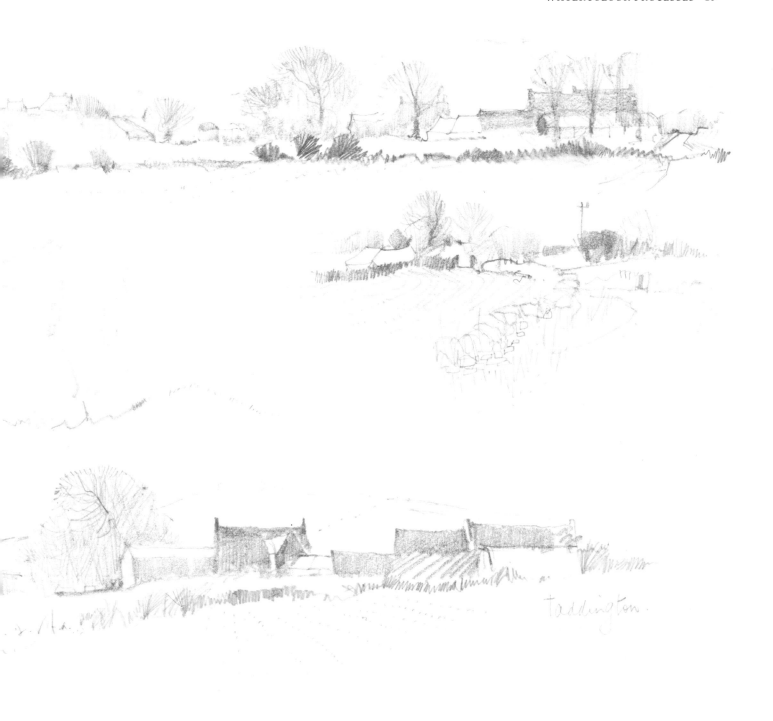

Figure 7 Cotswold sketch-note.
Pencil sketch,
225 × 275 mm [9 × 11 in.]

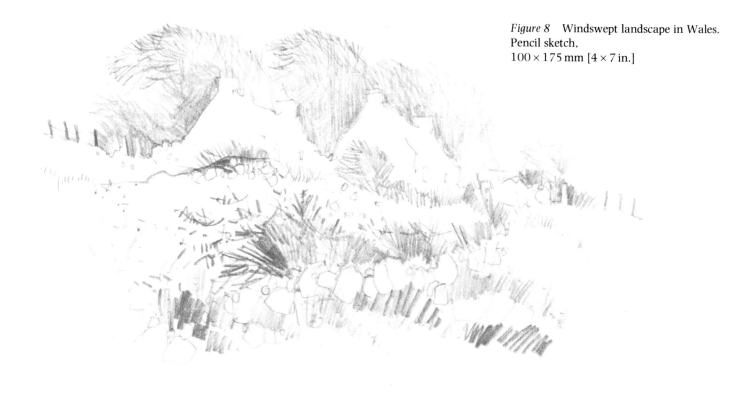

Figure 8 Windswept landscape in Wales.
Pencil sketch,
100 × 175 mm [4 × 7 in.]

coast of Wales the trees are black and scrubbed by the wind so that their outlines look as if they have been severely trimmed. They appear etched against paler skies, and in turn their tones make a dark background to the white-painted cottages. A light shape explains a dark shape which in turn explains a light shape: a counter-change of light, dark, light. The landscape is divided by wide walls made with boulders, some huge, some small, heaped together and packed with soil. Their sides slope inwards to the top, which is overlaid with turf and wide enough to walk along, two or more abreast were it not for the overcoat of tangled spiked gorse, black in winter and brilliant yellow in spring. I look at the gorse in terms of painting it, and I picture the process in my mind, a brushstroke of green-black paint from which I flick the prickly growth with a fine brush or pen. Always when looking at the landscape I imagine myself painting it: I see the features as washes and brushstrokes

and I mentally perform the various operations.

The brush actions involved in watercolour painting are exciting. At one time the side of the brush caresses

the paper to lay a wash, and then the tempo quickens and the brush is lifted so that its tip only touches the paper to draw lines of colour. The painting action forming a large shape such as a

Figure 9 A tree. Sketch in monochrome wash, 90 × 100 mm [3½ × 4 in.]

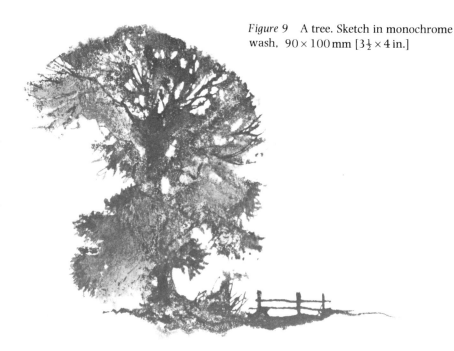

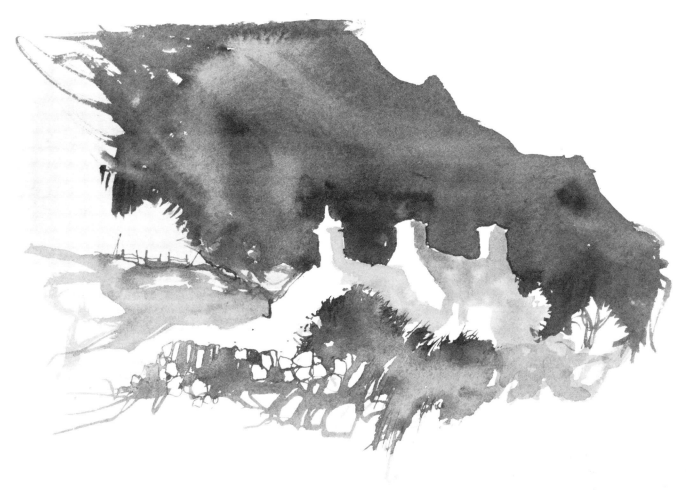

Figure 10 Welsh cottages.
Sketch in monochrome wash,
125 × 175 mm [5 × 7 in.]

tree converts to a sideways flick to suggest a line of shadow, and then without the brush being lifted from the paper the tip moves on to paint a fence. It is all one continuous action, like writing one's signature, up, down, a loop and stop, pausing only to recharge the brush and aiming always for a feeling of continuity and fluidity. Some of the processes are predictable to a degree, but one is never absolutely in command. An unexpected trickle of paint might be the catalyst for a shift of emphasis. It calls for rapid change of handling and resourcefulness to exploit a new situation. This seems to be a reasonable progression in developing an idea and more exciting than a process where all stages are so practised that they are always predictable.

Perhaps this reads like a game of chance in which I play with uncontrolled colour and hopefully wait for something to turn up which I might be able to convert into a recognizable subject. If this were so, the progress of the painting would be conditioned entirely by the whims of the medium and one could visualize a mountain of discarded sodden watercolour paper, the penalty of gimmicky devices. The fact is that my painting processes follow a fairly regular pattern, always starting from a definite idea which attracts me. This might derive from a subject I have actually seen, such as an interesting group of buildings, or it might be entirely imaginative, developing from a thought which unexpectedly comes to mind.

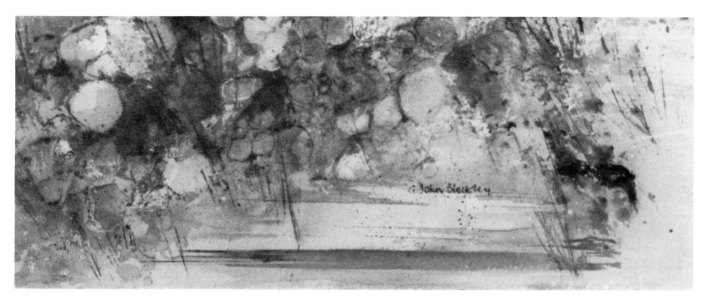

Figure 11 **Still Pool.** 150 × 380 mm [6 × 15 in.]

Still Pool is an example of this latter sort of painting. It was not based on a particular place but developed in the studio from a sudden idea to work out an almost non-figurative impression of a pool of water. It is painted in washes of blue and green, which merge together with hints of pink around the edges. The circular, almost cellular shapes were painted with the wrong end of the brush into damp paper, and the straight, crisp, reed-like lines were sliced across in watercolour. The lines and circles were not consciously thought of as reeds or stones, although I would not mind if they were interpreted as such—or even as bubbles! For my part, I thought that the circular and straight lines would make satisfying complementary motifs appropriate to an impression of water. I enjoyed the processes employed in painting these motifs, and I am reasonably satisfied that my personal reactions are expressed. It was a purely imaginative project, and a spontaneous reaction to a sudden thought, but although it was painted quickly the methods used were deliberately thought out.

Painting is a fascinating process of finding techniques with which to express an idea, but there is a danger that technique can take over and become the purpose of the painting. The painter should always stop and question his sincerity of approach and it seems important to me that he should look for processes with which to express ideas rather than adjust the subjects to suit rehearsed techniques. My reason for detailing techniques which I have used is that it is a positive way of illustrating and arguing the flexibility of the medium. I would like to think that they might be regarded as starting points for further explorations. I do not claim any special inventiveness in the processes which I have described, inks and resists are widely used by today's watercolourists, but I adapt and extend such processes in order to convey impressions which excite me. It is a process of exploration, of nervous excitement in watching features emerge and constant debate in deciding how recognizable I want them to be. The addition of a chimney might be just sufficient to explain an uncertain shape. Much better, I think, than an immediately obvious statement. For me, painting must have this nail-biting feeling about it and watercolour painting will always have this whether it is used in conventional or experimental methods. I enjoy both the traditional and my experimental processes. Which I use depends upon the idea that activates me. The application of a wash in the traditional manner is a continuing enjoyment always accompanied by a feeling of expectancy, it is the fundamental process from which all adventures start.

Conventional processes

In traditional watercolour painting pigment is mixed with water and brushed on paper to form a 'wash' of colour. This may be left as a flat wash or it may be manipulated to create the fluid changes of colour which are unique to the medium. Further wet colour may be floated into it so that different colours melt together, and thicker paint may be introduced to produce more tangible, yet still soft-edged, shadowed effects. Such processes are the start of all watercolour painting.

Basic washes

I mix pigment with water in the palette lid and brush it on the paper in random directions to distribute the

paint evenly over the paper and create a basic wash (Figure 12).

Now I paint two more washes side by side, using more pigment in one to make it darker. I make them touch and the darker wash melts into the other.

Painting into a wash

I paint a pale wash and wait until it is just damp. I dip my brush into the water, absorb the surplus water on a rag and with this moist brush I pick up paint from the palette and paint into the damp, pale wash to create soft, shadowed darks (Figure 13).

I paint an even wash and with a

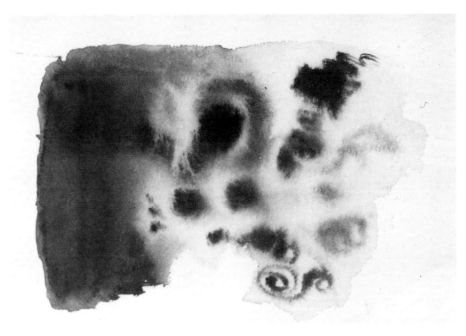

Figure 12 Basic washes.

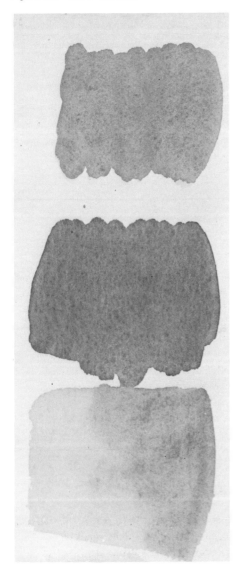

Figure 13 Painting into a wash (1). *Figure 14* Painting into a wash (2).

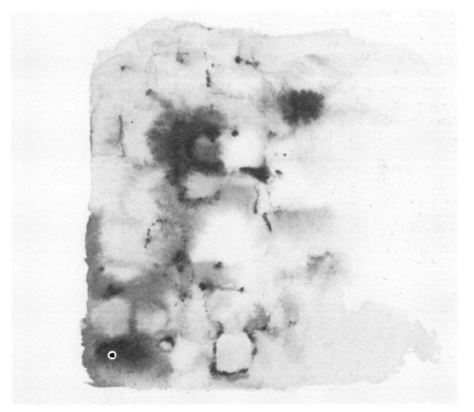

moist brush lift colour from one edge and from the centre. Using a damp brush I float darker paint into the first wet wash to create soft, dark patches. The secret here is that the dark paint should be less wet than the first paint so that it will soften gently into it. Now with the tip of a damp brush I pick up neat pigment from the palette and draw soft lines into the still-damp paper to further emphasize the rectangular pattern (Figure 14).

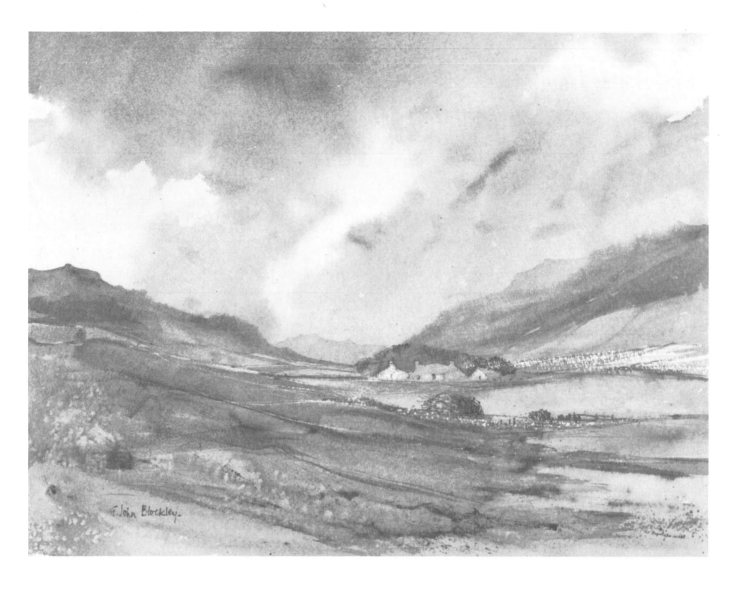

Figure 15 **North Wales Landscape.**
250 × 355 mm [10 × 14 in.]

Landscape: conventional techniques

I painted *North Wales Landscape* fifteen years ago, using conventional techniques. I began with a very diluted wash of raw sienna over all the sky area, adding a hint of cadmium red in the lower sky, then further raw sienna in the ground and burnt umber in the immediate foreground, so that the paper was covered with one wash of these varied colours all melting into each other. Using French ultramarine and lampblack, I then painted the dark cloud shapes into the still-damp sky, leaving the first wash for the light areas of sky. I also painted the soft, dark tones into the damp foreground. The paper now was almost dry, and at a stage where excess water painted into it might disturb the drying pigment, and so I let the paper dry completely. The mountains were then painted with the top edges crisp on the dry paper. The occasional soft edges were achieved by first dampening the paper locally. Finally, a few crisp accents of definition were painted on the dry surface. This is a process of working from light to dark, much of the first light wash being preserved in the final work. I have retained the lightest parts chiefly in the sky, with small fitful glints in the far-distant landscape.

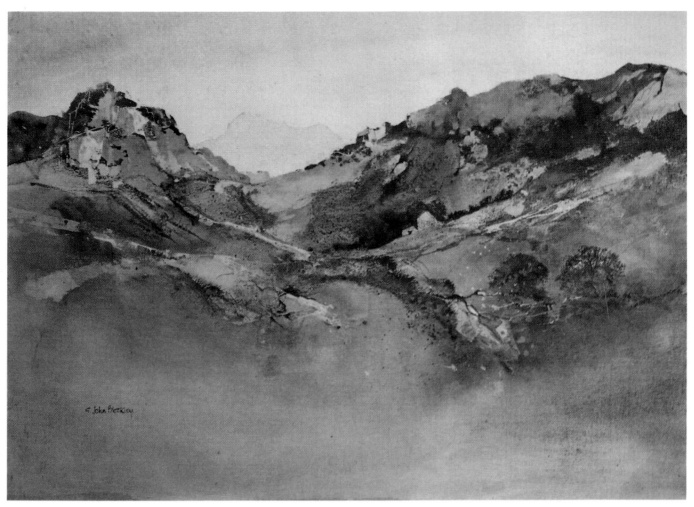

Plate 1 **Nant Ffrancon, Snowdonia.** 275 × 495 mm [11 × 19½ in.]

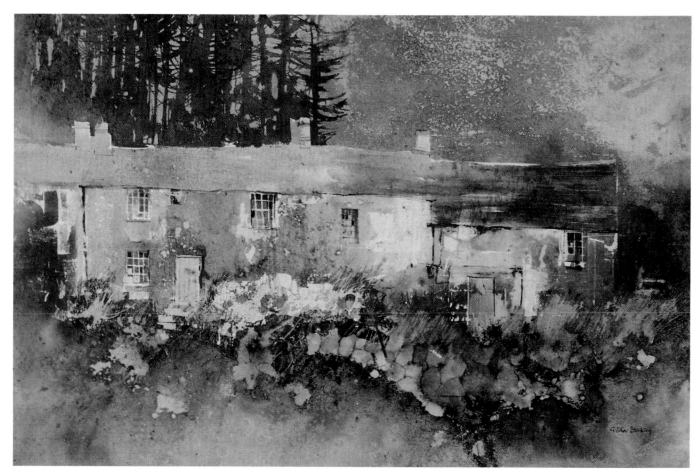

Plate 2 **Stone Cottages.** 340×500 mm [$13\frac{1}{2} \times 20$ in.]

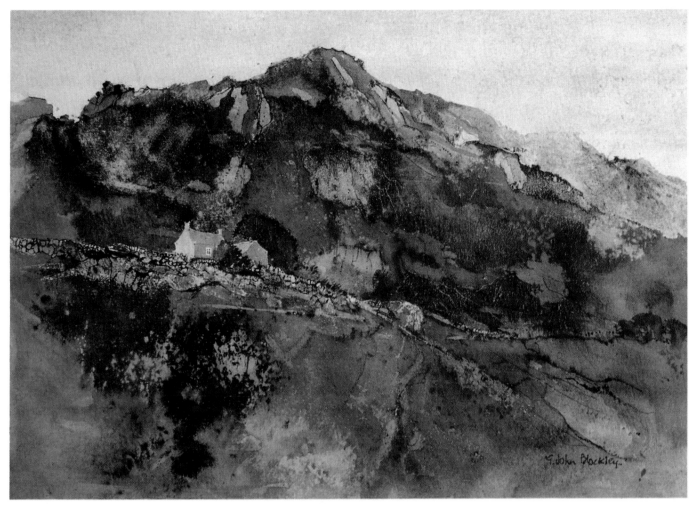

Plate 3 **Llanberis Pass, Snowdonia.** 235×325 mm $[9\frac{1}{4} \times 12\frac{3}{4}$ in.]

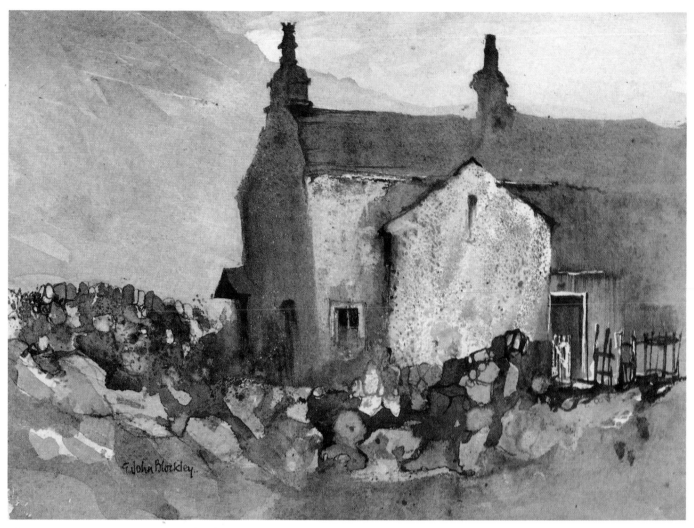

Plate 4 **Cottage in Wharfedale.** 210 × 285 mm [8¼ × 11¼ in.]

Experimental techniques

We now begin to look at some less conventional techniques which I have found useful in representing textures of the landscape.

Drawing into a wash

I paint into a first wash but using the wrong end of the brush. The tip of the wooden handle, being less absorbent than the hair, picks up a quantity of sticky paint which when drawn sideways over the damp wash deposits a line of intermittent globules. I occasionally pause and press into the paper to make a larger dot.

A very sharp handle or stick will leave a thinner, tentative sort of line, with smaller beads of paint along it. Sometimes I hold the stick loosely so that it almost finds its own meandering route, dwelling lightly in one spot and then moving on again. Sometimes I roll the stick between my fingers while it travels across the paper. The process creates an intriguing broken soft line within which small intense darks appear (Figure 16).

I paint an irregular-shaped wash, leaving spaces within it. I echo these spaces at the bottom of the wash by drawing a textured broken line with a stick or brush-point. In order to produce the broken line over textured paper, the paint must be only just moist. I touch darker paint into the wet wash to give soft changes of tones. With a fine-tipped brush, a piece of stick or a fingernail, I flick paint upwards from the wet first wash to form grass-like lines. Sometimes I use the sharp edge of a painting knife to pull these lines out of the wash.

Wash over wax resist

I rub the side of a clear wax candle over parts of the paper and apply a wash. The wax resists the wash, and this produces a textured pattern of

Figure 16 Drawing into a wash (1).

Figure 17 Drawing into a wash (2).

Figure 18 Wash over wax resist.

Figure 19 Washing colour away.

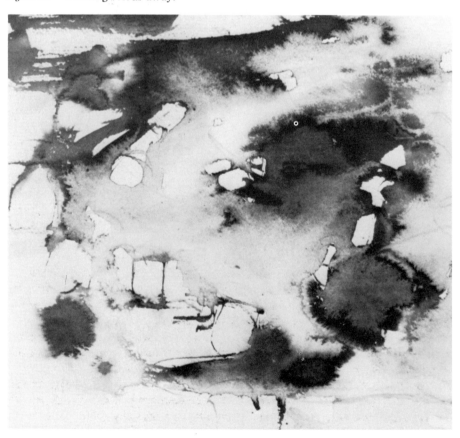

white paper within the over-all shape. Sometimes I wash a colour over the paper, let it dry and then apply the wax. This will leave a textured pattern in colour. I add to the pattern by floating further dark colour into the wet surface, and with my fingernail I tease linework out of this colour to roughly outline and emphasize some of the white shapes (Figure 18).

Washing colour away

We normally avoid wetting a nearly dry wash because the pigment in it will be disturbed and washed aside to form an undesirable deposit. However, I like to exploit this quality, by deliberately adding water to a drying wash to obtain interesting shapes. I start with a wash of even colour over the whole area, leaving a few spaces of dry paper in the middle. When the wash is nearly dry I dribble clean water into it, washing away the paint in places to form an abstraction of white and dark shapes. Some of the darker areas are deposits of pigment and some of them I make by adding further colour. I sharpen up the white spaces by outlining them with watercolour drawn with a fingernail or a drawing tool (Figure 19).

Figure 20 Drawing with a wax candle.

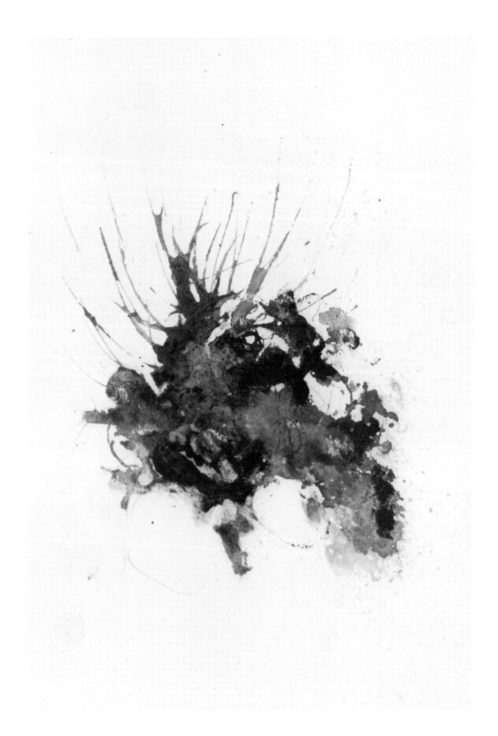

Drawing with a wax candle

I hold a brush fully charged with colour vertically over the paper and squeeze the bristles between finger and thumb to drop a pool of colour on to the paper. With the side of a short piece of clear wax candle I drag the paint into any shape which pleases me. Then I use the sharp rim of the candle end to tease lines of colour out of the upper edge. The interest here is that the candle simultaneously applies a resist and colour to the paper. This seemingly contradictory process results in a line of minute paint globules, or a subtle mottled pattern within the larger pool of colour. A similar pattern may be obtained by dabbing the pool of colour with crumpled tissue paper.

Figure 21 Ink patterns (1).

Figure 22 Ink patterns (2).

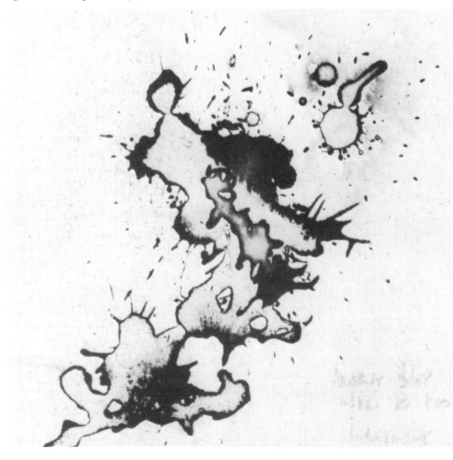

Ink patterns

I dip a brush into a bottle of black waterproof drawing ink. I always use black, as other colours are likely to fade. Holding the brush point downwards, I squeeze the bristles between my fingers to drop a blot on to the paper. A big brush, with plenty of ink and held some distance above the paper, will produce an interestingly shaped splash. I wait for this almost to dry and then hold the paper under the tap. The ink which is still wet is washed away to leave the dried ink in interesting patterns. Sometimes I exercise some control by drying parts of the blot with a hairdrier, leaving chosen areas wet to wash away, but even then the exact pattern is rather unpredictable, sometimes pleasing but sometimes unacceptable, and so we start again.

Ink and water textures

Waterproof ink and water are incompatible when mixed together. This obvious fact may be exploited to produce interesting granular effects. I paint a very wet watercolour wash on the paper and immediately pour ink straight from the bottle into it. The ink separates from the water as a film which in turn fragments into pieces of dark colour. I tilt the paper so that excess water channels through the fragments, moving them over the paper and breaking them into even smaller coagulated particles. By manoeuvring and tilting the paper I coax the particles of ink into patterns. In Figure 23 I have drawn grass-like lines into the damp wash with a pen. My next step will be to develop further the impression of textured stonework, lichen and grasses and then I will complete the painting by adding a distant landscape with cottages silhouetted against an empty sky. The additions will be kept very simple so that the main interest is in the foreground textures, the grain in the rock surfaces and the slender grasses.

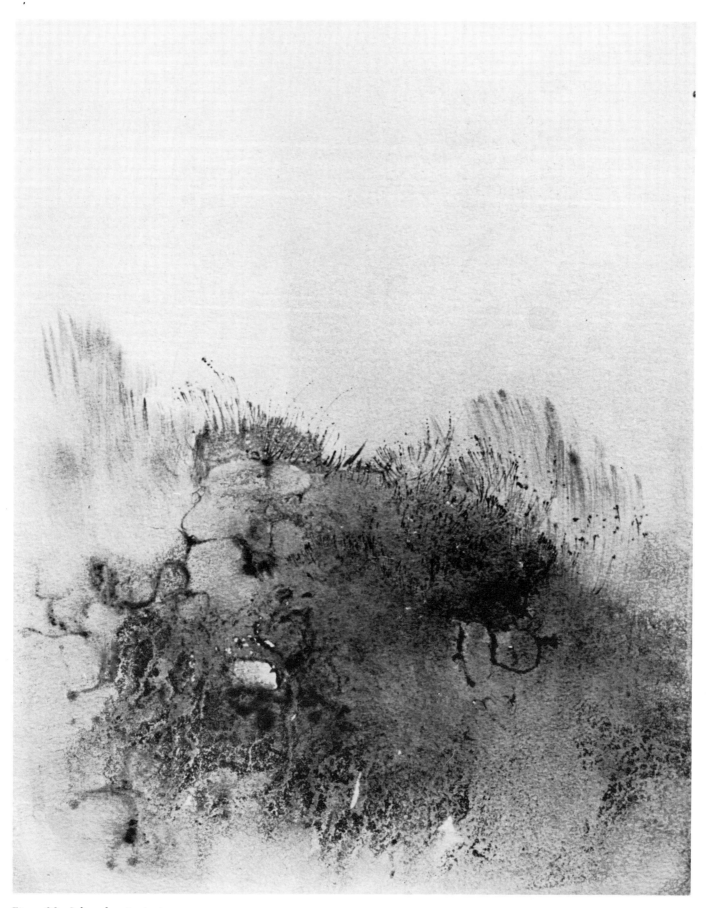

Figure 23 Ink and water textures.

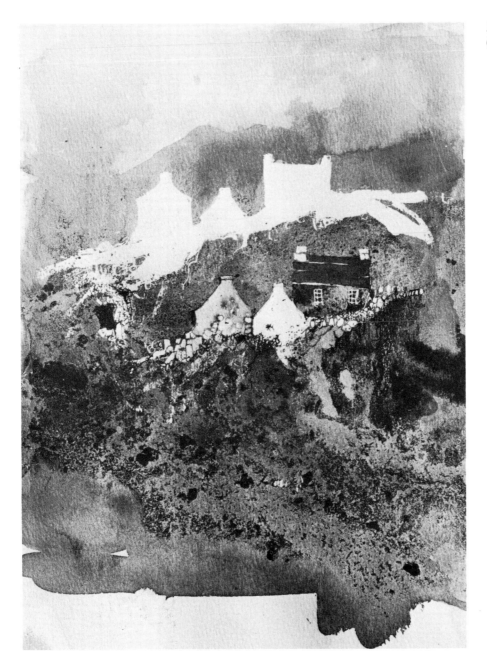

Figure 24 **Mountain Cottages** (masking out).

Masking out

It is convenient to be able to mask out shapes so that colour may be washed over them. This saves having to paint carefully around them. Masking fluid, a rubber solution, is painted over the shape to be masked; when the paint is dry the masking fluid is gently rubbed away with the finger. It is very important to wash the brush thoroughly in water immediately after using masking fluid, because if the rubber solution is allowed to dry, the brush will be ruined.

In *Mountain Cottages* I painted the shapes of the houses and the walls with masking fluid, applied washes freely over them, then removed the fluid. The first illustration shows the houses at the top ready for further painting. The lower houses have already been completed. The windows were drawn in masking fluid with a pen. I also used a pen and watercolour to draw stones within the wall at the

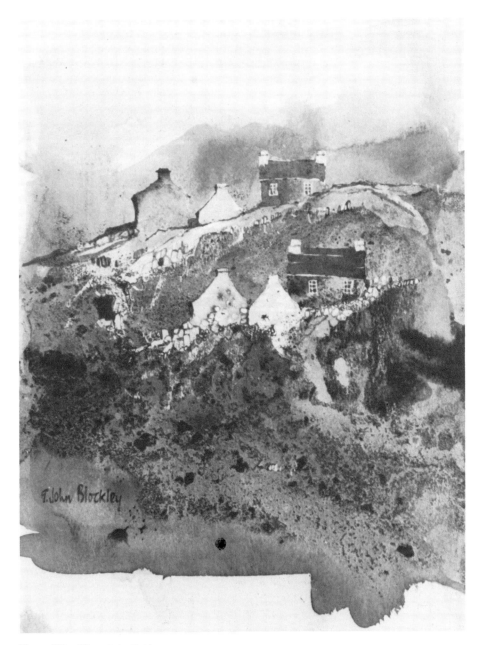

Figure 25 **Mountain Cottages.**
250 × 200 mm [10 × 8 in.]

foot of the lower buildings, giving some precise detail within the over-all 'abstract' foreground.

The sky and the mountain behind the cottages were painted with traditional wet into wet processes. The foreground was painted by the process already described of pouring black waterproof ink into a wash. This time I used less water in the first wash so that when I tilted the paper the water movement was less and the ink

separated into coarser particles to resemble bigger rock and scree formations. I also intensified and enlarged some of the dark areas by adding further ink into the paper while it was still damp.

I used masking fluid to draw window-frames in the upper cottage, let the fluid dry, and washed colour of varying strength over the three cottages. I left the white paper for the chimneys.

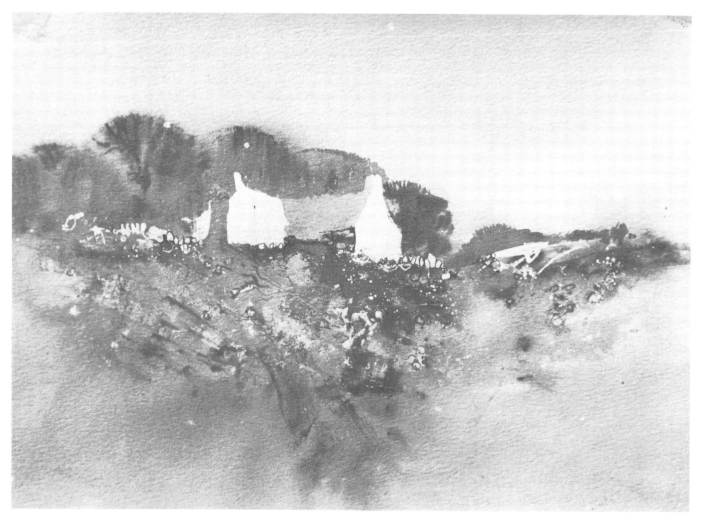

Figure 26 **North Wales Textures** (masking out).

The unfinished painting *North Wales Textures* also shows the masked-out white parts of a building ready for further painting. Some stone walls have been masked out with spots of fluid. The painting employs traditional watercolour processes as well as the more experimental techniques. The paper has been covered with a wash of varied colour and the trees have been painted softly into this damp background. The foreground is seen as a textured pattern suggesting stones and boulders. It was painted by pouring black waterproof ink into a wet wash. Further droplets of ink or water were added to cause uneven drying. When some parts were dry the painting was held under the tap to wash away the remaining wet ink. This is a variation of the ink-blot technique. The masking fluid was rubbed away to expose the white shapes of the buildings.

The window-frame was then drawn with a pen and masking fluid and pale grey washes were painted over the roofs and walls. Some of the stones and boulders were firmed up by outlining them with pen and ink, a few long grasses were also drawn in, and the distant mountain on the right was painted as a simple flat wash.

The general colour scheme is raw

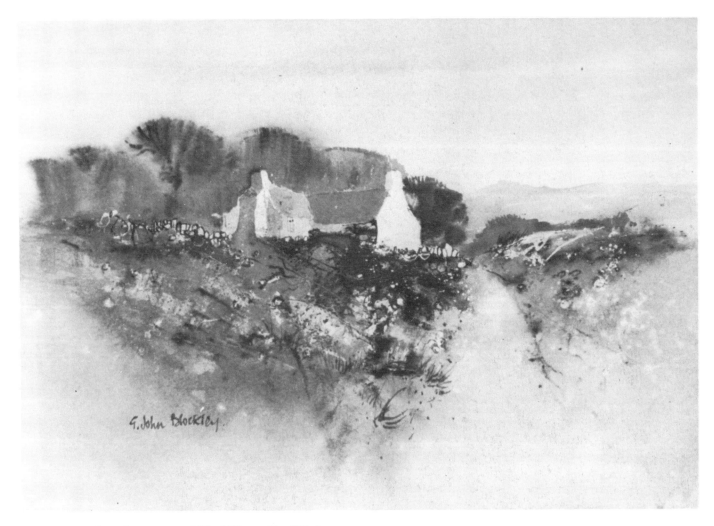

Figure 27 **North Wales Textures.** 150 × 250 mm [6 × 10 in.]

sienna all over the painting, with diluted cadmium red brushed into the road while wet and burnt umber into the foreground on either side of the road. This brown wash is modified to subtle mixtures of warm grey by the black ink poured into it. The soft-edged trees are burnt umber. This gives a colour range of sombre browns, blacks and greys, with blue roofs and distant mountains and a pale raw sienna sky which is echoed in the lighter parts of the foreground. The red road is diluted to almost pink and reads well against the sombre brown-black surrounds.

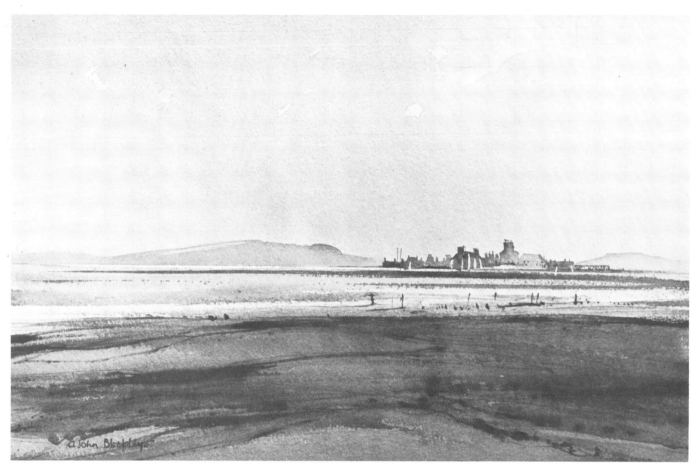

Figure 28 **Lancashire Estuary.** 250 × 355 mm [10 × 14 in.]

In the painting *Lancashire Estuary*, the sky and distant land were painted in conventional washes. The water highlights were masked out first. The soft-edged lines in the foreground were drawn with the end of a brush handle into damp paper.

Tree: conventional and experimental techniques

The painting opposite employs some techniques described so far. I started in a conventional way with a wash of varied colour all over the paper and without preliminary drawing. I used diluted raw sienna in the sky area, adding a little cadmium red half-way down the paper to give extra warmth in the lower sky. The wash was continued to the bottom of the paper,

with further raw sienna and red added into the land area to make it darker than the sky. The paper was now covered with colours which melted together with no hard edges; these represent the lightest parts seen in the painting. I waited until the wash was damp and then, using cobalt slightly warmed with burnt umber and a brush less damp than the colour on the paper, I blended in soft tree shapes. In this way I produced two soft-edged, misty-looking tree shapes. One of these, on the right, I left untouched in the final painting. With the same brush and colour I also blended a few soft-edged passages into the foreground. I let the paper dry.

If I had wished to continue this watercolour in the traditional way, I could have gone on to add darker

passages of colour to the main tree and to the foreground, leaving some edges hard and softening others with a clean, damp brush. Instead, I chose to employ resists, ink and washing-out processes to obtain the textures of the tree bark and the ground which interested me.

I lightly dragged a wax candle sideways over the big tree trunk, and into the ground area at its base, then made dark brushstrokes of burnt umber over the tree and over all of the foreground, without attempting, at this stage, to create a pattern of light and dark. The wax underlay resists some of the colour so that the lighter underlying wash shows through with a rough, mottled effect to represent the tree bark. Using a brush, I flicked a few branches sideways from the wet trunk, and this completed the tree. I dried the

tree with a hairdrier, shielding the foreground with my hand. I now quickly decided in my mind the pattern of light and dark I would like in the foreground, and proceeded to dry with the hairdrier the dark areas I wanted to keep, and to wash away the rest of the dark paint to reveal passages of the underlying light wash. At the same time I created uneven drying in the dark passages by dropping in separate blots of water and ink so that the foreground contained wet and dry patches of watercolour and ink. The grass-like lines were drawn out of the wet parts with my fingernail, (alternatively I could have used the rim of a candle, or a stick), and when these were dry I held the paper under the tap to wash away any still-wet passages of colour and ink revealing the irregular blotches of light paint underneath. This is an exciting, partly unpredictable process.

Figure 29 **Tree.**
200 × 150 mm [8 × 6 in.]

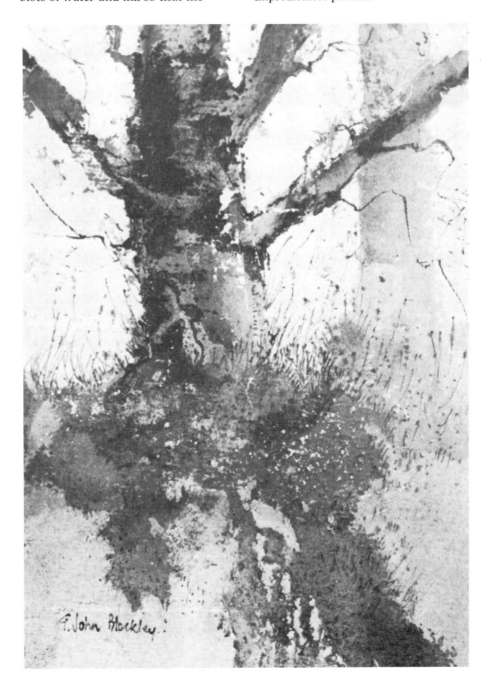

2 Landscape Features

It has been said of Turner that his landscapes become skyscapes. Here is a lesson, that shapes can blend softly together in the ground area as well as in the sky. The idea of working wet into wet seems natural for painting skies but many painters paint the ground entirely with hard-edged, busy brush-strokes which break up the painting and give it a fussy look. We can prevent this by covering the paper all over with varied colour so that sky and landscape are integrated from the very start. Clouds and ground tones are painted into the first damp wash and the painting is developed by adding definition and detail.

It might be helpful to discuss the method of painting skies by the wet into wet process and to see how the process extends to integrate sky and land. Then we can see how the same process may be used for painting features of the landscape.

Painting skies

I like to have soft-edged skies in my paintings, although I acknowledge that crisp-edged clouds can make exciting patterns, whereas soft-edged clouds can look woolly and indecisive. To avoid this apply the paint decisively and then leave it alone as much as possible. Do not worry the paint on the paper. I especially like horizontal cloud strata that echo some land profiles. This is particularly noticeable over moorland country where the land sweeps in gentle curves. The act of painting such clouds is very satisfying. A brush loaded with colour is stroked firmly across the paper through a wet sky to produce dark, soft-edged clouds. This brush action is positive, and the judgement of relative wetness between brush and paper is critical. The cloud has to be painted with a brush a little drier than the sky wash already on the paper. If the brush is wetter its colour will disperse into the wash and disappear.

Sometimes a very simple sky is needed, just to support an important feature. A darker tone spreading into a lighter sky may give sufficient secondary interest to a main feature such as a sharply profiled tree. Avoid making both sky and landscape busy. Choose one or the other. I tend to keep my skies very simple: sometimes just the merest blush of tone diffused into a pale sky. The first wash might be palest raw sienna, only just staining the paper, or it might be primrose-tinged, in aureolin or a similar colour. I also like cadmium red diluted to pink. Sometimes there is a feeling of green about the sky. Pale green, hardly detectable, perhaps even imagined—but interesting. For dark cloud tones I use French ultramarine or cobalt slightly greyed with black, and for inky dark skies I find Winsor blue useful, also mixed with a touch of black. Many painters mix light red with blue to produce a grey, tending towards mauve, and rather pretty. I dislike the mixture—intensely.

Relating sky to landscape

I carry my sky wash down into the ground area and float ground colours into it. If there is still some sky wash left in my palette lid I use it to mix a ground colour. Raw sienna added to a left-over sky mix of blue-black will make a green sympathetic to the sky colouring. I add other colours, warm browns greyed with blue, and I brush shadow-like tones into the wash while it is damp to create soft darks across the landscape. Finally I add in details. In this way the sky and landscape relate.

Figure 30 (top) **Storm Sky, Yorkshire.**
225 × 355 mm [9 × 14 in.]

Figure 31 (right) **Evening Sky, North Wales.**
200 × 300 mm [8 × 12 in.]

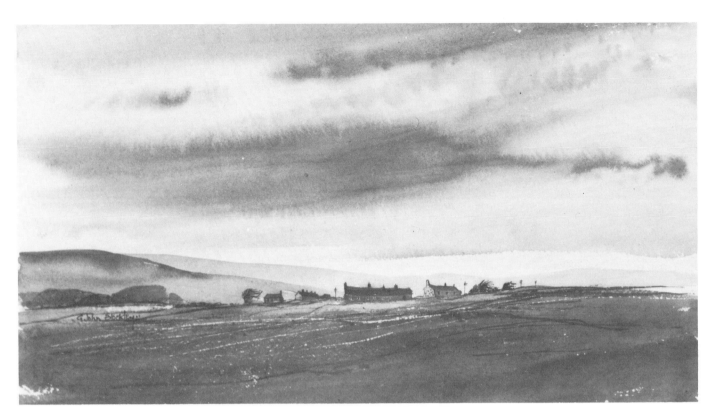

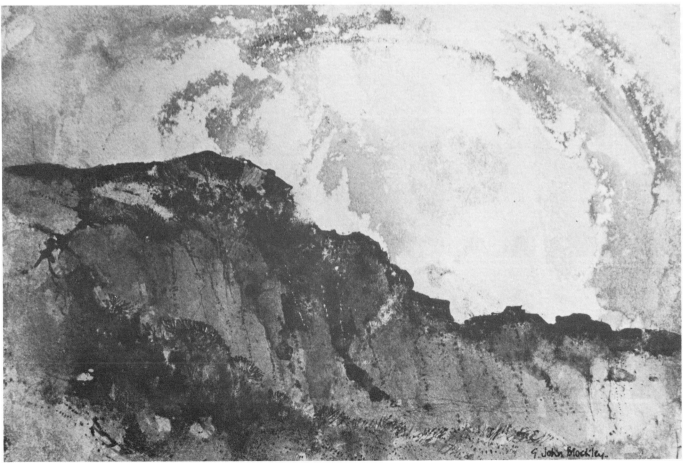

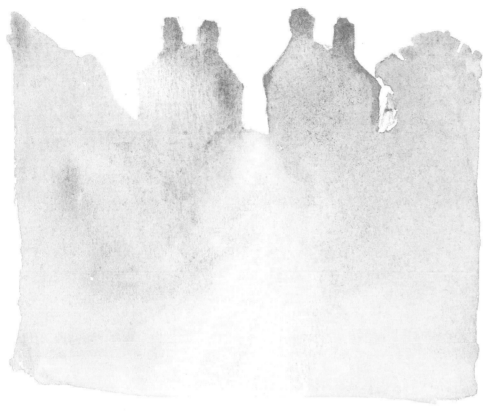

Relating features to the landscape

I repeat this process of working from an over-all impression towards precise detail when painting features within a landscape. I select the lightest colour in a house and paint a complete shape, walls, roof and chimney. Then I add darker tones where I see them for the roofs, windows, doors, and shade all of them into damp paper so that they are soft-edged. Finally I add sharp detail. Houses, trees, people are all painted in this way. Sometimes I paint a feature and the ground it stands on in one continuous wash and then add definition.

In all these cases much of the first wash remains, so that the result is clean and fresh and features integrate with the ground instead of looking as if they have been stuck on. The process gives cohesion and enables the eye to travel easily over the painting. The method does require rapid responses and some dexterity; it can be difficult, especially if the paper is big and the weather quick-drying. In these conditions it is convenient to concentrate on small areas and to work into paper redampened locally with a brush moist with clean water.

The other way of blending features into the paper is to paint them over a dry background and immediately soften an edge with a moist brush. A cloud may also be painted as a hard-edged shape and softened with a brush. The essential requirement is that features must soften into their background.

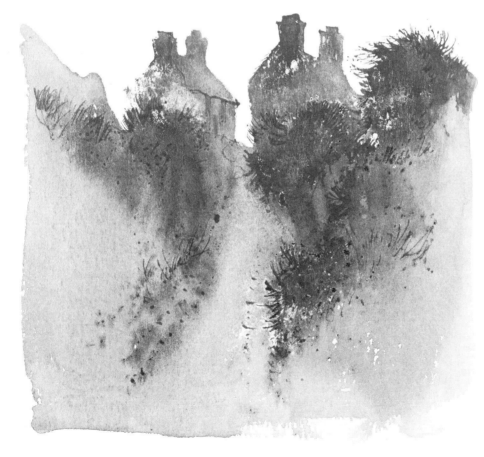

Figure 32 Features—sequence.
Stage 1: one wash over the houses and ground.
Stage 2: definition added.

Hard-edged shapes

Sometimes hard edges are needed in a painting—for a crisp white building perhaps. Such a shape can be achieved by carefully painting a darker background around it, but this is laborious and interrupts the free flow of colour over the paper. An easy way is to mask out the shape first with masking fluid and then the colour can be washed freely over the painting. I use an ordinary writing pen dipped into masking fluid to draw fine details such as window-frames, gates, posts, stones, washing hanging on a line, and to stipple dots and blades of grass.

It is of course possible to paint the landscape and then paint light-coloured details over it with opaque paint such as gouache. I have no quarrel with gouache when it is used as the principal medium, but I am uneasy about its use for minority parts of the painting. Small amounts of opaque paint tend to look like afterthoughts or corrections.

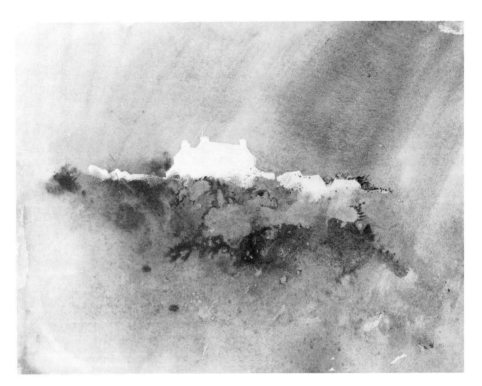

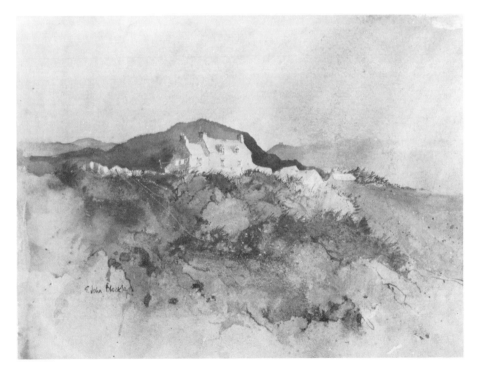

Figure 33 (top) **Cottage on the Moor**
(unfinished, showing cottages masked out).

Figure 34 **Cottage on the Moor.**
250 × 355 mm [10 × 14 in.]

Figure 35 Figure group. Stage 1: a meaningless shape. Stage 2: converted into a group of figures.

Dark shapes: people, trees

On the other hand, dark shapes can be painted over paler washes without too much opacity. I enjoy painting a meaningless dark shape and converting it into a recognizable feature. A random shape can be converted into a group of figures just by adding some heads and legs. Don't necessarily bother to paint the number of legs to correspond exactly with the number of heads. We are aiming for an impression of a group, and if someone does want to count the number of people in a group my guess is that he will count the heads and not the feet. I am talking about figures in the context of landscape painting where the scale is such that the heads require little more than a touch of the brush on the paper.

The crown of a tree is frequently its distinguishing characteristic. I always start at its upper edge, carefully defining the profile, and having established this I drag the colour downwards. I hold the brush with my knuckles facing the paper so that the brush lies flat on the paper. The dragging action leaves spaces of paper showing which conveniently represent gaps in the foliage. I add darker tone into the damp tree shape and then finally a few crisp darks.

Water

When painting water I continue the lightest colour wash in the sky to the bottom of the paper. This will represent the lightest part of the water. When the wash is just damp I add darker brushstrokes for reflected clouds or reflected features, and finally I harden some edges with further paint as the paper dries. I am careful to place these hard edges together and near to some important part of the painting so that the interest is not scattered (Figure 37).

We should be aware that tones and colour tend to alter in reflections. Light features darken in reflection and dark features lighten, but I would not hesitate to adjust these tones if it added interest to the painting. I might draw attention to a dark shape by exaggerating its intensity, or use it to emphasize a light passage.

Masking fluid is useful for making white highlights in water. I sometimes brush the fluid in horizontal bands quickly over a rough-surfaced paper and then wash dark colour over it. When the masking fluid is rubbed away bands of sparkling highlights are exposed within the dark surrounding water. Try using an oil painter's hog-bristle brush; the stiffer bristles introduce interesting lines within the brushstroke (Figure 38).

Figure 36 **Elm Trees.** 200 × 225 mm [8 × 9 in.]

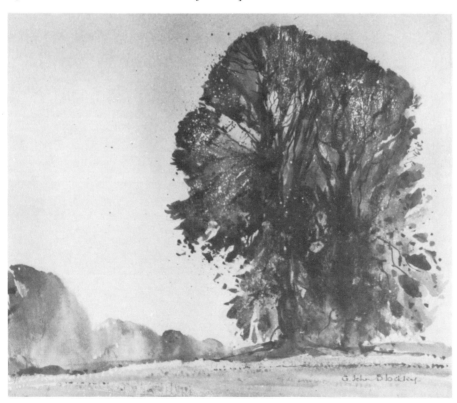

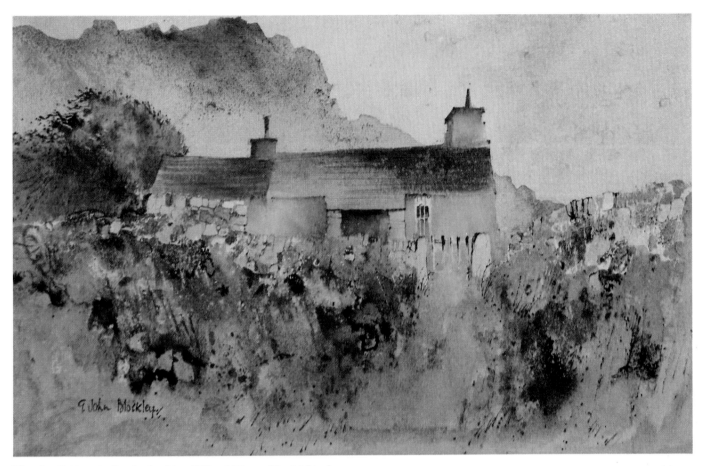

Plate 5 **Cottage in Pembrokeshire.** 200×315 mm [$8 \times 12\frac{1}{2}$ in.]

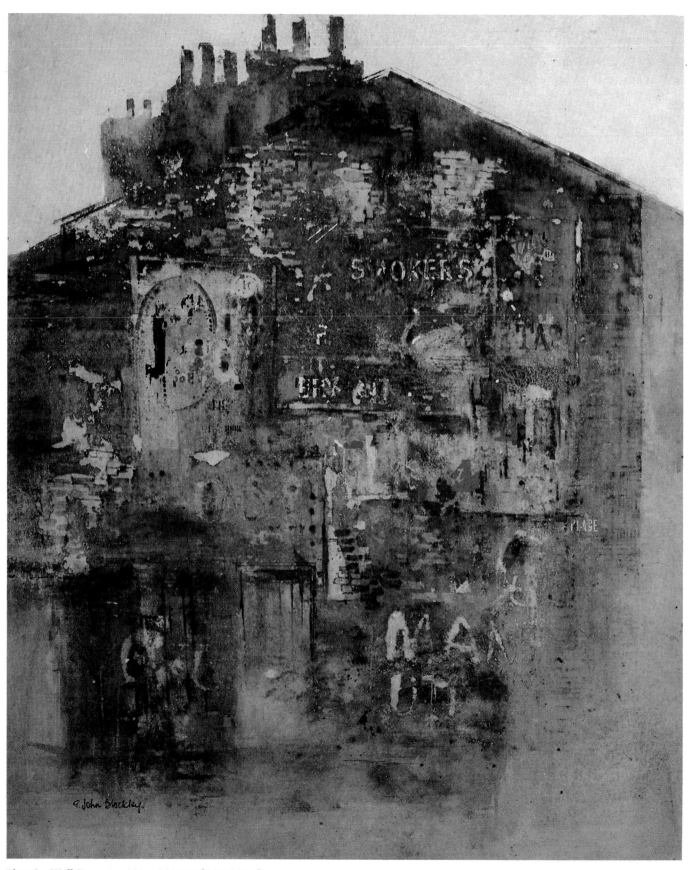

Plate 6 **Wall Textures.** 400 × 330 mm [16 × 13 in.]

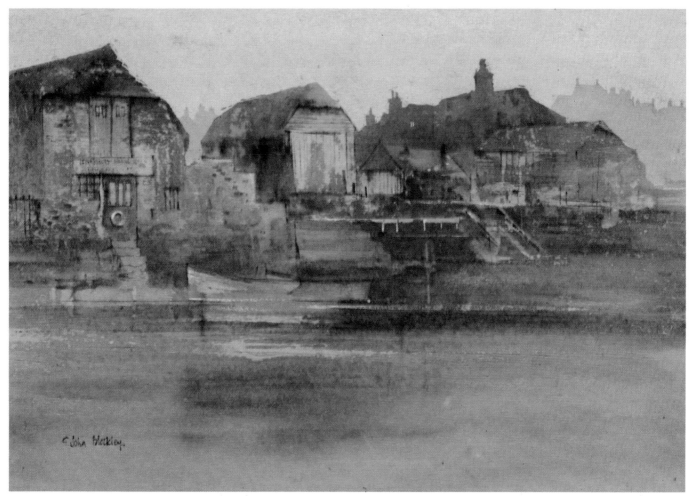

Plate 7 **Tewkesbury.** 220×325 mm [$8\frac{3}{4} \times 12\frac{3}{4}$ in.]

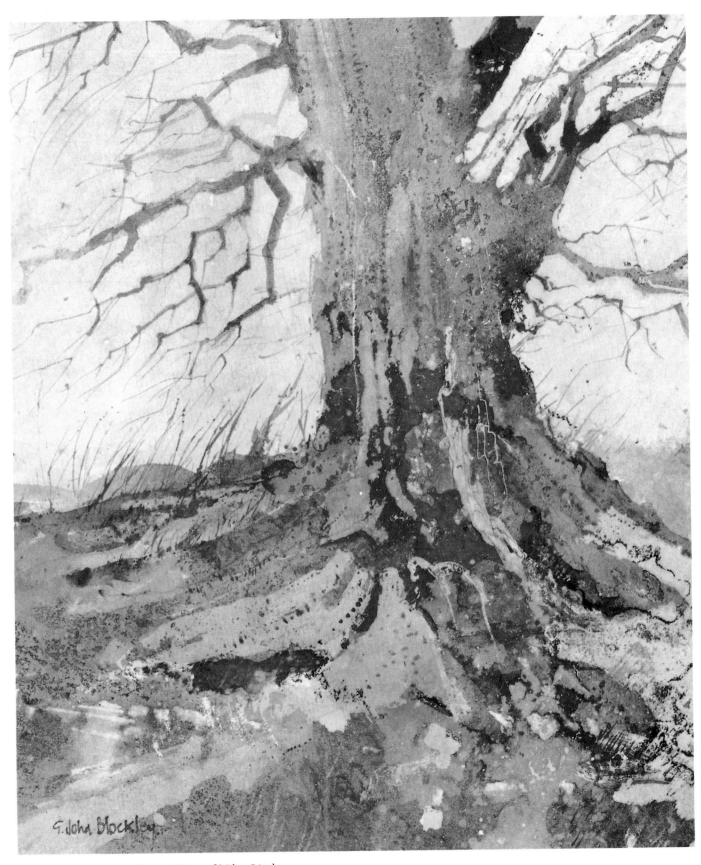

Plate 8 **Tree Textures**. 260 x 205 mm [10¼ x 8 in.]

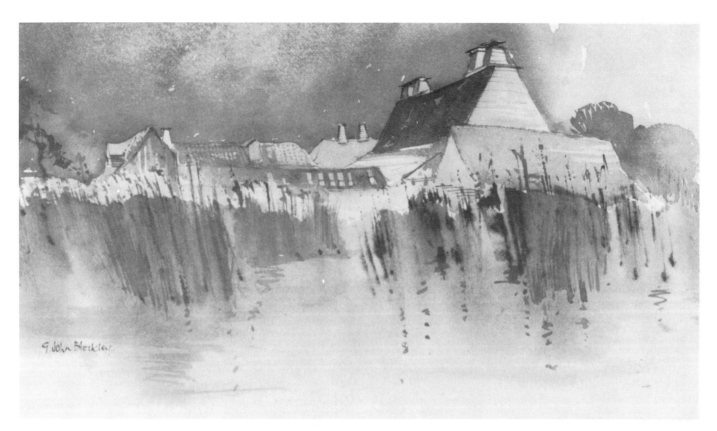

Figure 37 **The Maltings, Snape.** 150 × 250 mm [6 × 10 in.]

Figure 38 **Yorkshire Coastal Village.** 150 × 250 mm [6 × 10 in.]

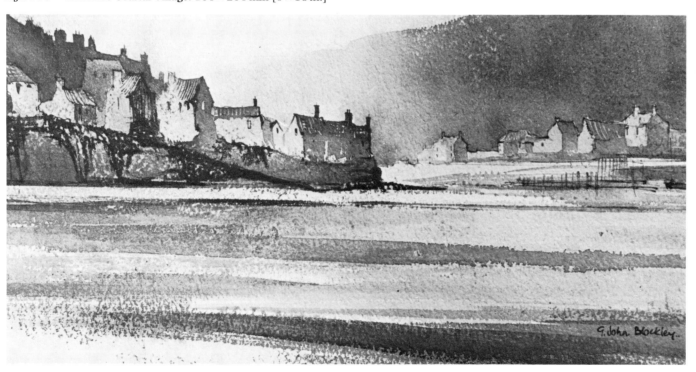

Details

When I paint details I follow the same procedure that I use for landscape. I start with the lightest colour, add mid-tones into it while it is damp, and finally add the darkest, hard-edged accents. A window is painted dilute colour all over, the glass panes are brushed in damp, and then crisp definition is added to dry paper. Notice that a window is recessed into the wall and the top panes are shaded by the thickness of the wall above the window. Some of the panes reflect dark and some reflect light. Windows are built into the house, not added afterwards, and this impression can be given by letting some window tones blend into the house tones. If the outline is omitted in places the dark window-panes will blend into the cast shadow at the top of the window and the light window-panes will blend into the light wall. Be cautious about outlines. They do not exist in nature and when we paint them we tend to separate the detail from its surroundings. Always try to paint without using an outline and explain an object by its surface tone; dark against a light background, or a light detail against a dark background.

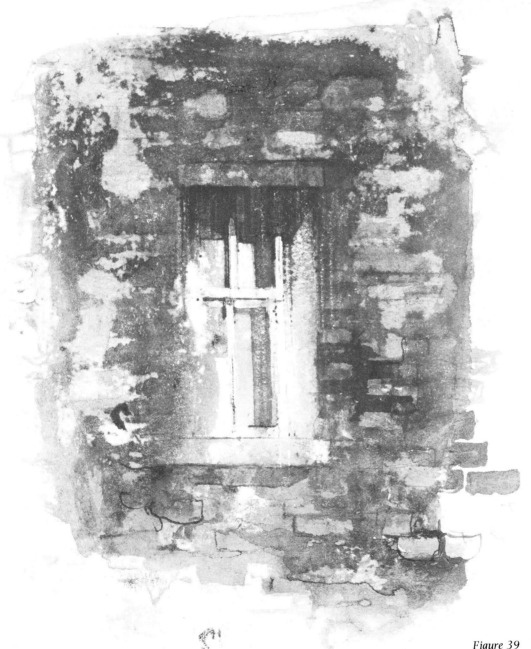

Figure 39 Window. Watercolour sketch, 165 × 125 mm [6½ × 5 in.]

Shadows

Shadows are very useful. They make interesting patterns and they describe the volume and shape of things. A cast shadow will often explain a parent object which is not itself within the picture. For example, a building with an interesting profile, but outside the picture area, could cast a useful shadow across the painting foreground. Shadows suggest objects and stimulate the viewer's imagination: involve him by leaving things out. A cast shadow will suggest contour, such as the roundness of a tree and the slope of the ground. A large shadow painted as a simple wash can provide a quiet area as a foil to other active areas.

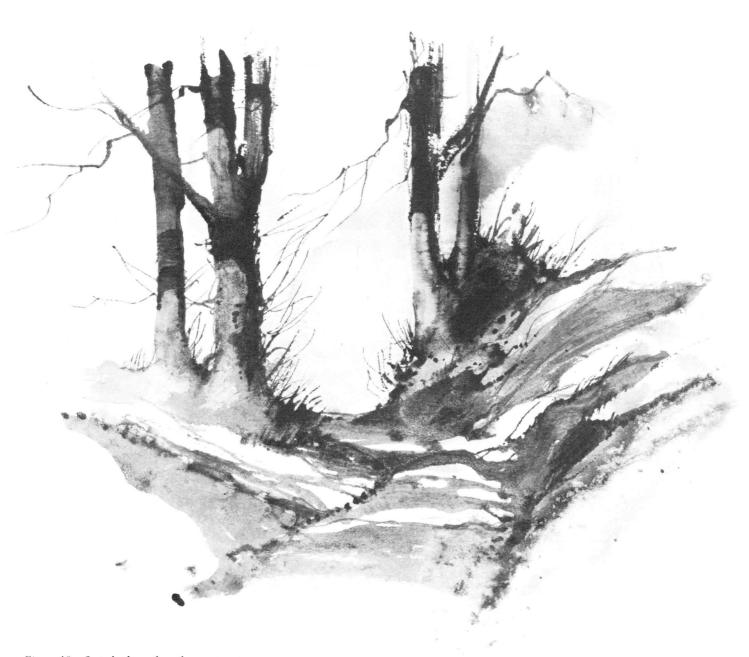

Figure 40 Cast shadows describe contours.

Silhouettes

I have talked about softening features into the ground. This impression can be helped by darkening the feature towards the top, drawing attention away from the ground. It seems to me that features do darken towards the top and have crisp edges, especially when silhouetted against the sky. The change of tone from dark at the top to light at the base also gives relief and interest to a shape. Small objects, especially, seem to me darker at the top, as if their small mass is concentrated to a strong contrast by the bigger surrounding area. A chimney pot against a big sky is an obvious example. I also think of a man's head as a small concentrated mass, darker than the rest of his body. These are subtleties which we need to look for. They add a touch of imagination and quality to a painting.

Jurston Farm, Dartmoor

Jurston Farm is a long stone-built building with walls mostly grey with hints of pink and a thatched roof. In silhouette the thatch merges with the stone walls to a long dark shape against the sky. The farmer lives at one end of the building and the cows at the other. Other parts are used for storing hay and machinery for threshing corn, with pulleys driven by flapping leather belts. Some of the stones in the building walls are bigger than the men who lifted them into position four hundred years ago.

I wanted to express the crisp roof profile and the contrast of the low-toned building with the light field in front.

I drew the outline of the building very faintly in pencil and then covered the sky and ground with masking fluid, leaving only the building as white paper. When the masking fluid had dried I brushed a warm grey over the building area, using cadmium red mixed with cobalt modified to grey with the anonymous-coloured mixture which had been left over from yesterday's painting and had dried in the palette corners. I let the wash nearly dry, then added stiffer pigment into the roof area and let that dry.

The building was painted in this simple process of one wash with hints of tonal change brushed into it, and the actual painting time cannot have been more than a minute. When the wash was dry I rubbed away the masking fluid to expose white paper, so that the building was left as a cut-out looking shape in the middle. I then painted the sky and road with a wash of palest blue-grey, a hint of pink, and the field in Winsor yellow muted ever so slightly with yesterday's left-over grey mixture. It reads acid sharp against the grey building. The trees are big, blot-like shapes of Winsor green into which I squeezed drops of lampblack from a brush. Using a pen, I drew lines of colour from the trees to describe their profiles.

With a pen dipped in watercolour I carefully indicated the construction of the roadside wall, in which some of the stones are the height of the wall with small, fist-sized stones fitted in between them. The tops of the walls are covered with turf from which spiky hedges grow. I handled these in the same way as the trees, drawing with watercolour.

Figure 41 **On Dartmoor.**
125 × 380 mm [5 × 15 in.]

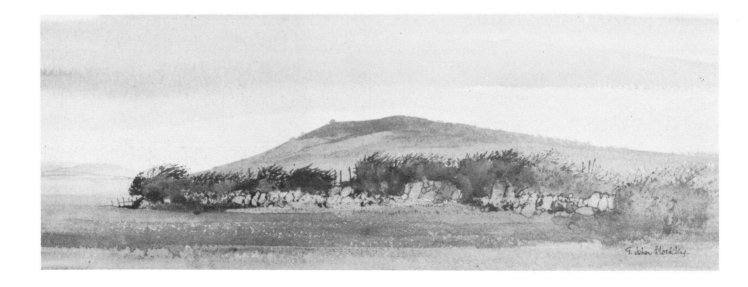

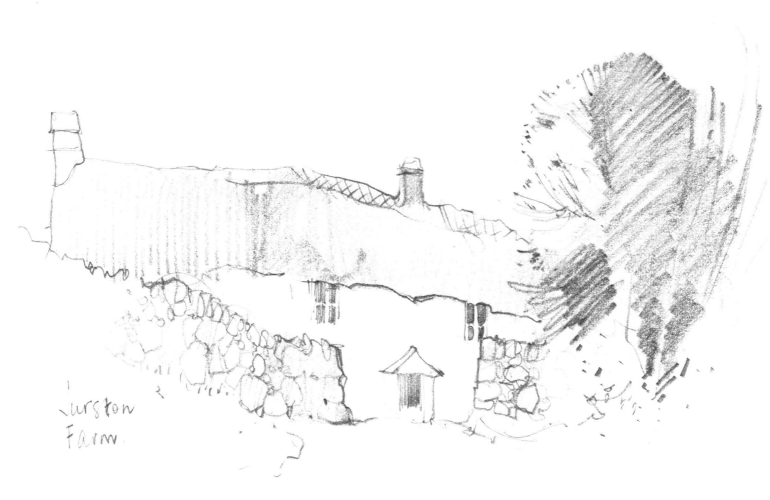

Figure 42 Jurston Farm, Dartmoor.
Pencil sketch,
125 × 200 mm [5 × 8 in.]

Figure 43 **Jurston Farm, Dartmoor.**
150 × 370 mm [6 × 14½ in.]

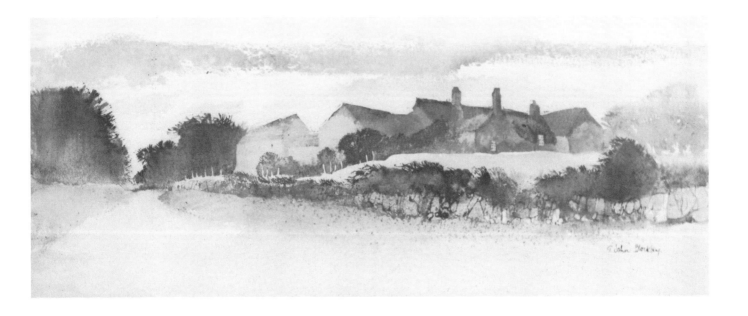

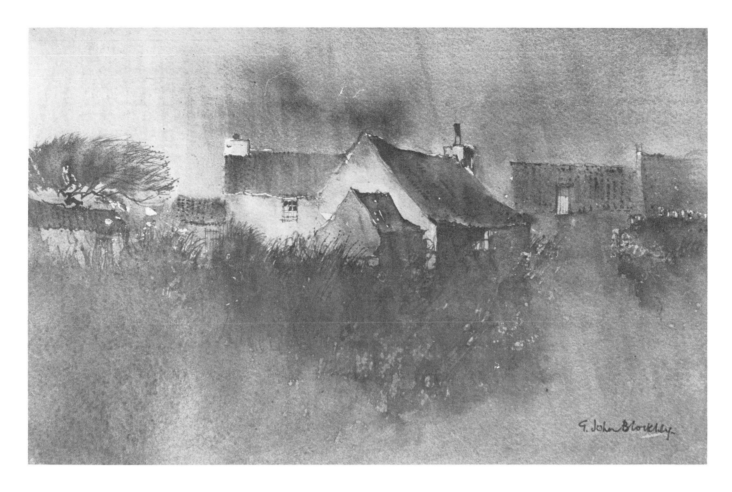

Figure 44 **Pembrokeshire Farm.**
175 × 275 mm [7 × 11 in.]

Pembrokeshire Farm

It was morning and the sky grey with imminent rain so that the buildings softened and almost floated. I covered the paper with a blue-grey wash, lighter in the area to be occupied by the buildings, and with palest raw sienna in the lightest part of the sky. I added further pigment into the damp wash to strengthen the central foreground, and using a pen I teased paint out of this darker tone to make the tops of the grasses. I also teased paint out of a brushstroke to form the windswept tree.

The paper at this point was nearly dry, a dangerous stage to work into. I let it dry, redampened the building area with clean water and added the soft-edged red roofs. I then dampened the sky and brushed in a soft-edged dark to emphasize further the pale walls of the building.

It is a simple little painting in blue-grey and grey-green with soft-edged pink roofs. The roofs explain the house and detail elsewhere is minimal; the pale blue-grey wash brushed over the paper at the beginning has been left to represent the almost white walls.

Pembrokeshire Cottages

I saw these cottages in late evening. They had been cemented all over to withstand the weather and appeared silver-grey and crisply shaped, under the pallor of a new moon set in a sky of deepening blue-black. The natural colours of the ground reflected a greenish tinge from the sky.

Back in the studio I used masking fluid to mask the cottages; this fluid dries with a hard edge, which can be a problem if a soft-edged shape is required, but in this case it was to my advantage since I wanted to reproduce the sharp edges of the cottages.

I washed a mixture of Winsor blue and lampblack over the paper and added a hint of pale Winsor green into the lower sky and the ground. I allowed this wash to dry so that I could paint the cloud drifts and ground shadows with hard, ragged edges, just slightly darker than the first wash. I thought of these ragged clouds and shadows as intermediate edge values between the velvety smooth blue-black sky and the crisp edges of the buildings. Windswept bushes alongside the cottages were drawn in with a pen dipped into the same blue-black mixture.

When the wash had dried I rubbed the masking fluid away to expose the white shapes of the cottages. These I tinted in with palest colour to just stain the paper with blue-grey and a suspicion of Winsor green. I left the slightest flicker of light along some of the edges, added a few pen dots to the walls and flicked out a few pinprick lights with the point of a razor blade. These flickering highlights within the palest grey-green colours of the walls gave the impression of silver light against the low-toned sky and ground. I was careful to heighten the importance of one cottage by keeping it slightly lighter than the others.

I mounted this painting in dove grey with a narrow inserted slip of silver-green between the mount and the painting to pick up the hints of this mixture in the painting. The frame was dull silver with bronze rubbed through to add a feeling of warmth to the painting.

Figure 45 **Pembrokeshire Cottages.** 100 × 300 mm [4 × 12 in.]

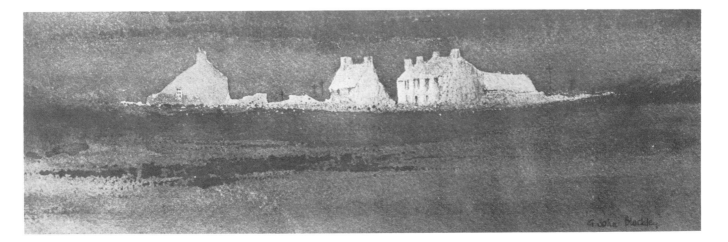

Cotswold Cottage

I painted this a few weeks after coming to live in the Cotswolds. The roofs of the cottages are fascinating. They are covered with stone slates which were made by laying slabs of newly quarried stone on the ground and waiting for the frost to split them. The slates are rough, of different thicknesses, and over the years they mature to a deep warm grey with hints of purple, in places almost black. On the north-facing roofs velvety pads of moss grow, green weathering to bronze, and everywhere silver-grey incrustations give sparkle to the sombre colouring. The walls of the building weather from the newly quarried honey-coloured stone to shades which change with the light from cool grey to apricot. The result is a textured fabric, roughly woven, with a home-spun look totally different from the appearance of flat machine-age roofs and walls.

I masked out window details in the roof with masking fluid and then covered the paper with a wash of raw sienna and dribbled into parts of it a warm grey made from a mixture of burnt umber and cobalt. With the wrong end of the brush I drew faint lines of the same grey to suggest random-shaped stones in the wall. I poured black ink into the roof and caused it to dry unevenly by adding water to parts of it. I modified the black by squeezing burnt umber from a brush into it while it was still wet. With some of the roof dry and other parts still wet I plunged the paper under the tap, washing away the wet ink and leaving a mottled effect of dry dark patches with blotches of lightly stained washed-out bits.

I felt that this treatment had achieved the weathered look which interested me, and so I quickly completed the painting. I defined the window, added a touch of palest blue-green to the door, and into redampened paper I drew soft-edged impressions of plants at the foot of the cottage wall; and then when the paper had dried I dragged a mixture of raw

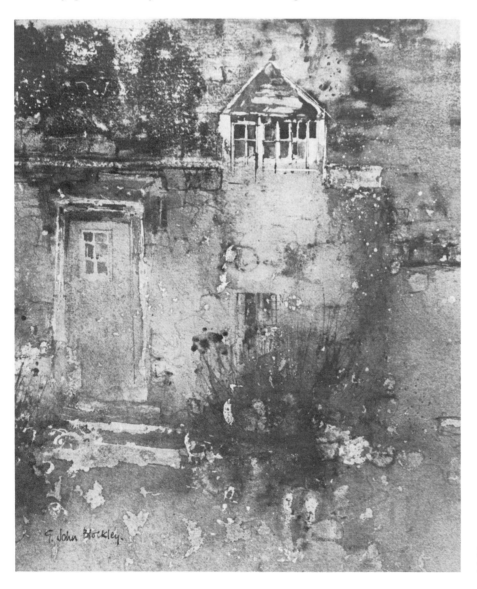

Figure 46 **Cotswold Cottage.**
300 × 250 mm [12 × 10 in.]

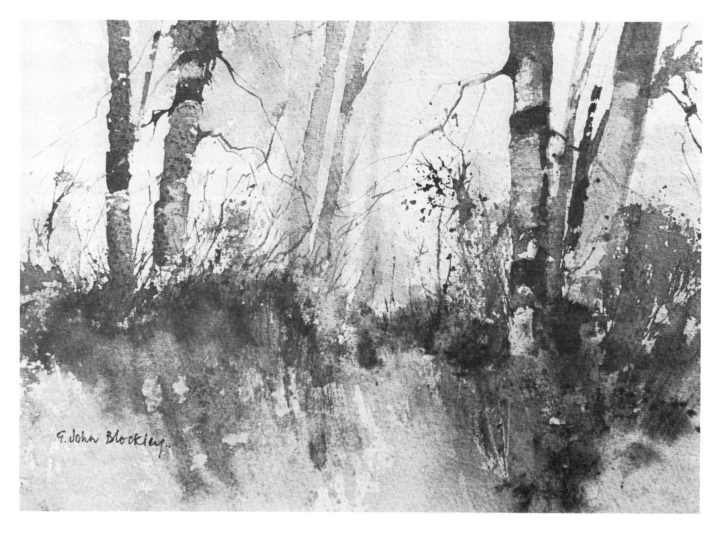

Figure 47 **Path through the Wood.**
225 × 355 mm [9 × 14 in.]

sienna and a little burnt umber over parts of the walls, leaving some patches of the first raw sienna wash exposed, as a further indication of random stones in the walls.

Path through the Wood

This small sketch was painted directly on the spot one morning. I washed cobalt blue over the sky and raw sienna over the ground, allowing them to touch while wet. I then let the paper dry. I wet the ground area again and brushed in the darker tones, using burnt umber greyed with a little French ultramarine.

The trees were painted into the redampened sky, with vertical brushstrokes of raw sienna for the light parts and sideways strokes of burnt umber for the dark parts which describe the roundness of the tree trunks.

The painting was done using traditional watercolour processes, with the slight qualification that I used my fingernail to tease paint out of the wet ground colour to form the grasses and undergrowth. I used only one brush, a 50 mm (2 in.) wide wash brush, to make vertical strokes for the ground textures and sideways strokes for the tree trunks.

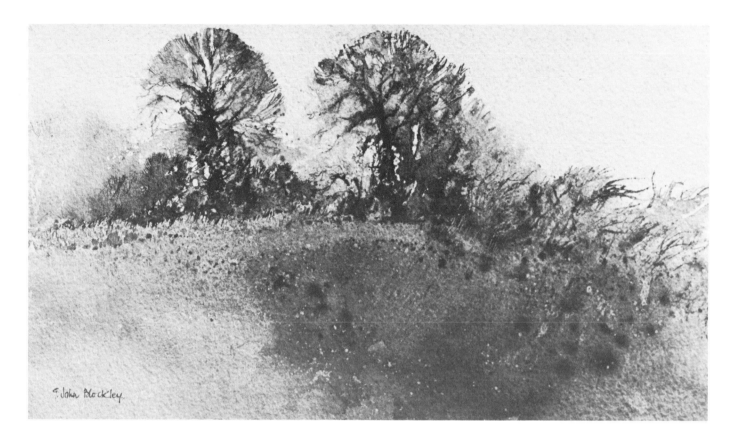

Figure 48 **Dying Elm Trees.**
225 × 380 mm [9 × 15 in.]

Dying Elm Trees

This is painted on a heavy handmade rough-surfaced paper. The sky is manganese blue, a new experiment for me. It is a bright blue, similar in hue to cobalt, but very intense. I mixed it with plenty of water and washed it over the sky with the paper lying flat so that the blue pigment precipitated out of the water and granulated into the rough paper texture. The result is a bright shimmering blue sky. I immediately covered the lower half of the paper with a very wet wash of raw sienna into which I floated traces of cadmium red. The combination of a very wet mixture of two colours on a rough, flat surface again created precipitation, this time into gold and red to represent the cornfield. The intense golden light of the corn is emphasized by a cool grey shadow-like tone brushed into the centre; this also serves as a dark base to support the long grasses which I drew with my fingernail at the right of the painting.

The trees and neighbouring bushes were begun with a blush of brown cooled with blue brushed into redampened paper. The trunk and branches were drawn into this first damp tone with a small pointed brush, and then with a pen dipped into watercolour I flicked in a few crisp lines and dots to sharpen up the base of the trees and some branches. Finally, I dampened the foreground again and touched it with spots of brown madder from the tip of a brush, to give soft-edged red spots into which I added black centres to suggest the poppies growing in the corn.

The final painting shows golden corn under a shimmering blue sky, quietened by the more sombre colouring of the dying elms and foreground shadows.

Stone Barn

With a pencil I lightly indicated a few guiding lines, the roof profile, the position of the windows and the big door, then I washed in the sky, using

raw sienna influenced to pink by mixing a little cadmium red with it. I continued this wash to the bottom of the paper, progressively adding a little more of each colour to make the ground darker than the sky, but the same colour. While the wash was still wet I introduced a little cobalt into the sky, the merest hint, and I repeated this into the area of the door. I now had a wash of colour all over the paper, representing the finished sky, the light parts of the building, and the ground, all of them blending together. I added a little green, raw sienna and cobalt into the foreground wash to suggest grass at the sides of the road. Then I let it dry.

Next I painted the background tree, dragging French ultramarine greyed with black over the paper, starting from the top of the tree and shaping it

around the chimney. With the same colour mixture I painted the two tall trees and continued this into the grass bank below, then I immediately touched in some dark brushstrokes of burnt umber. I used a wide flat brush to paint the trees, moving it sideways so that the bristles followed the roundness of the tree trunk. The gaps appearing in the trunks were accidental, although I had hoped for them, and I left them as light reflections on the trunks. The flat brush left a broken edge to the tree and I felt that this was consistent with the rounded surface curving towards the light. Using a round brush I flicked in the branches, making them point downwards with angular changes of direction. The downward-pointing branches were a conscious adjustment to help the painting: they lead the eye towards the

building and at the same time echo some of the slopes within the building. The brushstrokes of burnt umber introduced some warmth into the tree trunks and they also blended into the first blue wash to give hints of green. I used more of this colour combination to paint over the building area, leaving some of the underpainting showing for the light parts. These can be seen in the windows, the stones over the door and the door itself, and in the textured wall surface. A few dark definitive brushstrokes in the chimney, windows and door complete the painting.

The process is basically very simple: the first wash describes the sky, the ground and the light parts of the building. The second wash describes the trees. The third wash describes the building surface. A few dark brushmarks give definition.

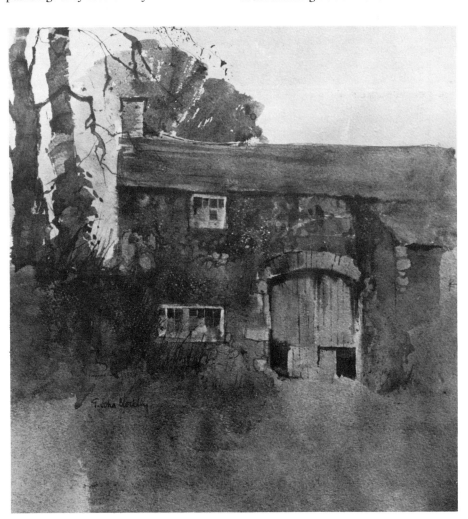

Figure 49 **Stone Barn.**
300 × 250 mm [12 × 10 in.]

Cottages, Western highlands

I painted this from sketch-notes made on a painting trip to the west coast of Scotland. The mountains fall steeply down to the sea, rough trees grow at the bottom and a row of a few cottages strung out along the shore face out to sea. The roofs are corrugated iron, some red-rusty and some painted black. In one of them a young family lived. The mother had come here from an industrial town to sketch and paint. She helped the income by collecting mussels and carried them in a sack to the station for sending to London. I worried a bit, with guilt, about my own relatively comfortable painting life.

I was intrigued by the textured mountain-side, of rock scree through which the rain had coursed to make deep gullies. Within these gullies the rock debris is worn to fine particles which glint silver, impossible to express in pure watercolour.

Instead of starting with my usual wash of colour all over the paper, I washed a blue-green mixture over the sea to represent its lightest parts, and brushed only clean water over the mountain area. I poured ink into the wet mountain part and rocked the paper so that the ink lying on the water surface broke up and precipitated to suggest the granules of rock debris. By tilting the paper I coaxed rivulets of water through the fragmented ink to reproduce the natural water channels down the mountain-side. The process washed away the ink to reveal the paper, which, having escaped my usual preliminary colour wash, remains only slightly stained and gleams with the silvery look which I saw on the actual mountain slope.

With the paper just damp I darkened the area occupied by the trees with burnt umber and with a small brush flicked the edges of these dark shapes to indicate the rough tree growth. I shaped the trees around the chimneys and roof profiles and so all I needed to do was to paint in the roofs, add a little drawing with a pen, and the buildings were complete. Using a fine brush, I added some drawing to the rocks and some tone to their shaded sides.

Finally, the darker tones of the water were put in with horizontal

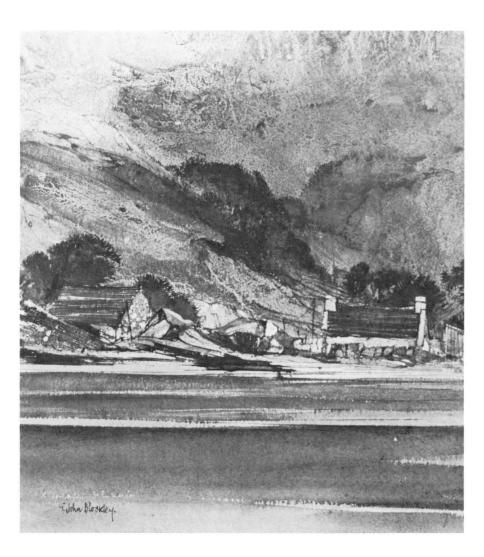

Figure 50 **Cottages, Western Highlands.**
275 × 250 mm [11 × 10 in.]

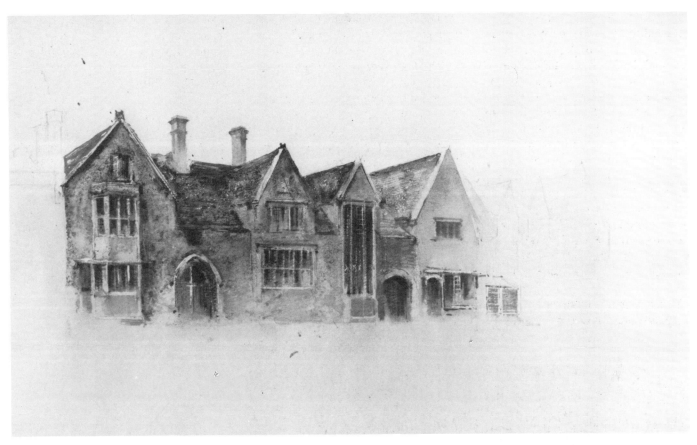

Figure 51 **Chipping Campden, Gloucestershire.** 200 × 460 mm [8 × 18 in.]

brushstrokes of French ultramarine. These were warmed occasionally by raw sienna and a little burnt umber stroked through them to give a hint of the local colour of the reflected mountain. I left strips of light water, but not too many, as I wanted the bands of dark water to be wide enough to provide large, quiet, unfussy areas of colour as a foil to the textured mountain-side.

Chipping Campden, Gloucestershire
This unfinished painting shows three stages of painting a building. My first pencil outline is seen at the right of the painting.

Next to it the top of the building has progressed to a first wash of colour only, and, below, the first soft-edged tones of window and door are seen.

On the left the painting has been taken further. A very wet mixture of raw sienna and burnt umber was washed over a preliminary wash of raw sienna and by rocking the paper backwards and forwards the burnt umber was precipitated out to cause the textured effect. The architectural details are also fairly advanced and need only a little crisp drawing in places.

I have painted the buildings in this way to compare in one the sequence of stages. I would not normally paint a later stage with part of the building only just drawn. Every part of the painting would advance at the same rate.

In the finished painting the base of the buildings will be sharpened just a bit in places and some figures will be added with minimal detail, just enough to suggest human interest in the painting.

3
Demonstrations

Some of the paintings illustrating this chapter were done some while ago and my discussion re-creates the processes I used. Other paintings were done specifically for the book and were photographed at stages during painting. Some of these were painted in a continuous operation with the photographer leaning over my shoulder, clicking at my command and in some cases running behind me from the painting table to the studio sink to photograph my washing-away operations. Other paintings were interrupted and posted away at intervals of time to the photographer and restarted two or three weeks later.

Although the demonstrations are useful to show the gradual build-up of a painting, these interruptions suggest that a painting is made in a sequence of precise stages, whereas ideally the process is continuous. The fluidity of the watercolour means that the process is seldom static; a wash can change direction unexpectedly, sometimes to advantage and sometimes towards disaster, when immediate correction is needed. Sometimes adjustments are small, but often the painting can change considerably and very quickly. A wash can be very pale one moment and dark moments later. The behaviour of the medium demands intense concentration from the painter so that he is ready to react to sudden changes. However, there are periods of waiting for washes to dry, and it has been possible to phase some of the photography to these intervals.

I have another, more important, reservation about demonstrations. It seems to me that they suggest a cut-and dried process and conceal the constant exploration, questioning and rejection without which all painting is facile. In watercolour painting deft wet into wet painting can give slick representations. A wash of palest raw sienna, only just staining the paper and allowed to touch a wash of blue, will give a quick imitation of a sky. Frequently such washes are painted over most of the paper, with just a strip of landscape along the bottom; this is really nothing more than a skilled basic process, a piece of basic painting vocabulary, put forward as a considered work. A confidence trick. I include one opposite. I painted it as a demonstration to a class while I was answering a barrage of questions. It took half an hour. I told them it was slick. They liked it. It did demonstrate some wet into wet painting in the sky and in the ground and the follow-up brushwork and so served a purpose, but the holes in it, hard-edged all round, are unconsidered and untrue to nature. I keep it in my reject store.

I have to emphasize that I am trying to indicate throughout the book the ways of painting that I have found most suitable for expressing ideas that interest me. I would like to think that the thoughts leading to the painting are as important as the techniques I have used.

Most of the paintings here derive from something actually seen, from a sketch or a visual memory. Although I paint mainly in the studio, I can mentally relive the time when I made a particular drawing out of doors, and I quite vividly recall the conditions of the time. This comes from years of working outside, in all weathers, and even now I do spend a lot of time out of doors, walking through the woods near my studio, and in the fields, looking and thinking about the things that interest me. I have heard it said of someone, whose name I cannot recall, that his favourite place is wherever he happens to be at that moment. I can understand that. The countryside and industrial towns are good places to paint in. I love their particular qualities, mood and atmosphere. I am also keenly interested in their details.

Details are fascinating. At one time in my life I made paintings of complex architectural projects for a living. I painted them in washes of flowing colour, but beneath this freedom lay mathematically constructed drawing, with every feature in correct

proportion and diminishing in correct perspective. They were developed on a drawing board with every plane of the complicated building projected to its particular vanishing point. And a Ford motor car in the painting was a Ford motor car and every man had two legs. Every door and every window-pane was drawn precisely and immaculately. The drawings were 'tight' and made with a hard pencil. Then I rubbed the drawing away until in parts it was only just visible, and with a big brush I flooded watercolour over it, letting the sky wash blend into the building and the building wash into the ground. Gradually the painting built up, recovering selected detail and suppressing, but not totally

eliminating, other detail, aiming all the time for a product architecturally convincing but veiled by free wet into wet watercolour, giving light and atmosphere to fit the building into its environment.

I mention this to show my interest in detail and I like to think that there might be a sense of detail within my present work. I do believe in looking hard, and in depth—in detail. I have mentioned my interest in the dandelion flower and, continuing the theme of plant life, the inverted umbrella-like structure of the cow parsley is fascinating to observe and to draw. The main stem is ribbed and from its top the stalks spring out to form a concave frame which in winter looks

brittle and fragile; suspended curves liable to shatter. From the tips of the stalks flower bracts radiate, each one a small sheath from which tiny antenna-like spikes protrude. They are searching structures to draw.

An awareness of detail gives confidence. I paint in Wales and I need to know and have some understanding of the way the builders, centuries ago, positioned their cottages to resist the weather and not necessarily facing the most attractive view. I need to know that the roof slates are graded in weight, large and heavy at the eaves and progressively lighter and smaller towards the ridge. I think it is important to observe the construction of fences and farm gates, to know that

Figure 52 Slick demonstration. 250 × 380 mm [10 × 15 in.]

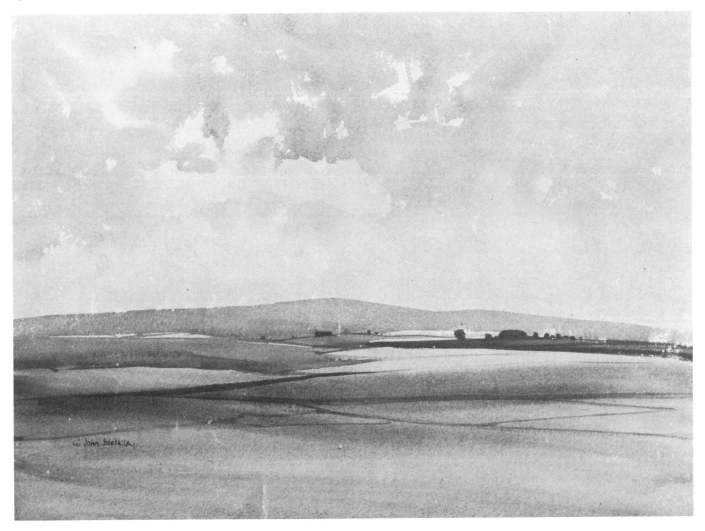

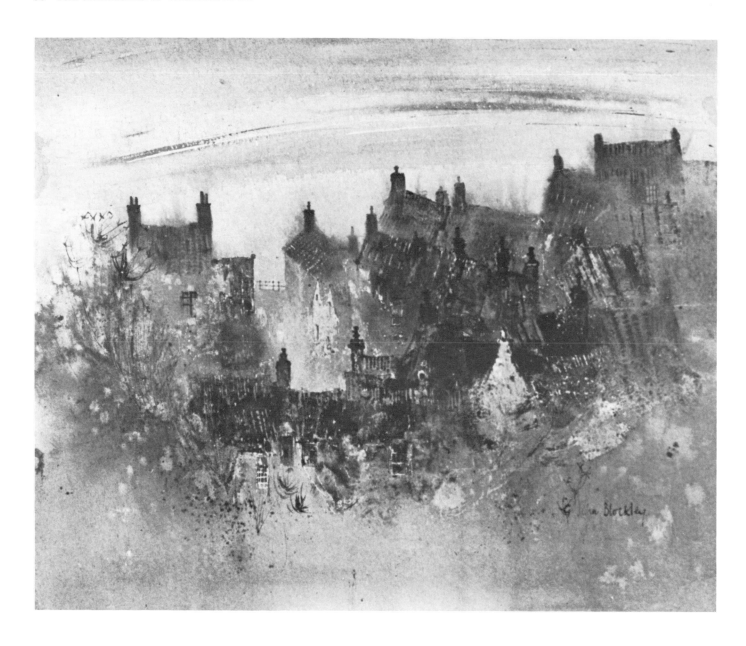

the horizontal bars in a gate are unequally spaced, closer at the bottom so that animals' horns won't entangle with the bars as they try to reach succulent grass on the other side. A slapdash detail can make the whole painting unconvincing.

If you develop a habit of always looking closely at things, the habit will continue when you look at a subject with the purpose of painting it. The eye automatically measures and compares one item with another. It measures the space between the windows of the house and compares it with other distances and spacing, and so even if you choose to paint in a free manner there will be a sense of underlying rightness.

Staithes, Yorkshire

Staithes is a fishing village on the North Yorkshire coast. The cottages huddle together on a hillside which falls steeply down to the sea. The roofs are made with curved pantiles vermilion in colour and weathered in parts to green and umber. Looking down on the scene I was intrigued by the chimneys which stood up from the confusion of rooftops. A slightly rippled blue-green sea fills the top of the paper. I started the painting above by washing cobalt mixed with a little Winsor green over the sea area and then changed to raw sienna for the lower half of the paper. While this was still wet I brushed cadmium red mixed with just a little black, some burnt umber and green into the part occupied by the

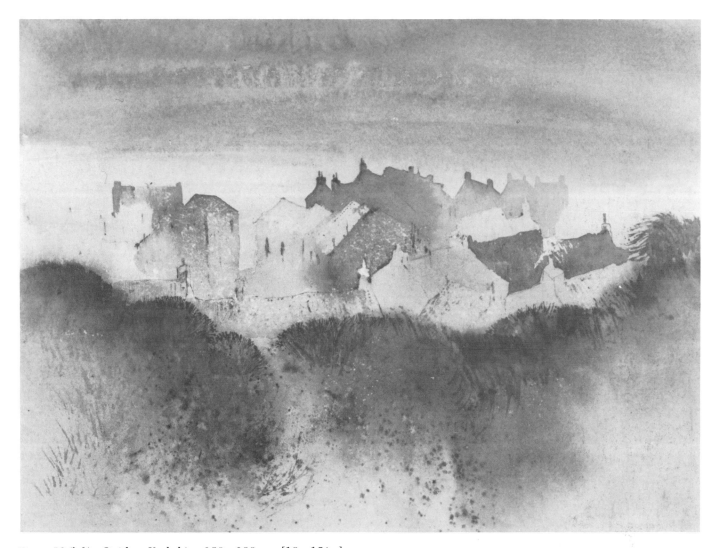

Figure 53 (left) **Staithes, Yorkshire.** 250 × 380 mm [10 × 15 in.]

Figure 54 (above) **Staithes** (first attempt). 250 × 355 mm [10 × 14 in.]

cottages. I made no attempt at definition at this stage, I only wanted to cover the paper with the lightest tones and general colour of the sea and ground and to have a soft-edged darker blush of colour hinting at the reds, browns and green within the building cluster.

When the paper dried to just damp I worked stiffer red paint into it to firm-up some of the roof edges, and with the end of the brush handle I impressed dots of pigment into the damp roofs to suggest rows of indented tiles. I used

sepia paint and touches of Winsor green. My aim was to work into the first damp impression, hinting and suggesting building details. Is that a window? A door? And then, as the paper dried, I added the silhouetted chimneys painted crisply to confirm and identify the buildings. I really rely on these few details to explain the whole.

The unfinished illustration shows a first attempt at this subject. It fails because I fell into the trap of defining the buildings too soon and they are

beginning to appear as recognizable individual shapes instead of the homogeneous cluster I wanted. Also, I got carried away with the foreground bushes and completed them, and so lost my first impression of buildings massed together and profiled against the sea. I could have abandoned this original intention and continued the painting, but I preferred to start again.

Evening Light

This very small painting was made in the studio and is a favourite of mine. It represents a little problem which I gave myself to paint—a very small landscape with minimal yet recognizable content. I wanted to work into the paper while it was damp, making soft-edged brown shapes, dots and smudges, all the time judging the rate of drying so that at the last possible moment the tree on the left and smaller distant tree on the right could be added soft-edged into the still slightly damp paper.

The paper was covered with traditional washes, using raw sienna so diluted it hardly stained the paper, and then a little cadmium red and some French ultramarine neat from the paint-box were brushed into the sky area with circular motions of the brush to describe the cloud pattern. A touch of cadmium red indicated the sun. With the paper very wet I added more raw sienna into the ground area, and followed this with droplets of burnt umber squeezed from the brush with my fingers. The paper was so wet that by holding it flat and then tilting it backwards and forwards I could make a pool of burnt umber wash across the foreground, causing minute particles of the pigment to precipitate out and speckle the left side of the painting, suggesting grass, perhaps. When the paper had dried to damp I brushed some larger areas of burnt umber into it, indicated the edge of the road with a soft line, and impressed some dots of pigment from the wrong end of the brush into the road to create a line of soft dots. These could suggest the track of a vehicle, but are primarily intended as nothing more than soft dots to relieve the otherwise empty road. As the paper was just on the point of drying I drew in the trees with a small brush. Then with the paper dry I added a very small amount of crisp drawing to the top of the trees and a few sharp scattered dots in the foreground.

Features are kept to a minimum and they are unambitious; the painting is concerned with patterns of light and dark and with large areas of tone placed against areas of speckle. I was concerned with edge values mostly soft, some firmer, and with the smallest amount of crisp definition.

Figure 55 **Evening Light.**
130 × 105 mm [5¼ × 4¼ in.]

G. John Blockley.

Beech Trees

My aim is to paint a group of trees as strong, positive shapes against a pale sky. The trees will be patterns of black and grey against a pale pink sky. The foreground is rich with colour, browns and reds blending into paler ochres.

Stage 1 A pencil outline of trees. I normally dispense with this stage.

Figure 56 **Beech Trees.** Stage 1.

Stage 2 I mask out the spaces between the trees, leaving the trees and foreground as blank white paper. The masking fluid dries as a yellow film and so is easily seen in the illustration as a darker tone.

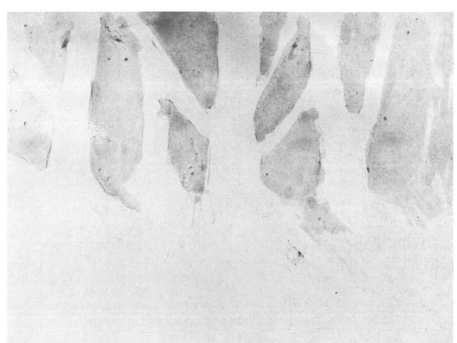

Figure 57 **Beech Trees.** Stage 2.

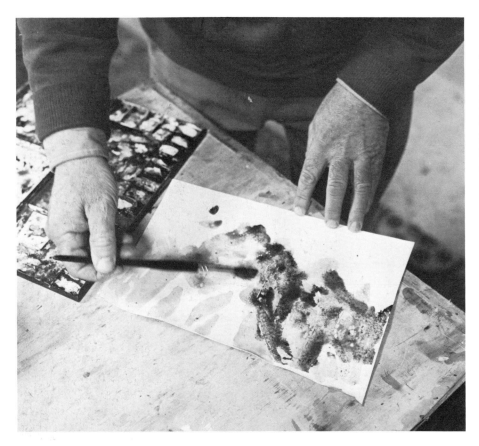

Stage 3 The masking fluid dries quite quickly and I brush watercolour freely over the paper, varying the colour as I do so, starting with raw sienna and cadmium red into which I blend patches of burnt umber, brown madder, Winsor blue and Winsor green. I make no attempt to separate these colours but allow them to touch and merge together on the paper.

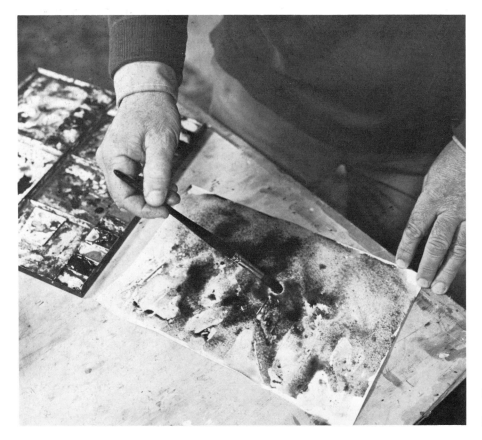

Figure 58 (top) **Beech Trees.** Stage 3(a).

Figure 59 (left) **Beech Trees.** Stage 3(b).

Stage 4 I pour black waterproof ink straight from the bottle into the wet painting and tilt the paper to make the ink run through the paint. At this stage the paper is covered with random mixtures of paint and rivulets and pools of black ink.

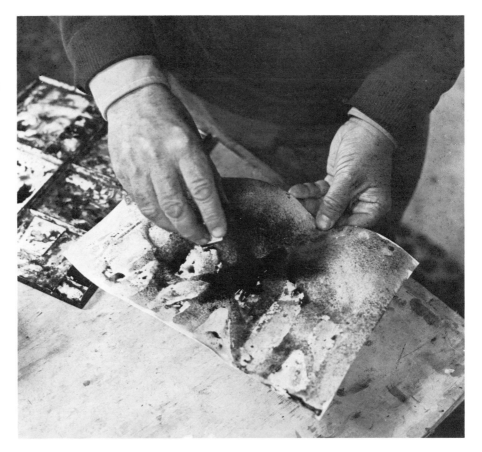

Stage 5 I dry parts of the painting with a hand-held hairdrier. When I first attempted this the drying was a haphazard process, but with experience I learnt to dry the ink in the parts I wanted to retain as dark patches in the final pattern. The trees at this stage are partly obscured by the pools of colour, but I retain the picture in my mind.

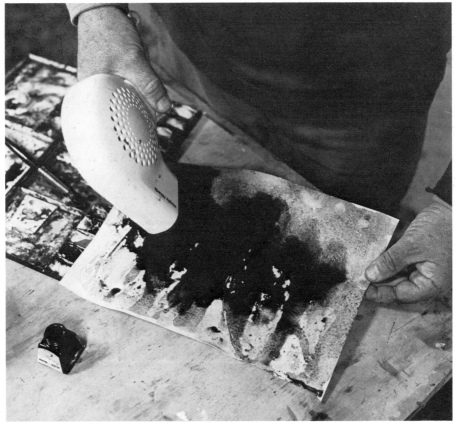

Figure 60 (top) **Beech Trees.** Stage 4.

Figure 61 (right) **Beech Trees.** Stage 5.

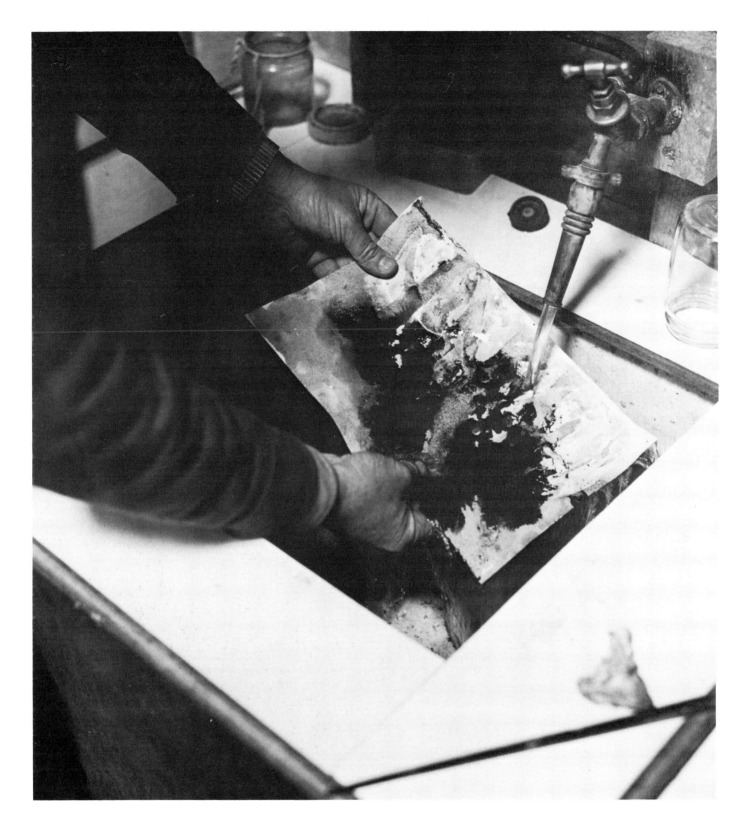

Stage 6 I hold the painting under the
tap and wash away the still-wet ink to
expose lightly stained paper mottled
and patterned by the darker dried ink.

Figure 62 **Beech Trees.** Stage 6.

Stage 7 When the paper is quite dry I rub the masking fluid away with the fingertip, or a piece of rag, to expose the white spaces between the trees. The trees then appear as hard-edged, positive shapes.

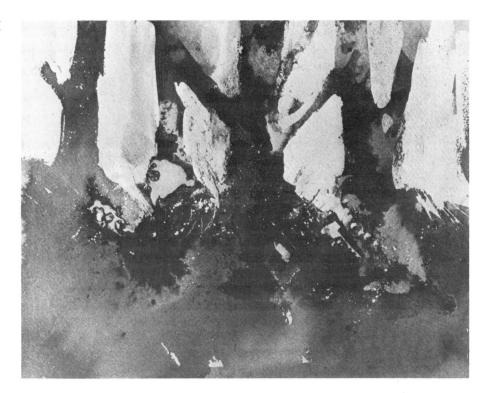

Stage 8 The painting is completed by washing in the sky with diluted cadmium red and by drawing in further branches and sharpening up some of the ink shapes with pen-and-ink drawing.

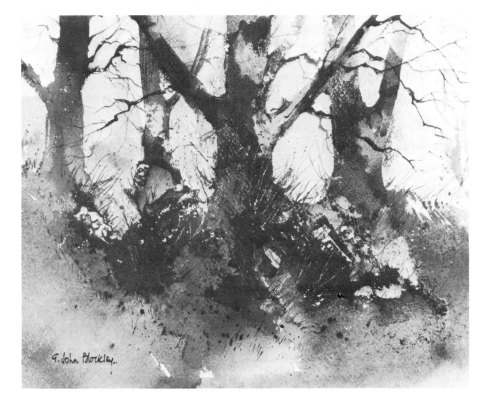

Figure 63 **Beech Trees.** Stage 7.
Figure 64 **Beech Trees.** 250 × 355 mm [10 × 14 in.].

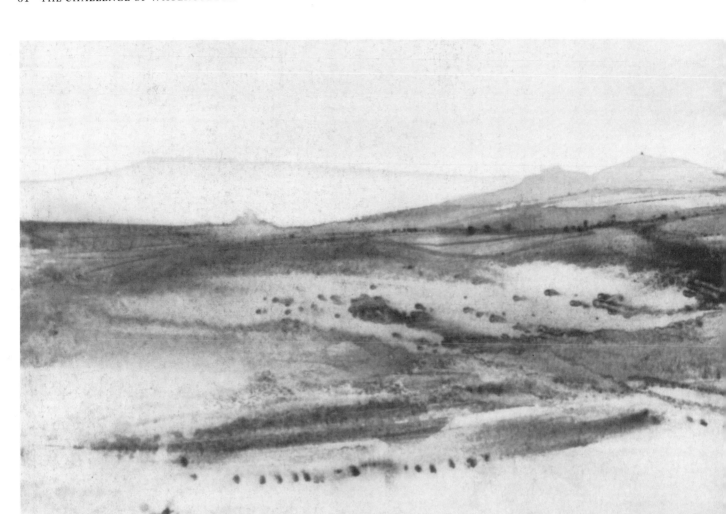

Figure 65 **Dartmoor.** 190 × 560 mm [7½ × 22 in.]

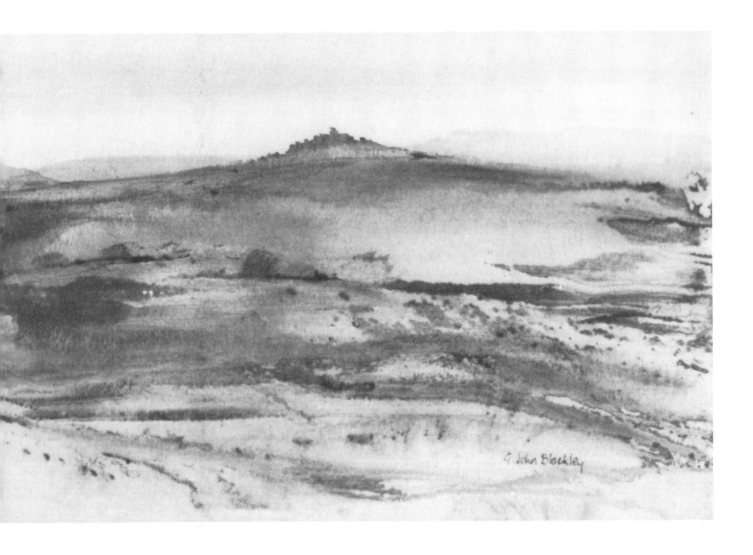

Dartmoor

I sat for a long time one evening with a painter friend looking across the expanse of moorland. That morning I had painted Hound Tor from close up and now we saw it to our right on the distant skyline. We identified the other granite masses spread along the horizon, Honeybag Tor, Chinkwell Tor, Bell Tor and Bone Hill Rocks. In between lay the moor with peat bog, and occasional drifts of emerald green grass in a landscape covered mainly with tufted sedge grass, tawny, sometimes orange, changing to large ragged-edged blots of brown, almost purple bracken.

The land surface was grained, and scored with big splashes of colour, bleached in places to almost white. It was not a tidy, definable pattern and so I painted it with washes of raw sienna, droplets of burnt umber and larger pourings of black ink. I washed away wet paint with water from my supply bottle to obtain the bleached-out patches within the dark blotches. I drew some string-like lines by dragging moist pigment with the wrong end of the brush. The fact that these lines might suggest broken walls enclosing the occasional cultivated patch is incidental. I regarded them as a useful means of tying the random patches together.

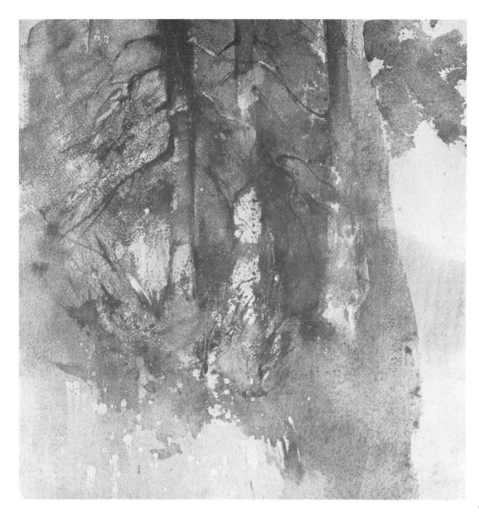

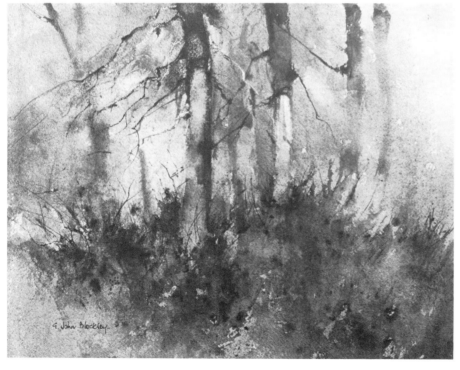

October Trees, Early Morning

This is a favourite painting spot in a wood not far from my studio. Bright sunlight was already pouring through the trees, except in one place where persistent mist showed through a gap between the trees. The ground was still in soft morning shadow except where long grasses were silhouetted against the filtering background light. I immediately wanted to paint my impression of sunlight and lingering mist out of which the trees emerged. The painting was done entirely by traditional methods. I started by painting a wash over the whole paper, using very diluted French ultramarine for the misty parts and Winsor yellow for the sunlit areas and allowing the two colours to touch and blend together. Then immediately I brushed in darker and less diluted French ultramarine mixed with a little brown madder to hint at mysterious background tones, leaving the first yellow wash for the sunlit tree trunks. While the paper was still damp with the washes, using a No.12 brush I picked up moist burnt umber straight from the paint-box and stroked in the dark tree trunks and branches. I now had an impression of blue-grey mist, bright sunshine and soft-edged background, but I felt I had lost too much of the mist light. I could probably have recovered it by lifting colour with a moist brush, but I was keen to maintain a feeling of morning freshness and so I started again. In the second attempt the misty patch and the lights on the tree trunks have been retained and are cleaner.

The foreground was worked wet into wet with vigorous brushstrokes and then I drew in the undergrowth and the crisper grasses with just-moist burnt umber, using the wrong end of the brush. In order to retain soft edges

Figure 66 **October Trees, Early Morning** (first attempt). 355 × 330 mm [14 × 13 in.]

Figure 67 **October Trees, Early Morning.** 330 × 355 mm [13 × 14 in.]

in keeping with the morning atmosphere, the paper was damp throughout the whole process. When the painting was dry I added just a few more sharply defined shadows, branches and bits of undergrowth.

November Trees, Morning

I returned to my favourite part of the nearby wood. The lighting was quite different from that of my October visit. The gaps between the trees were cold grey and the trees themselves merged into the sombre lighting. In the painting weak light shows on the right and gives a useful echo to the main light which occurs in the foreground clearing.

I washed very diluted raw sienna over the whole of the paper and added traces of cadmium red greyed with a touch of black into the foreground. I followed this with stronger brushstrokes of moist burnt umber into the grass at the base of the trees. The conditions were damp and the paper slow-drying, and I was able to brush the darker background into the still-damp paper, leaving the original wash for the light part on the right. I used Winsor green modified with lampblack to make a grey-green wash for this background, and by varying the pressure of the brushstrokes into the damp paper I was able to suggest some atmospheric quality within the grey depths. I let the paper dry and redampened it on each side of the trees so that I could introduce further soft-edged darker tones of grey to suggest mysterious darks within the wood. These darks also define the lighter tree trunks. A few dark tones, and branches completed the tree description. Except for the drying period the actual painting time had been quite short— nearly all of it wet into wet painting with just a few definitive crisper bits of drawing. It wasn't really a morning for lounging about.

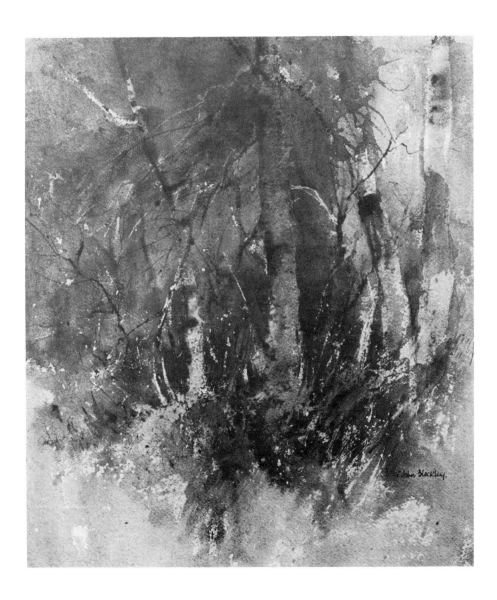

Figure 68 **November Trees, Morning.**
275 × 250 mm [11 × 10 in.]

Roadside Wall and Trees

Stage 1 I begin with a wash of raw sienna all over the paper and then I brush a stronger tone of raw sienna roughly over the wall area. I add varying colour into this, some burnt umber and French ultramarine, and let the paper dry.

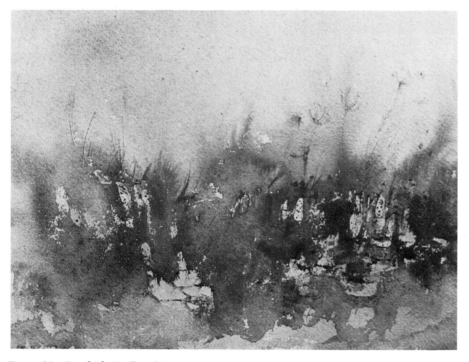

Stage 2 I rub a little wax over parts of the wall; the paper needs to be dry to accept wax satisfactorily. I redampen the paper in parts with clean water and in other parts with colour, leaving some of the first dry wash uncovered to represent stones in the wall. Other textured stones are formed by washing the colour over the wax. With a very fine brush and just-moist pigment I draw hints of grass and atmospheric shadows beyond the top of the wall.

Figure 69 **Roadside Wall and Trees**. Stage 1.

Figure 70 **Roadside Wall and Trees**. Stage 2.

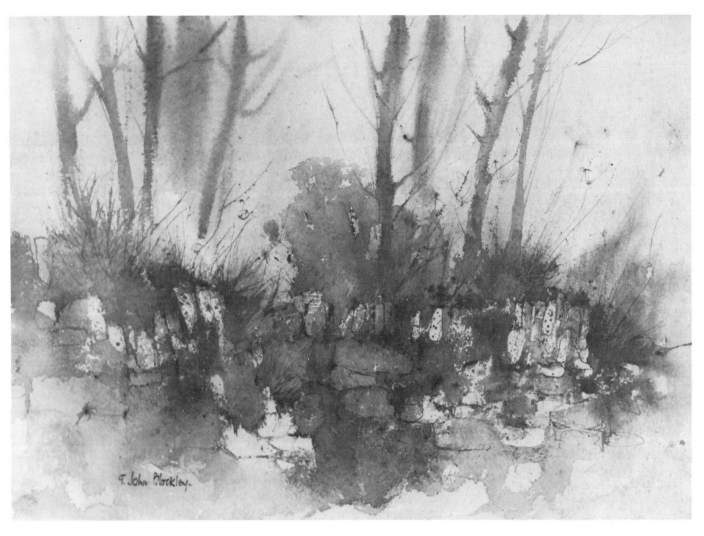

Figure 71 **Roadside Wall and Trees.**
250 × 355 mm [10 × 14 in.]

Stage 3 While the paper is still damp I strengthen some of the wall tones and add further tufts of grass with burnt umber and brown madder. The trees are vertical brushmarks stroked into the damp background.

I let the paper dry and then wash in some crisp-edged tree shapes and, using a small brush, sharpen up parts of the wall. I use my fingernail dipped in paint to flick in further grasses in hard line.

The textured walls in the country around where I live have combinations of golden glowing colour weathered in parts to warm grey. For these I use raw sienna, a good, warm colour, and the subtle greys I make with French ultramarine mixed with cadmium red. This gives greys tending to mauve. I subdue the mauve to my liking with a little raw sienna.

For the trees I use the same blue-grey, some times influenced to green by increasing the amount of the raw sienna.

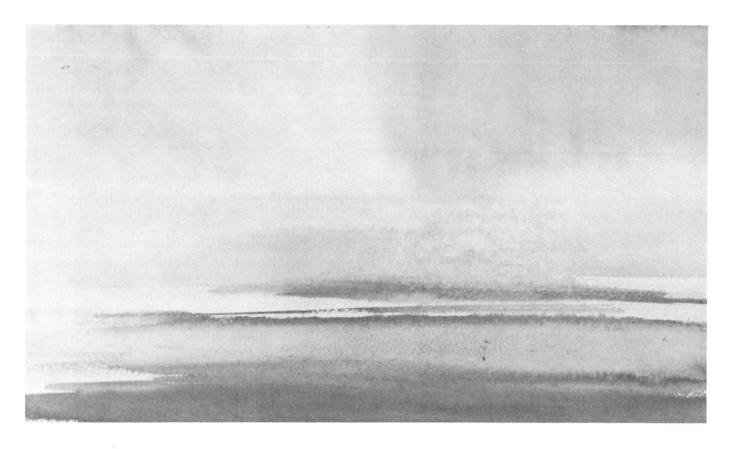

Figure 72 **Coastal Light.** Stage 1.

Coastal Light

A small, quick sketch painted entirely by traditional methods. The main point is that the sky and sea were painted in a continuous operation, not as separate parts. I used very diluted raw sienna for the light parts and French ultramarine for the sea mid-tones, with the addition of burnt umber for the stronger sea tones and buildings. All the colours were slightly greyed with left-over paint from the corners of the paint-box.

Stage 1 I wash in the light parts of the sky with downward brushstrokes and carry the wash to the bottom of the paper. While the wash is still wet I put in the darker tones of the sky. The cloud shape on the right is clumsy and so I quickly stroke a flat 50 mm (2 in.) wide brush diagonally through the wash. The lower brushstrokes are put in with horizontal strokes into the damp first wash, leaving some of this wash for highlights.

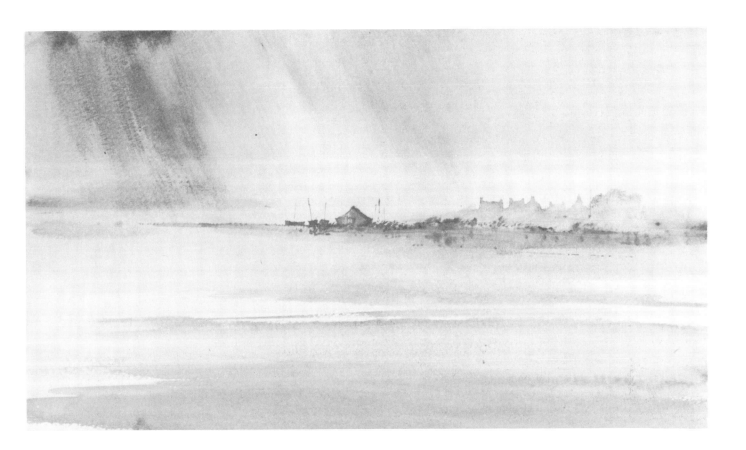

Stage 2 The silhouetted buildings, boats and headland are added in one continuous wash and the masts are flicked in with a small brush.

Figure 73 **Coastal Light.**
200 × 380 mm [8 × 15 in.]

Figure 74 **Bridge, North Wales.** Stage 1.

Figure 75 **Bridge, North Wales.** Stage 2.

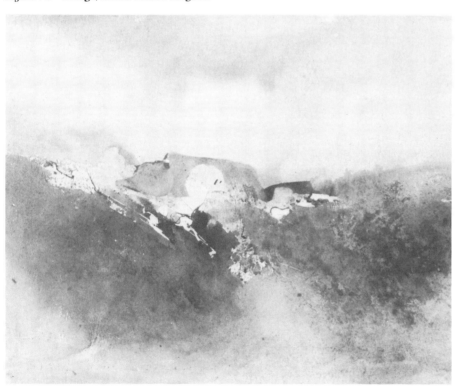

Bridge, North Wales

Stage 1 Using a pencil, I draw the outline of the bridge only. I would find further drawing inhibiting when painting, and in any case the bridge is the only positive shape I need to recognize in the preliminary stages. The mountain is the only other positive shape in the painting and this I paint in later.

With masking fluid I mask out the boulders in the immediate vicinity of the bridge. I also mask out the light parts of the bridge itself.

I mix a dilute wash of raw sienna and a little cadmium red and paint the light part of the sky. I extend a stronger mixture of these colours down to the bottom of the paper. While this wash is still wet I blend French ultramarine modified with a little black into the upper sky and into the foreground.

At this stage the paper is covered with traditionally applied washes which represent the lightest tones of sky and ground, into which I have blended some darker tones. There are no hard edges. The foreground on the right appears very pale, but remember it represents the palest part of the ground and only small fragments of it will remain in the final painting.

Stage 2 I strengthen the foreground even more, leaving a diagonal passage of the original wash in the centre leading towards the bridge. As the wash dries I draw and stipple stiffer pigment into it with a brush to create an uneven tone. I let the painting dry.

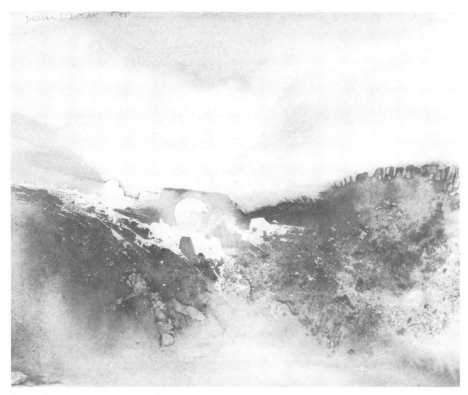

Figure 76 **Bridge, North Wales.** Stage 3.

Figure 77 **Bridge, North Wales.**
250 × 355 mm [10 × 14 in.]

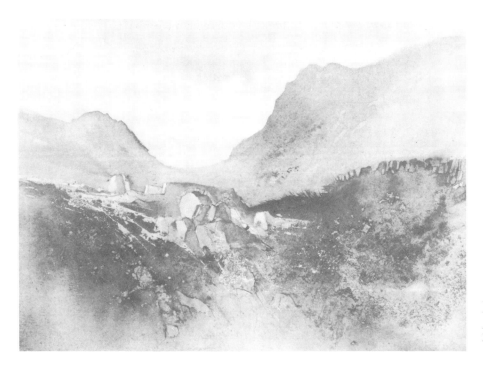

Stage 3 I dampen the sky with clean water and blend in the blue-black mountains. I also wet the foreground and add burnt umber and brown madder separately into it. Then I hold the paper horizontally in both hands and rock each edge up and down so that the wash sweeps backward and forward over the paper surface and the paint pigment deposits out of the wash to suggest a textured foreground.

I strengthen the skyline, tease long grass out of the ground wash and indicate some stone walling. I let the painting dry and rub away the masking fluid to expose white paper in the rocky area next to the bridge.

Stage 4 I strengthen the mountain, tint in the rocks and define them further with lines drawn with a fine brush.

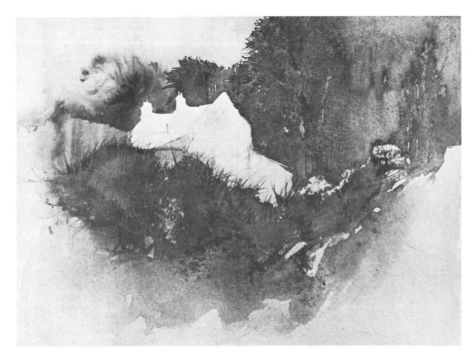

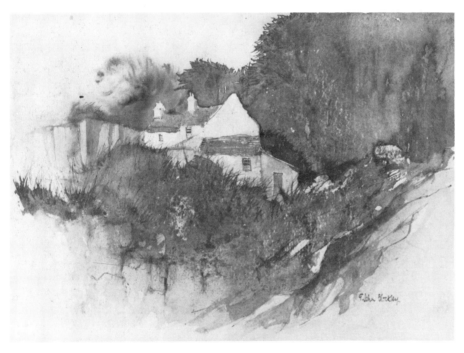

Figure 78 **Cottage in the Trees.** Stage 1.

Figure 79 **Cottage in the Trees.** 250 × 355 mm [10 × 14 in.]

Cottage in the Trees

Stage 1 The trees and the foreground tones combine to contain the light shape of the cottage. I draw the profile of the roof and chimneys only, wash the pale grey of the sky down to this outline and continue it down the paper, warming it with slightly greyed cadmium red towards the bottom. I immediately float a dark blue-green colour into the central foreground and as the paper begins to dry I draw in the soft-edged background trees on the left.

The mass of background trees is fringed at the top with almost feather-like ornamentation and this is echoed in the foreground grasses against the light building. I emphasize this repetition by keeping the tree mass and the foreground as simple dark tones. I paint them both with blue-green in one continuous wash which encloses the cottage. While the wash is still wet I float in more of the same colour to create a little tonal variation and from these wet shapes I flick the grass and tree-top fringes with my fingernail. The tree wash defines the crisp outline of the building.

Stage 2 The corners of the painting are too pale and so I add more warm colour. I also add a few more grass indications, and hint at stone and rock formations by drawing with a fine brush. I slightly distinguish the foreground from the background trees by drawing in some dark bushes.

The house so far is just white paper. I modify this with dilute washes, blue merging to palest pink—the merest hint to echo the warmth of the immediate foreground. The roof is put in with French ultramarine greyed by adding burnt umber and with this same mixture I add window-panes and just a little detail drawing in the house.

Tree Study

The painting started with washes of varied colour over sky and ground. Further colour was brushed into this wet background to indicate soft distant trees and soft foreground tones. I wanted the trees to be sharp-edged and with broken lights reflected from the trunks and branches; to obtain this effect I applied the watercolour paint with the sharp edge of an oil painter's palette knife in decisive short sideways strokes so that the trees were formed as crisp blocked-in-passages against the atmospheric background.

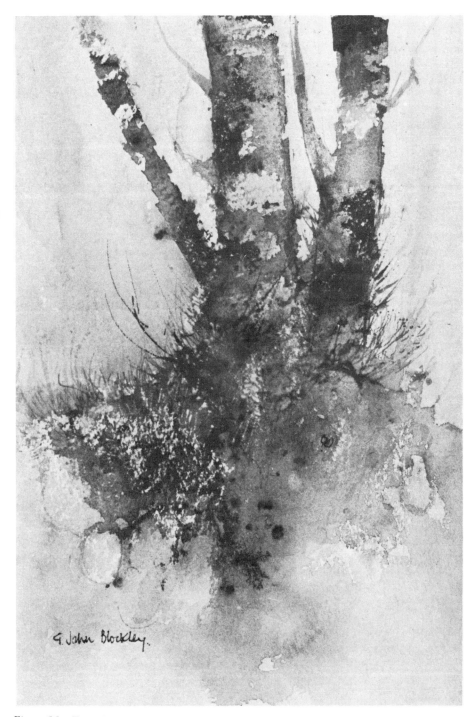

Figure 80 **Tree.** 225 × 175 mm [9 × 7 in.]

4
Patterns

Most of us have experienced frustrating searches for exciting things to paint, but gradually one learns to sense paintable qualities in familiar surroundings. The trained eye reacts to a commonplace situation and instead of thinking about picture-making one investigates particular qualities that appeal. At the time of writing this I am engrossed in making paintings of brick walls. I am involved with the patterns of walls eroded with age, with the surface patina deposited by industrial atmosphere. Cement rendering breaks away to produce interesting patterns, and remnants of advertising posters introduce accents of colour and blurred lettering. Having worked on this theme of exterior walls I am now starting to think about interior walls, and I mull over ideas for ways to show the wallpaper, ornately patterned but faded.

One theme leads to another, and each painting is influenced by previous paintings, so that perhaps every painting is a summation of previous experiences–or a rediscovery. Ideas do come easily now. I suppose they result from an accumulation of ideas and visual experiences. One idea combines with another to start off a new line of inquiry. The mind develops an awareness of paintable images and recognizes relationships which may be considered and adjusted before the painting is begun.

This way of thinking needs to be based on some basic principles and I would like to discuss some that I have found helpful.

Shapes

It is useful to look at a subject in very broad terms of shapes and patterns and to restrict the picture content. A single tree and its shadow need not necessarily be read as a tree and a shadow but can be considered as a composite shape, dark against light sky. Thinking in terms of shapes, patterns, lights and darks, makes subject selection easier and a personal

way of looking at things develops. We become interested in specific aspects of a situation rather than a literal examination of every detail.

Echoes

My sketch of Craster Harbour was made one morning in rain. I blocked it in quickly, using a B pencil. The sky was pewter, the buildings black in silhouette, their wet roofs silver light against the sky, and a vermilion roof peeping through the houses provided an accent of colour.

It was an arrangement of light and dark tones, and of interesting shapes. The chimneys were repetitive interests, the roof slopes echoed each other and

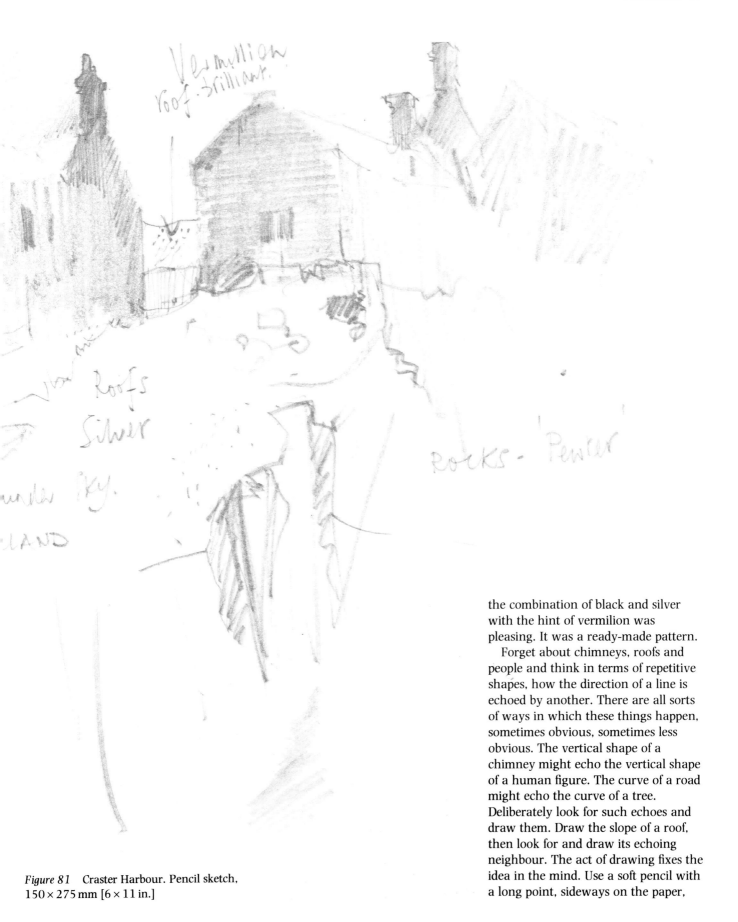

Figure 81 Craster Harbour. Pencil sketch,
150 × 275 mm [6 × 11 in.]

the combination of black and silver with the hint of vermilion was pleasing. It was a ready-made pattern.

Forget about chimneys, roofs and people and think in terms of repetitive shapes, how the direction of a line is echoed by another. There are all sorts of ways in which these things happen, sometimes obvious, sometimes less obvious. The vertical shape of a chimney might echo the vertical shape of a human figure. The curve of a road might echo the curve of a tree. Deliberately look for such echoes and draw them. Draw the slope of a roof, then look for and draw its echoing neighbour. The act of drawing fixes the idea in the mind. Use a soft pencil with a long point, sideways on the paper,

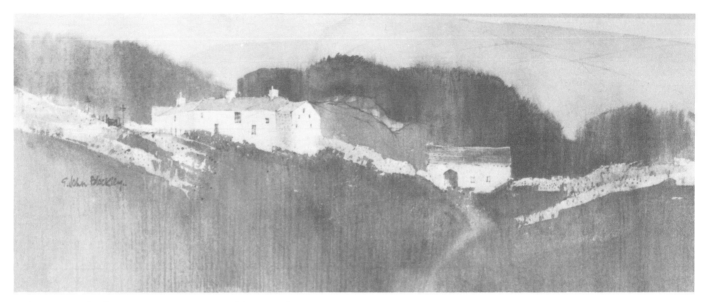

Figure 82 **Derbyshire Farm.** 100 × 275 mm [4 × 11 in.]

and freely hatch areas of tone and create patterns and shapes.

Continuity

Try to unify your paintings by joining shapes together. Notice how a tree shape is continuous with its shadow which in turn is continuous with a fence. One shape converts into another shape. Notice how a dark shape might reduce to a small shape and enlarge back again to an even larger shape, all connected together with perhaps a thread-like dark tone. Draw them accordingly, without lifting the pencil off the paper.

Notice that light shapes are also continuous. The light on the grass is continuous with the light on a tree trunk, so that the junction of the tree and the ground is lost. The base of a house melts into the ground. If dividing lines are omitted and features allowed to join together, the viewer's eye will travel comfortably over the painting. We can interrupt the flow if we wish at some interesting part and hold his attention, momentarily, before it sets off on its travels again.

The process of starting with large washes and gradually building towards

definition helps the feeling of continuity. My painting of Ford Village (opposite) illustrates this. I started with a light wash of varied colour all over, and the darker tones of the trees were worked into this. The lower trees make a continuous shape which encloses and defines part of the original wash as a group of houses. The group of houses was based on the initial wash, with some shaded sides and roof drawing added to indicate individual houses. Similarly, individual trees were suggested by sharpening the upper edge of the dark wash in places. Rather than describing individual trees, I have indicated an over-all upper profile.

Profiles

Profiles can be descriptive and will explain a shape with economy. A house can be described by its profile of roof and chimneys. A crowd of people can be indicated by the profile of heads and shoulders. Detail within the group can be minimal, giving uninterrupted continuity and the feeling of fluidity and economy which is an essential characteristic of the watercolour medium. We suggest and hint rather than fully describe.

Profiles can also be used as a sort of

route to take the eye through the painting. In my Ford painting the tree-top profile makes a circular route around the houses and leads towards the distant group of trees.

Edges

Edge values are important. A soft edge retires into its surroundings, hard edges are aggressive and attract attention and should not be scattered indiscriminately. At every brushstroke question whether a hard or a soft edge is required. Remember that edges may be softened with a moist brush.

Figure 83 **Ford Village, Cotswolds.** 300 × 250 mm [12 × 10 in.]

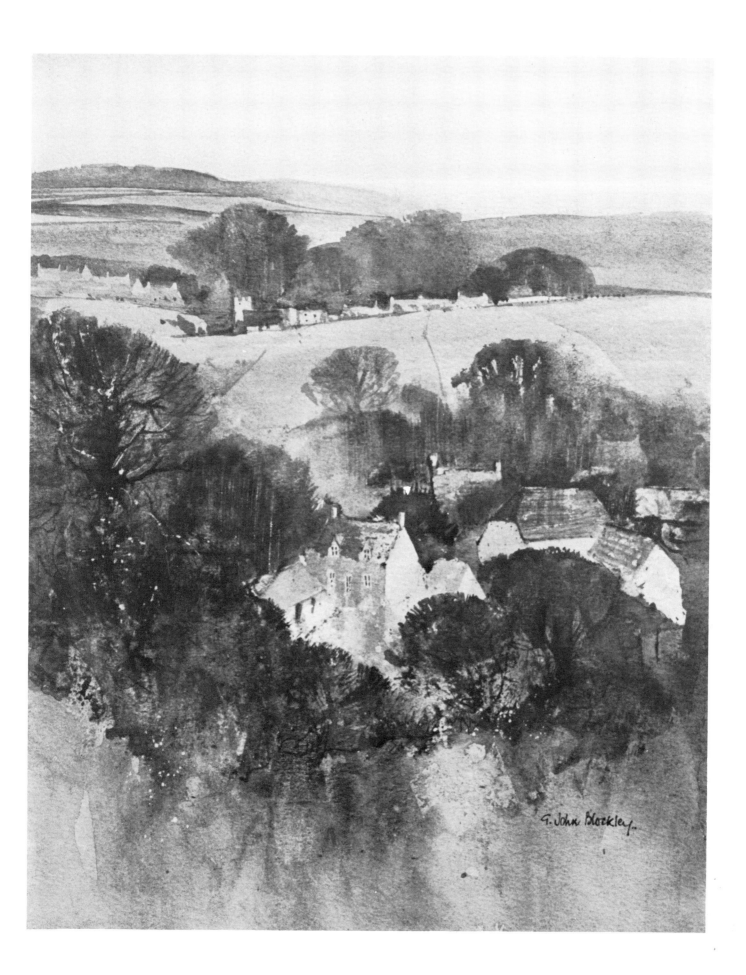

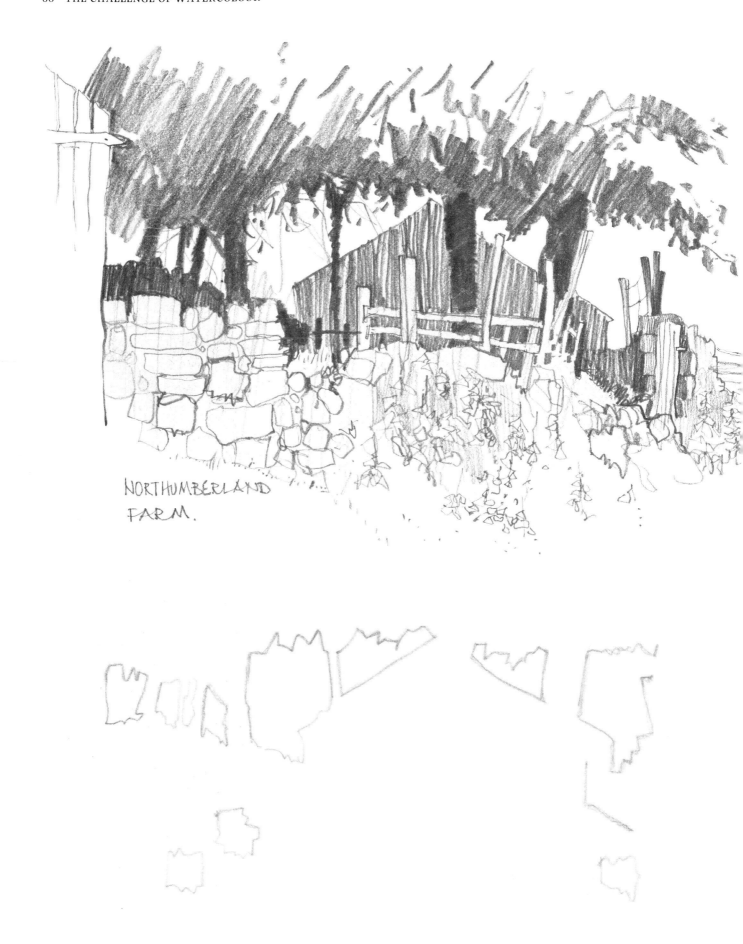

NORTHUMBERLAND
FARM.

Figure 84 Northumberland farm.
Pencil sketch,
150 × 275 mm [6 × 11 in.]

Figure 85 Negative shapes traced from
sketch of Northumberland farm.

Negative shapes

Look for interesting shapes which are
enclosed within other shapes, such as
a patch of light falling on a dark wall,
or the shape of a field enclosed by a
group of trees. The spaces between
objects are often referred to as negative
shapes. Look for these shapes; they are
sometimes more interesting than the
objects that enclose them, and they
can suggest a subject for painting. The
shape of the sky between silhouetted
buildings or between trees is often
interesting. Sometimes shapes are
repeated within a subject. The spaces
between the trees in my sketch of a
Northumberland farm are similar
shapes.

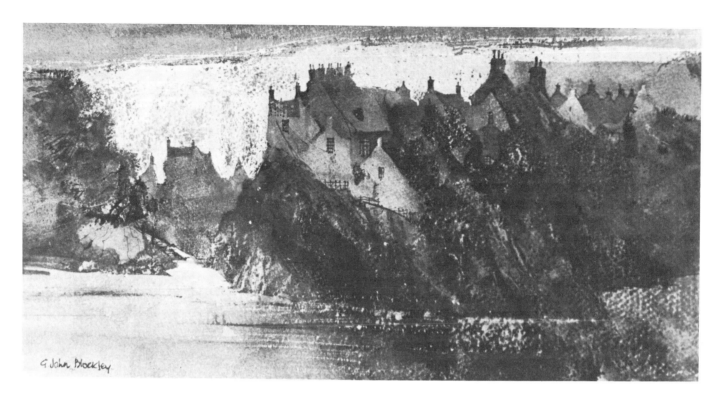

Figure 86 **Rooftops, Yorkshire Coast.**
150 × 300 mm [6 × 12 in.]

Figure 87 **Thurso, Scotland.**
Unfinished watercolour,
200 × 460 mm [8 × 18 in.]

Counterchange

The alternating pattern of light against
dark against light can be interesting,
and so can alternating sizes and tones.
We can make a small object more
important than a larger object by
emphasizing its tonal value, making it
either very much lighter or very much
darker than its neighbours.

We can arrange combinations of
these pattern-making ingredients. A
dark headland might be echoed in
shape by a passage of light on the
water and at the same time form a
counterchange of light against dark
against light.

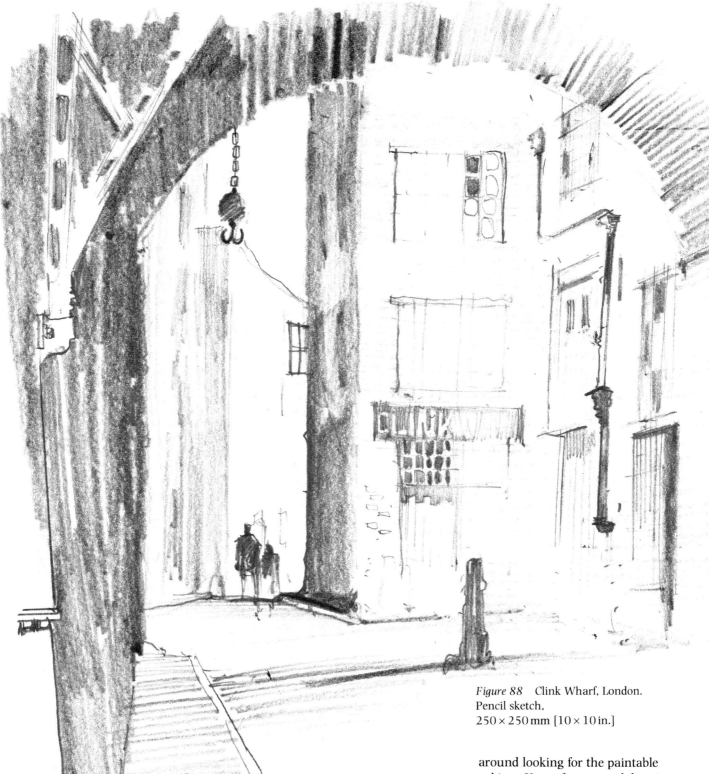

Figure 88 Clink Wharf, London.
Pencil sketch,
250 × 250 mm [10 × 10 in.]

Subject selection

I find that subject selection is made much easier by thinking in the terms I have discussed. I am tempted to say I no longer look for things to paint, but this would perhaps be too much of a simplification. However, I do like to settle quickly wherever I happen to be and see what I can make of the material immediately available, and there usually is some response if I look in terms of interesting patterns. It saves endless time spent walking around looking for the paintable subject. Very often several drawings can be made without moving from one spot, and from very ordinary material. This all reads a bit cut-and-dried, and of course paintings don't develop from given formulas. I just want to indicate ways of looking that will be helpful in deciding what to paint, especially when faced with a profusion of material.

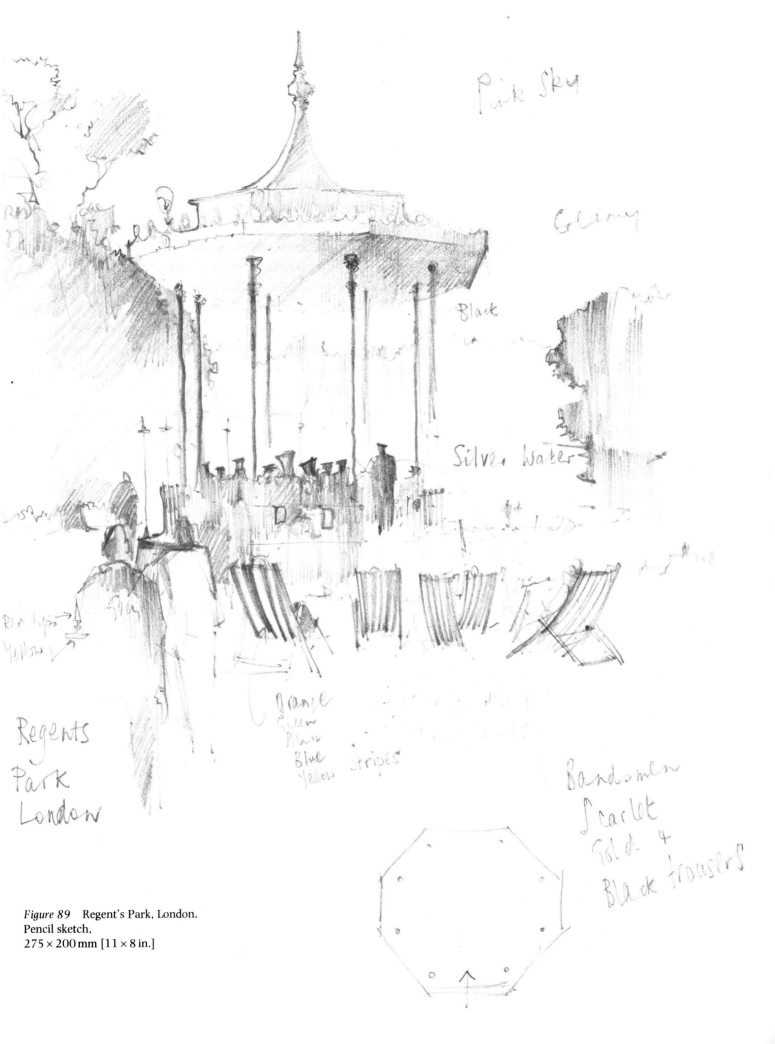

Pink Sky

Greeny

Black

Silver Water

Orange
Green
Brown
Blue
Yellow Stripes

Red lips →
Yellow

Regents
Park
London

Bandsmen
Scarlet
Gold +
Black trousers

Figure 89 Regent's Park, London.
Pencil sketch,
275 × 200 mm [11 × 8 in.]

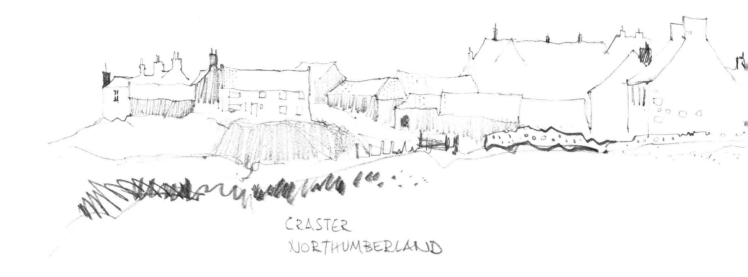

Figure 90 Craster, Northumberland. Pencil sketch, 200 × 330 mm [8 × 13 in.]

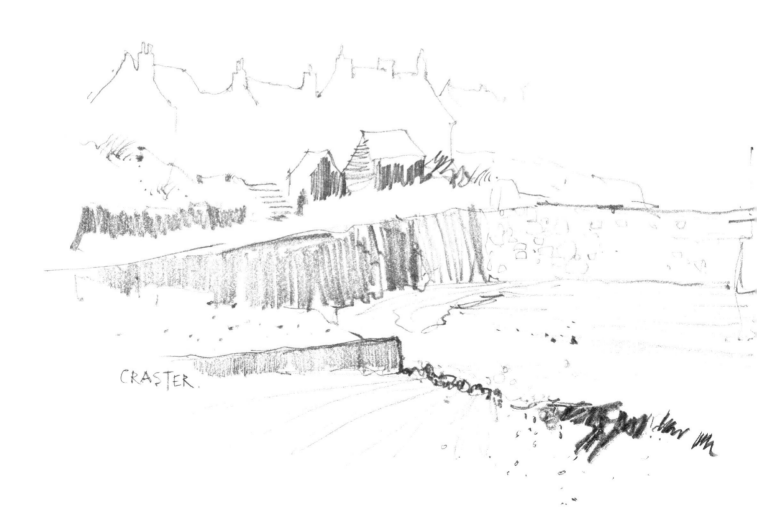

Figure 91 **Moorland Village, Yorkshire.** 300×460 mm [12×18 in.]

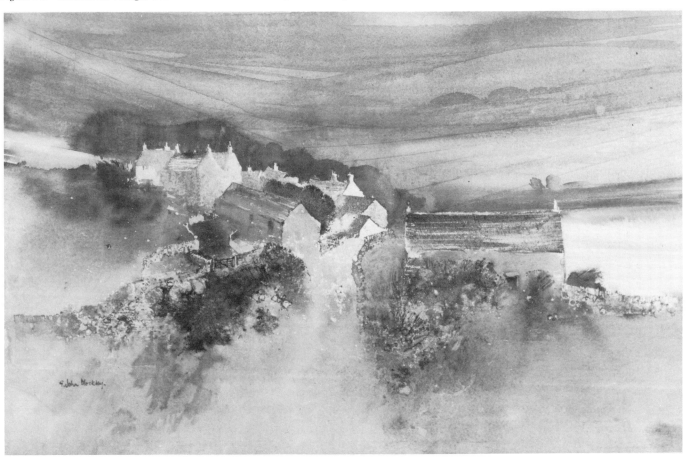

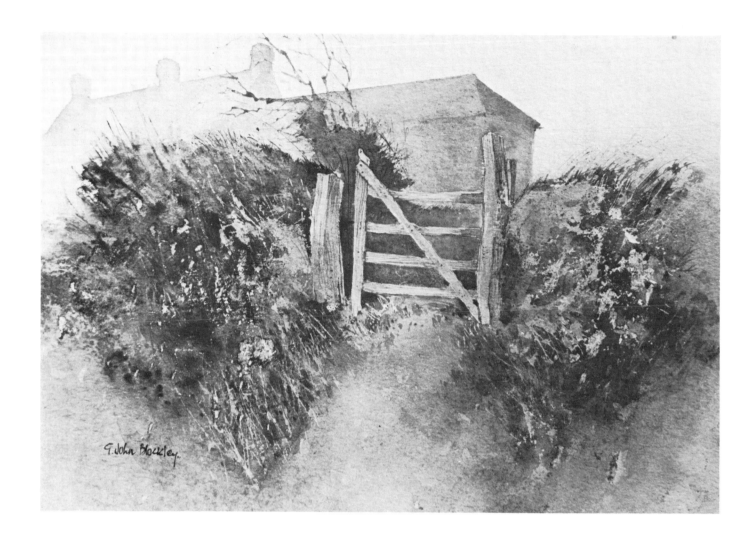

Figure 92 **Garden Gate, Exmoor.**
225 × 300 mm [9 × 12 in.]

Expressions such as 'centre of interest' and 'focal point' are often heard. This is a useful way of thinking in that it suggests a co-ordinated work leading up to a specific item of interest and without interruptive fussy detail or tonal contrasts. It suggests a gradual build-up to the one selected place. I prefer to consider the picture as built up from fragments of interest, a flicker of light here, of colour there, a shape, a curve, a line, every part of the painting having interest and validity and all integrated together into a particular form. In my painting of Hound Tor I was concerned with the quality of its edge, precise, cut-out in relation to mysterious contours within its mass. I like to think of painting as an awareness of some quality—the aura of the place.

Hound Tor, Dartmoor
I was tutoring one of my classes in Devon and one evening I went out alone and discovered this viewpoint. The mass of rock piles up against the sky and is capped with huge blocks balanced on top of one another, looking as if they were precariously placed by some huge hand.

The evening was still, and the sky daffodil light behind the black mass. I sketched it from different angles and from several distances. I thought how it came about, a molten fluid stratum pushing the earth's crust upwards and

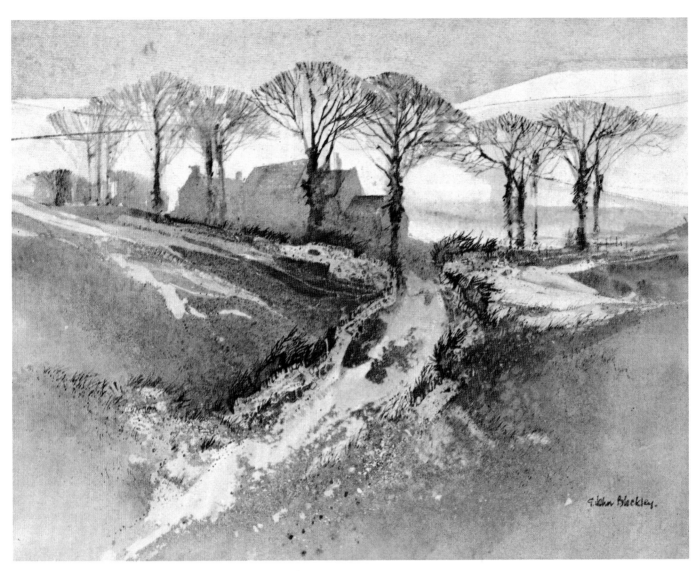

Plate 9 **Winter Moorland.** 255 x 340 mm [10 x 13½ in.]

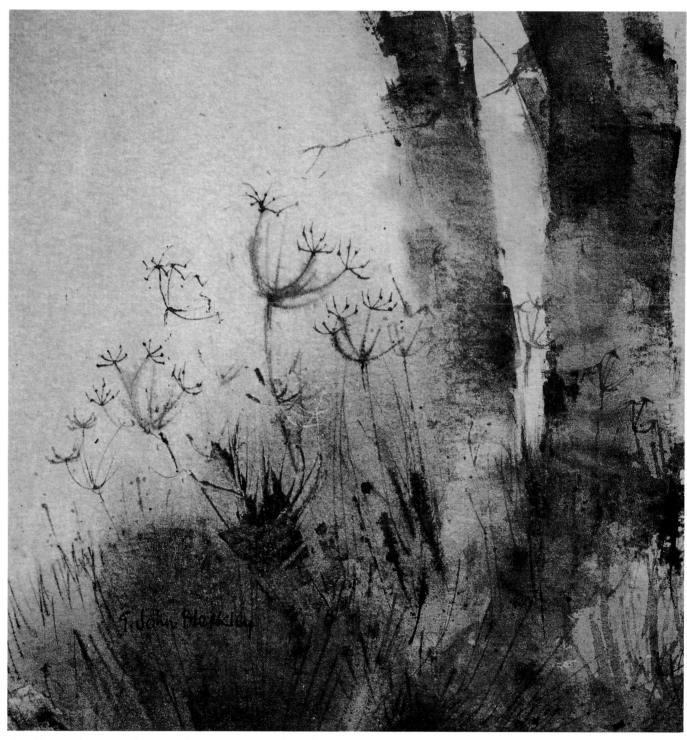

Plate 10 **Beech Trees and Cow Parsley.** 175×170 mm [$7 \times 6\frac{3}{4}$ in.]

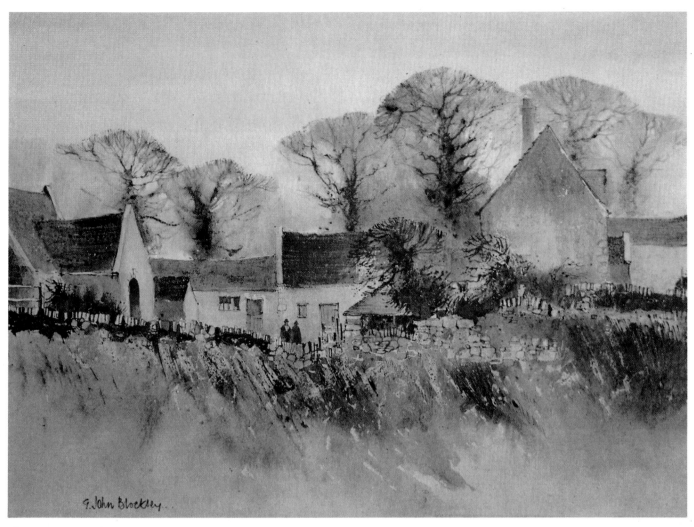

Plate 11 **Cotswold Farm.** 275×380 mm [11×15 in.]

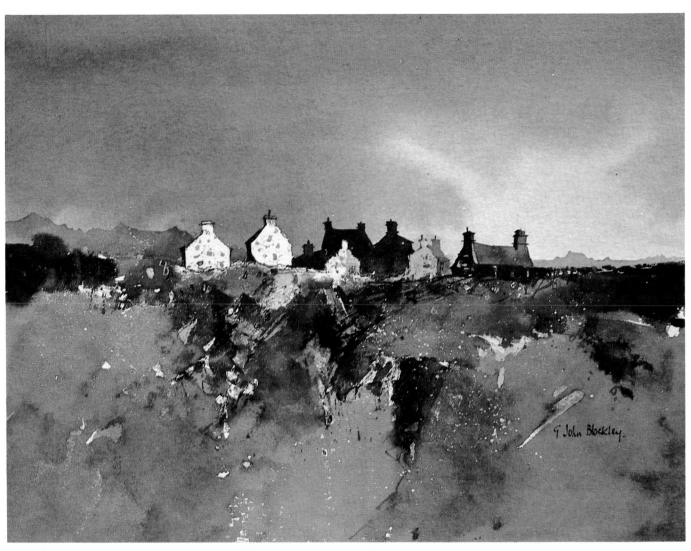

Plate 12 **Welsh Skyline.** 250 × 355 mm [10 × 14 in.]

the crust weathering away to form these shapes.

I saw the profile as hard-edged and angular, making a dark cut-out pattern interlocked with the light sky. I thought of it basically as a simple cut-out shape like a lino-cut, with slivers of lino left by the knife around the rock faces giving a sort of print-like misregister. This outline was dominant, but within the mass facets of rock caught the pale light, and in the lower slopes the rock fragmented to a coarse-grained surface. Spiked gorse grew in crevices from the rocks and green-black holly trees continued the abrasive quality, but conveniently their windswept growth provided some curved relief.

I made the painting the following morning as a demonstration to my class. The sky was more pink than it had been in the evening light, but the over-all tonal pattern was similar. I knew that I could best obtain the hard rock outline and the rock and ground textures by using ink and watercolour together and by causing some parts to dry and then washing out the parts which were still wet. I explained to the class that the demonstration would be a bit of an experiment, since this was the first time I had tried these processes out of doors and without an artificial means of drying, such as a hairdrier, it would be more difficult to create uneven drying. I decided to try the opposite process of adding water to

Figure 93 **Hound Tor, Dartmoor.**
175 × 250 mm [7 × 10 in.]

parts of the painting to create uneven drying.

I brushed masking fluid over the sky, keeping it hard and crisp around the rock profile but deliberately leaving some slices of paper showing. These would be stained by later paint to create the misprint lino-cut effect which had occurred to me.

I washed raw sienna over the exposed paper, added burnt umber into it and poured black ink into the wet wash. I tilted the paper back and forwards, dribbled clean water into it and dribbled Winsor green paint and then brown madder into it. It was drying too evenly, so I pressed my thumb into the now viscous surface to disturb it, paused a few moments and dribbled more water. I sensed the students shifting uneasily and I was inwardly slightly anxious. A little more dribble, a chat while the paint dried to almost dry and then I poured water from my supply bottle over it. The ink which I had kept wet washed away to expose the first raw sienna wash, and drops of still-wet ink washed away to show the lighter rock facets. However, although I achieved the secondary lights on the rock faces within the large mass, the ink remained undiluted in some parts and is slightly more densely black than I had wished. I dotted moist watercolour pigments into the paper, and slightly amplified some of the rock faces, using a pen dipped in watercolour. The paper dried, I rubbed away the masking fluid with my finger and painted in a simple sky.

The predominant feeling in the painting is of black and earth colours, low in tone but brightened by the pale gold foreground and hints of rich green. In one small area the black ink and brown madder have mixed to a subtle bronze tint and the Winsor green has penetrated this and combined with the red to produce neutralizing grey, which seems to give a cool metallic sheen to this otherwise warm area.

When I came to frame the painting I picked out this minority cool grey tint and hunted for a mounting board of similar colour. I found one with a finely grained linen surface and I used this to surround the painting, with an inner very narrow slip of palest ash-grey-green between mount and picture. I thought of it as lichen colour suitable to the subject. The frame was gunmetal tending to bronze. The frame and mount and the low tones in the painting seemed to gel together to bring out the glints of colour and lights in the eroded stone and foreground.

Gossip

This was an imaginary subject painted in the studio. I planned the nearer figure as a flat dark shape overlapping the lighter figure. With a brush I lightly drew a line from the top of the hat downwards, around the brim of the hat and the shoulder, and down the arm. While this line was wet I painted the background with burnt umber. Then I drew another line describing the left-hand side of the nearer figure and washed in this figure, again using burnt umber. These lines echo each other almost exactly, the diagonal line of the head echoes the slope of the hat in the other figure and then the shoulder and arm edges are similar. I wanted the light figure to be brilliantly lit and luminous, and so she is painted in clean washes of dilute raw sienna for the face, changing in one continuous wash to Winsor yellow for the coat. The colour was applied quickly to retain transparency and allow the paper surface to reflect light. The near figure is a simple flat dark wash. The brilliance of the yellow figure is emphasized by a vivid splash of vermilion in the scarf, but otherwise the figures are first-time washes without descriptive detail. The simplicity of these washes is emphasized by the background, which I treated in a more decorative, florid manner. While the dark background wash of burnt umber was still wet, random drops of black, green and crimson paint were dropped into it. I created uneven drying by adding water to parts and drying others with a hairdrier and then washed away the still-wet parts, leaving a pattern of darks soft-edged against the washed-out lights. This process created a decorative background with hints of red and green emerging from mysterious soft black shapes.

I dampened the lower part of the painting and with moist raw sienna stroked in the shopping bags and added rows of soft dots to suggest their texture. I dampened the face of the light figure too, added some shading and, using a small brush, indicated the features, paying particular attention to the raised eyebrow and quizzical sideways look of the eyes. I painted the features with raw sienna, repeating the initial colour used for the face. This repetition of colour is a device which I frequently use to prevent the features being overstated.

Figure 94 **Gossip.**
250 × 175 mm [10 × 7 in.]

G. John Blockley.

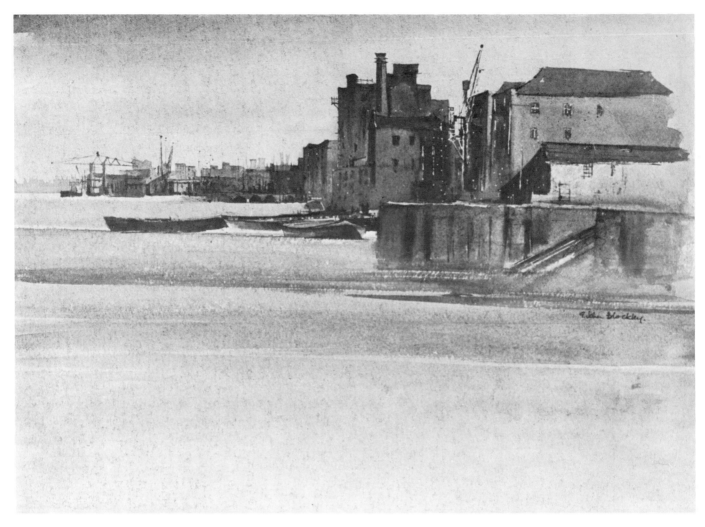

Figure 95 **Thames Warehouses, Rotherhithe.** 215 × 355 mm [8½ × 14 in.]

Thames Warehouses, Rotherhithe
The main point about this painting is that the buildings were seen and painted in terms of one continuous mass right across the paper. With this in mind I drew the roof profiles lightly in pencil and indicated the water-line. The sky and sea were put in as a wash of blue-green, over the whole of the paper. The clouds and their reflections were brushed into the damp paper with darker tones of the same colour. When this was dry I went straight for the big building mass and painted it in one wash of raw sienna over the sky wash. I added cobalt into the wet wash to cool the distance parts. Also in the distance I saw flickers of red and green where the sun caught the dockside machinery and boats. I spotted them in

with moist pigment into the damp wash. I also brushed burnt umber into the top of the central building to emphasize it. I let the paper dry while I considered how much, or rather how little, explanation was needed within the building mass. I dampened the building with clean water and stroked moist paint with vertical brush movements into it to suggest the shaded sides of the various buildings. I wanted soft edges within the mass so that its continuity would not be destroyed.

I aimed constantly for continuity in the buildings, the only firm interruptions being the sharp accents of lights on cranes and on a few windows which I had previously masked out. I was careful to contain

these edgy lights to one part and not scatter them busily around. With a fine brush I added a few darker strokes of definition within the building shape, taking care that they were not too contrasty, and then completed the painting with the barges and cranes.

I felt that the continuity of treatment was sympathetic to the reality of the subject, where the eye travelled smoothly over the warehouses, pausing occasionally to take in a flickering light or colour. It was important only to hint at detail and concentrate more on the interesting skyline in which the central building climbs like stairs to a maximum height, then drops to the lower level of the distant castellated horizon.

Figure 96 **Storm Sky.** 170 × 225 mm [6¾ × 9 in.]

Storm Sky

This is an imaginary composition. I thought of a sky, violent, with dark grey clouds enclosing a circle of intense apricot light, and further emphasized by black foreground shapes without recognizable form. The dark foreground is relieved by passages of raw sienna and brown madder which fuse together in parts to suggest reflections of the apricot sky muted to a kind of bronze.

I painted the sky with cadmium red all over and while the wash was still wet brushed into it a mixture of raw sienna and a little Winsor yellow. The clouds were defined with circular brushstrokes of a grey made with lampblack and raw sienna. The foreground was covered mostly with raw sienna and the rest of the area with brown madder and while this wash was wet I brushed in lampblack, some of it diluted so that it spread and some of it only moist, straight from the box, to give further black shapes. I also picked up further moist pigment from the box with the wrong end of the brush and stippled it into the paper. Then, as a sort of *coup de grâce*, I added a very small amount of Winsor green into the wet black paint on the paper. This is a very powerful green which I normally modify with another colour such as burnt umber before using it, but I knew that it would partially mix with the wet black paint already on the paper to give an acceptable green, muted, yet enough to add a little spice to the warm, earthy colours of the foreground. The painting so far consisted of soft-edged shapes painted wet into wet. Just before the sky dried I introduced some identifiable form by painting the trees, first as soft-edged rounded shapes; then, with the paper dry, and using a pen with watercolour, I added a few branches.

The painting was done quickly and with enjoyment, perhaps aggressively. I framed it with a silver moulding warmed with hints of bronze, choosing a moulding with predominantly crisp, square edges as a foil to the rounded shapes within the painting. The mount was a subtle grey-green with a paler inner narrow slip to balance the fiery sky.

Cornish Fishermen

This is an imaginary composition painted in the studio. It was planned as a dark mass, building up from the picture base, pyramid-fashion and culminating in the fisherman's head, which I deliberately positioned in the dead centre of the painting. On the right-hand side the figures are sharply profiled against the background and on the other side they melt into the surroundings.

With this plan in mind, I masked out the bands of horizontal light on the water and then painted the background of cottages and water with traditional washes, first a wash of raw sienna down to the water's edge and then blue-grey painted into this while damp for the background tone and faces of the cottages, leaving the raw sienna for the light areas. Then I let the paper dry. The dark pyramid shape is a wash of varied colour, mainly French ultramarine, raw sienna and burnt umber, into which I dropped pools of black. I caused this to dry unevenly by adding further wet colour into parts, and when the remaining parts were nearly dry I held the painting under a tap to wash away the still-wet paint and create soft-edged light and dark passages within the pyramid shape. With the paper still damp, I added dots of pigment to suggest the knitted jerseys.

Suggestions of hanging fishing nets were drawn on the left, then the strong vertical masts were added. The fishermen's heads were the last part to be dealt with. Until now the foreground dark had been kept as an anonymous shape of varied colour and tone, so it was meaningless until the heads were explained. One face looks outwards and the other two look inwards into the painting, and all have minimal detail. A flat wash shades one half of the outward-looking face, while the original background wash serves for the other half. The eyes, with drooping lower eyelids, and the nose were indicated using a pen dipped in watercolour. The other heads are just flat washes in silhouette.

Figure 97 **Cornish Fishermen.** 225 × 165 mm [9 × 6½ in.]

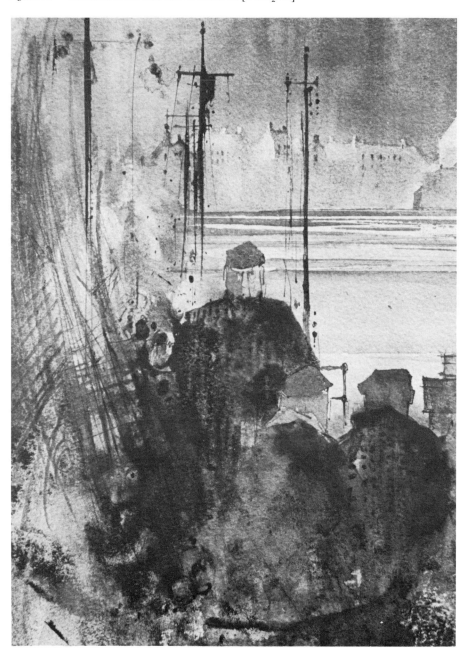

Welsh Landscape

This is an imaginary composition based on memories of Central Wales. My mind pictured the ends of the cottages as geometrically triangular shapes within a large shapeless mass of trees and undergrowth which I identified with occasional pen drawing. The spiky bushes which grow on the rocky hillsides also offered some places for definite drawing. The tops of the hills are rounded and bare except for a solitary silhouetted group of distant trees whose rounded top continues the rhythm of the landscape.

I washed palest grey over the paper, diluting it almost to white paper in the positions of the cottages. I left the top of the paper white and later painted this as sunlit fields in dilute Winsor yellow and dragged lines quickly with a small brush to indicate the walls which enclose the fields. While the first grey wash was still wet I added bright green on the left and cadmium red into the bottom right corner. The green was a mixture of cobalt blue and Winsor yellow, slightly muted by the grey wash already on the paper yet still giving me the fresh-looking green that I wanted.

I redampened the centre of the paper, leaving dry shapes for the cottages, and dropped black ink into the damp paper. The ink was allowed to spread and form the soft-edged dark tree mass and while this was still wet some colour was washed away under the tap to create soft-edged light passages at the bottom of the paper. When the ink had almost dried I held it under the tap again to create a mottled effect within the big black shape. As the black ink dried a little pen drawing was added to suggest twigs, undergrowth, and the spiky bushes. The distant trees on the skyline were added with a brush and their edges sharpened with pen and ink.

My aim throughout the painting process was to have a large area of soft-edged black to be identified as trees by occasional drawing, and relieved by washing away to give mottled and random shapes of grey. Colour is provided by small areas of green and red diluted to almost pink. The cottages become progressively whiter as they climb the hill, so that the lightest is near the top of the paper. They are arranged to face in slightly different directions to suggest an interesting spiralling effect as they climb the hillside.

The painting was framed with a dull silver moulding, some of the silver being rubbed away to expose traces of red underneath. The mount was a carefully chosen subtle grey-green with a slightly ribbed surface, and a narrow slip of paler grey-green separated the mount and painting.

Figure 98 **Welsh Landscape.**
175×165 mm [$7 \times 6\frac{1}{2}$ in.]

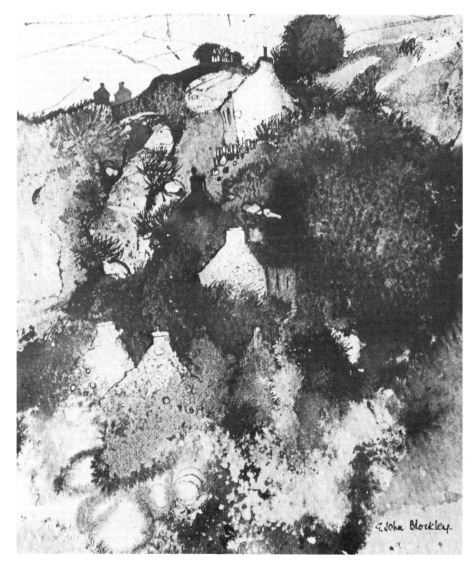

5
Sketch-notes

The sketches in this book are my working notes. Some of them are quick notes recording essentials as information for later paintings, and some are taken considerably further and are complete in themselves.

Essential details

Sometimes I carefully draw essential topographical details in combination with only brief annotations, enough to remind me of the general surroundings. A farmhouse might be detailed and the foreground registered with brief, but to me, informative symbols which are sufficient reminders when I come to paint in the studio.

Disciplined drawing

The degree of finish depends upon the time available, or my mood. The important thing is to draw often, compulsively. The mechanics of the drawing depend upon the type of drawing. Some of my sketches here are drawn with deliberate, considered line. I look at the subject and then draw a decisive line. Every line is debated and then drawn precisely. I ask each time whether a line is necessary, or if the drawing is already sufficiently descriptive. The constant awareness of drawing with economy is good training for economical painting.

In order to draw you have to look, and you should draw what you see and not have a preconceived idea of what you think the subject should look like. Look at a tree and decide its characteristic shape, decide the proportion of one part to another and how much one line slopes relative to another. Stop thinking of a tree. Think analytically in terms of shapes, slopes, proportions.

Free sketching

I also like to draw with greater freedom of linework. I like the variable motion of the pencil meandering over the paper, then hesitating while the eye debates, then moving on again lightly and then with increased pressure. There is a feeling of the pencil almost finding its own way, with just a guiding nudge now and again. Don't grip the pencil. You are not signing a cheque. Hold it loosely as though allowing it to think its own path. But still draw with economical line. It has been said that it is better to draw without looking at the paper, but concentrating on the subject and just giving an occasional glance downwards. The suggestion goes a bit too far perhaps, but I have some sympathy with its sense.

I do not regard this way of working as in conflict with my other more precise way. The mind and eye are still in command, analysing and measuring so that the apparently loosely wandering lines are really a controlled build-up to parts of importance and emphasis.

Pencil work

I draw mostly with a B pencil, sometimes 2B. This grade of pencil hardness will give a precise line and sufficient range of tone from grey to black. I prefer pencil to pen because of this range of line density and because areas of tone can be massed in, again with varied density. The shaded side of a building can quickly be registered by dragging the side of the pencil over the paper. The way of holding the pencil can vary during the act of drawing from the normal way for writing to holding it between thumb and all four fingers so that the pencil lead lies flat on the paper for blocking in areas or for making thicker lines. Conté crayon or conté pencil also gives a variety of line thickness and density.

Sketching paper

For finished drawings I like a smooth paper over which a lead pencil will

Figure 99 Roadside trees. Pencil sketch ,
200 × 250 mm [8 × 10 in.]

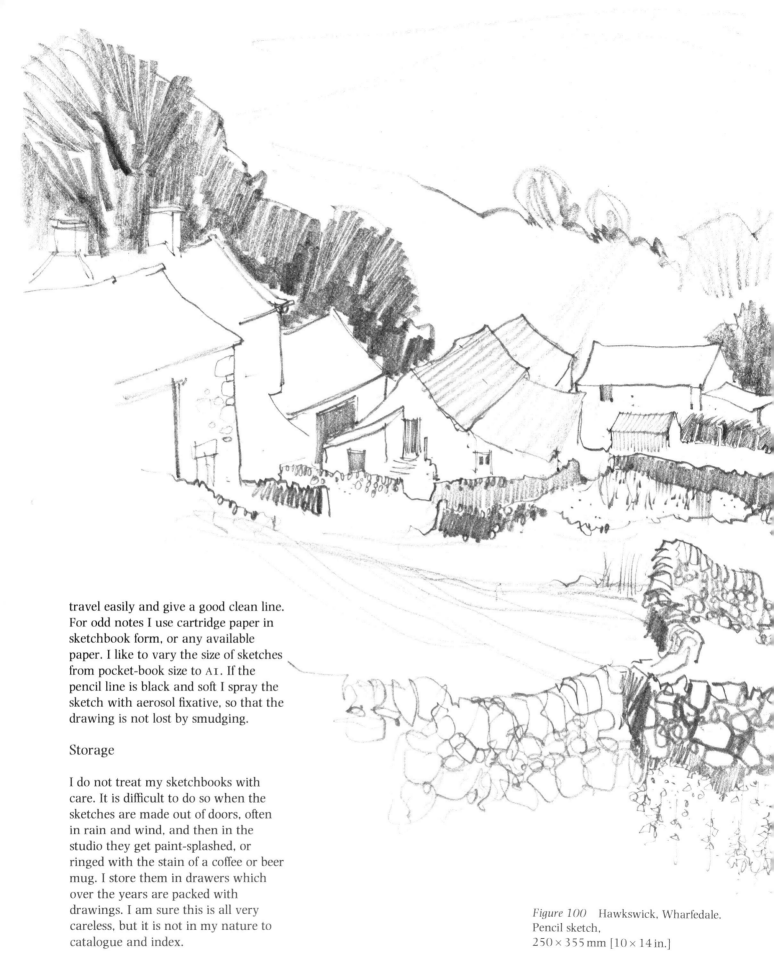

travel easily and give a good clean line. For odd notes I use cartridge paper in sketchbook form, or any available paper. I like to vary the size of sketches from pocket-book size to AI. If the pencil line is black and soft I spray the sketch with aerosol fixative, so that the drawing is not lost by smudging.

Storage

I do not treat my sketchbooks with care. It is difficult to do so when the sketches are made out of doors, often in rain and wind, and then in the studio they get paint-splashed, or ringed with the stain of a coffee or beer mug. I store them in drawers which over the years are packed with drawings. I am sure this is all very careless, but it is not in my nature to catalogue and index.

Figure 100 Hawkswick, Wharfedale. Pencil sketch, 250 × 355 mm [10 × 14 in.]

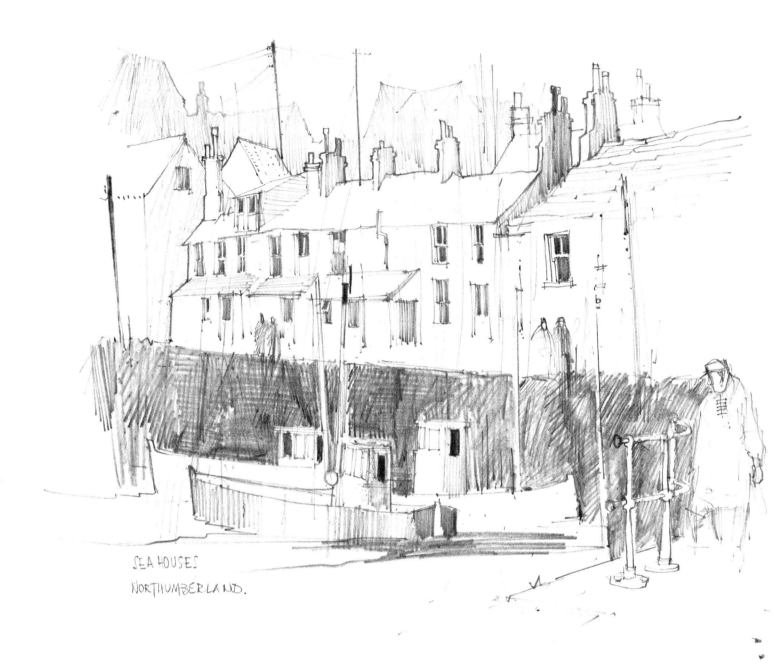

SEA HOUSES
NORTHUMBERLAND.

Figure 101 Seahouses, Northumberland.
Pencil sketch,
200 × 250 mm [8 × 10 in.]

Figure 102 Seahouses, Northumberland.
Pencil sketch,
200 × 275 mm [8 × 11 in.]

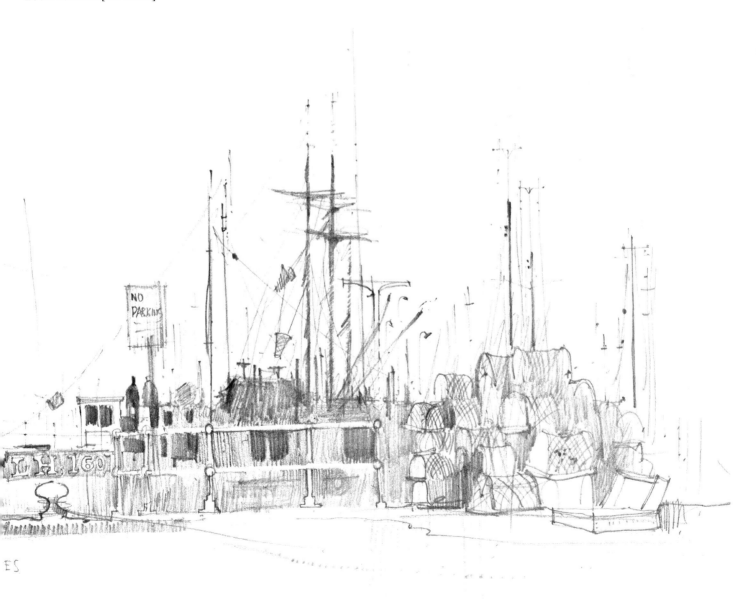

Figure 103 Tewkesbury. Pencil sketch,
150 × 250 mm [6 × 10 in.]

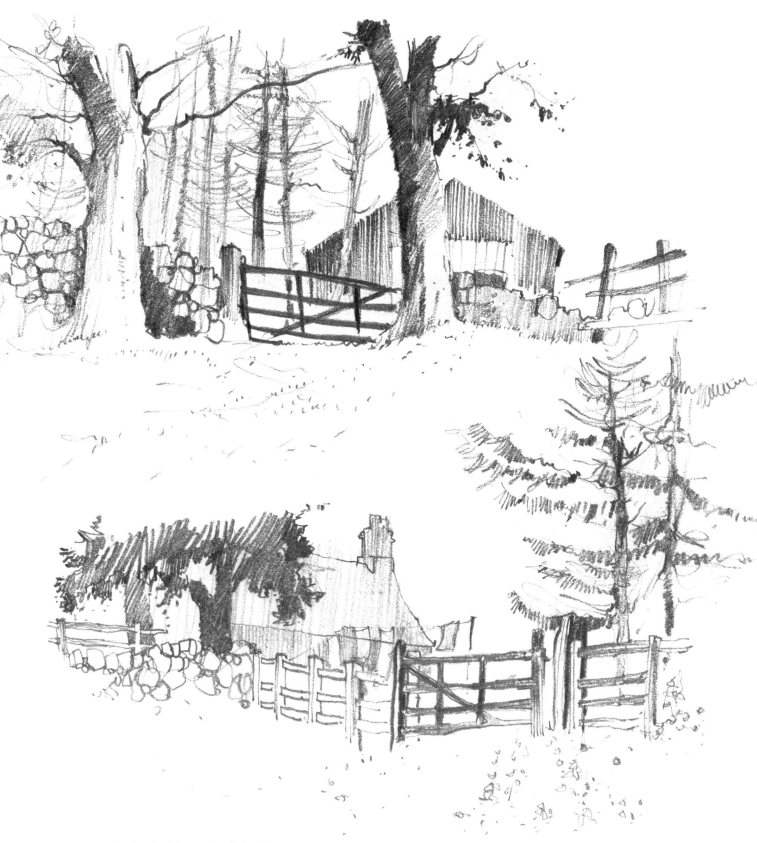

Figure 104 Northumberland farm. Pencil sketch,
250 × 250 mm [10 × 10 in.]

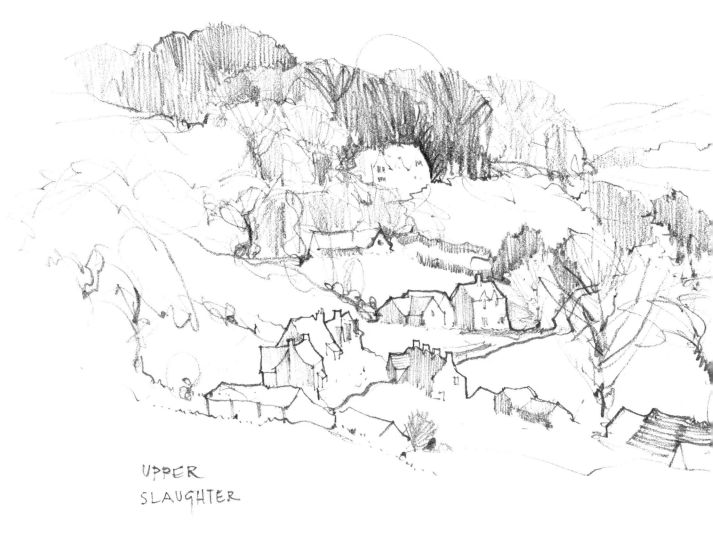

UPPER
SLAUGHTER

Figure 105 Upper Slaughter, Cotswolds. Pencil sketch,
175 × 275 mm [7 × 11 in.]

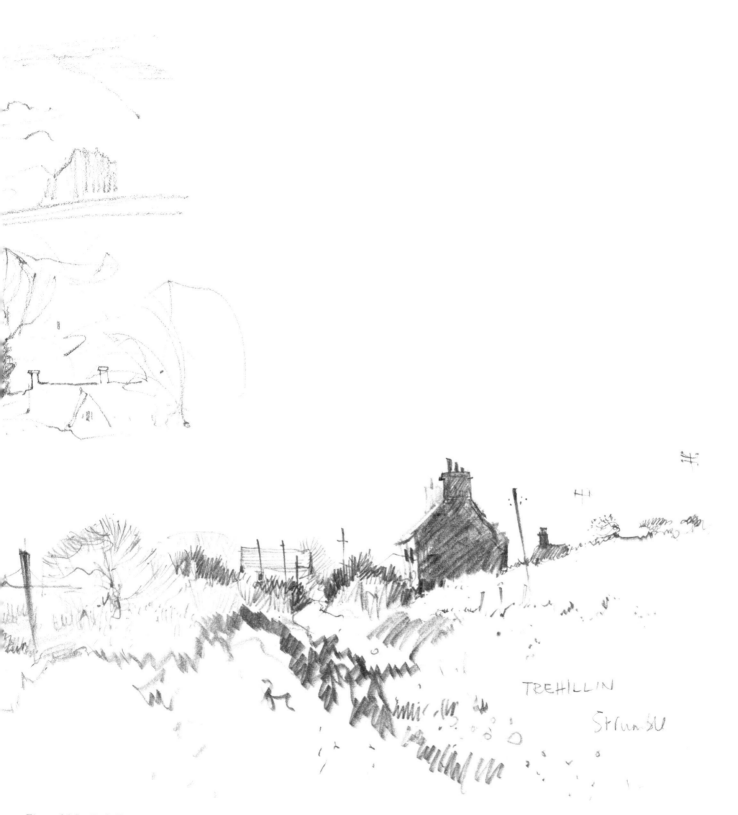

Figure 106 Trehillin, Pembrokeshire. Pencil sketch,
101 × 304 mm [4 × 12 in.]. The painting illustrated in Plate 13 and Figure 137 was based on
this sketch.

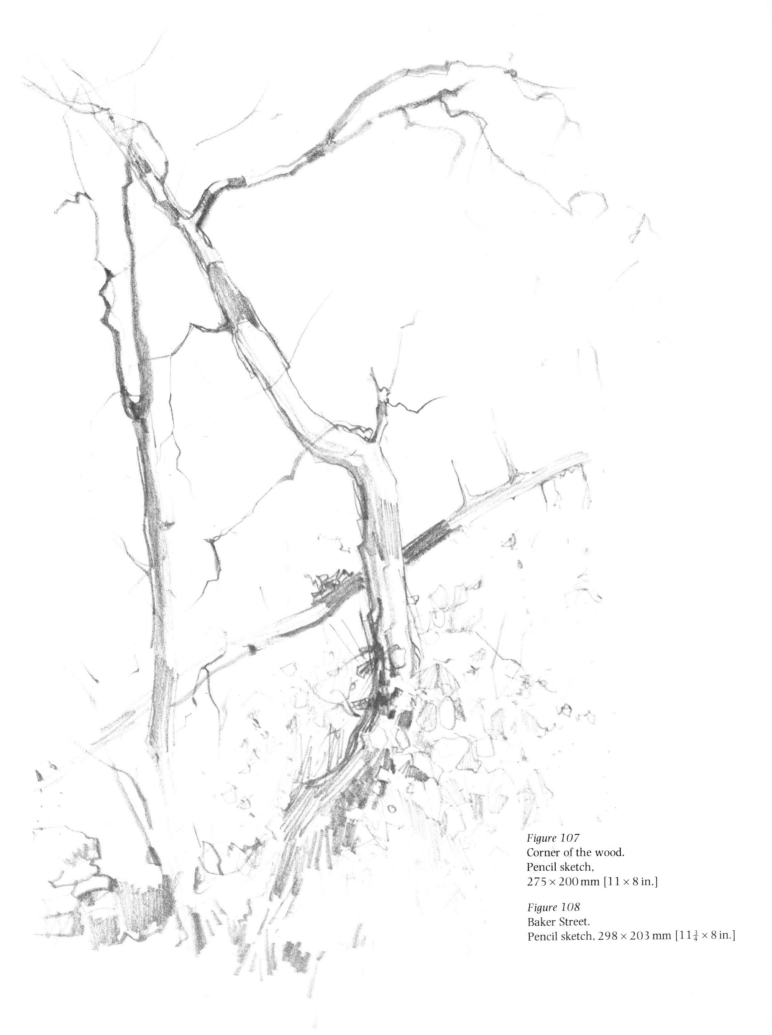

Figure 107
Corner of the wood.
Pencil sketch,
275 × 200 mm [11 × 8 in.]

Figure 108
Baker Street.
Pencil sketch, 298 × 203 mm [11¾ × 8 in.]

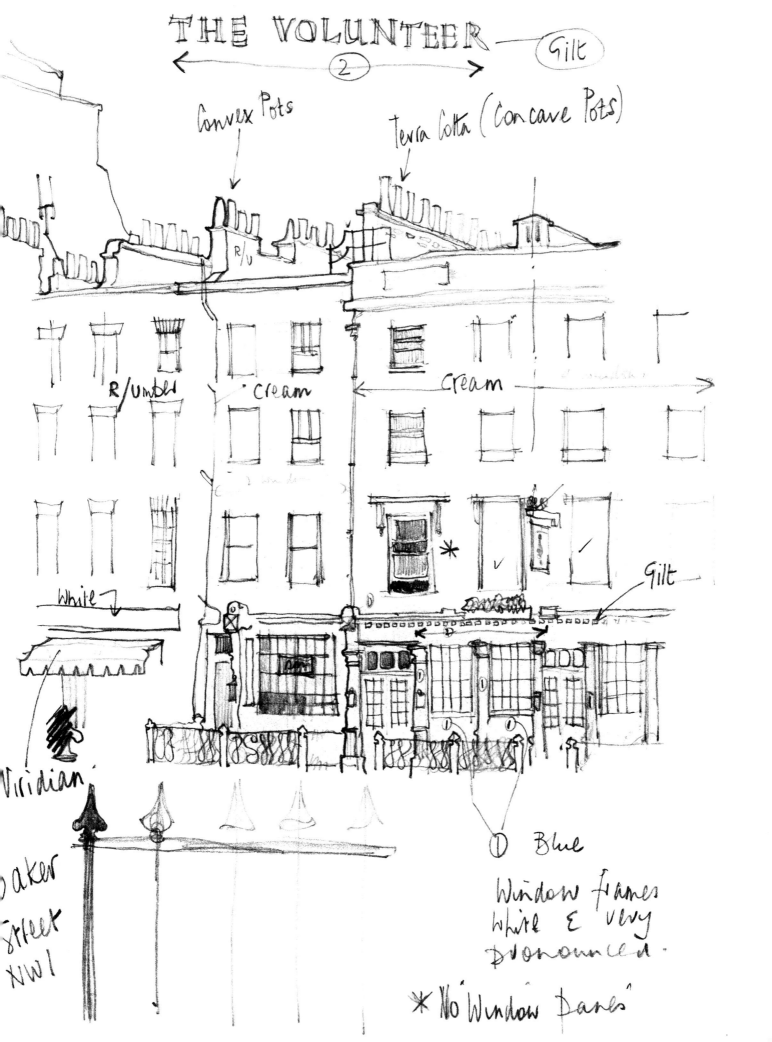

THE VOLUNTEER 2 Gilt

Convex Pots

Terra Cotta (Concave Pots)

R/U

R/umber Cream Cream

White

Gilt

D

Viridian

Baker Street NW1

D Blue

Window frames white & very pronounced.

* No 'Window Panes'

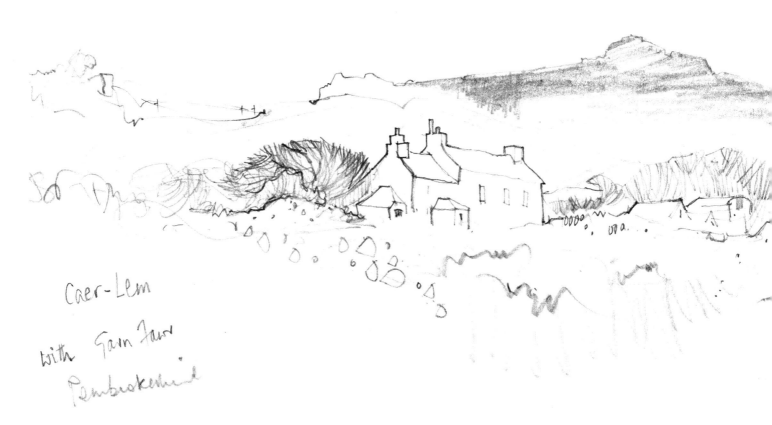

Caer-Lem
with Garn Fawr
Pembrokeshire

Figure 109 North country farm.
Pencil sketch, 125 × 254 mm [5 × 10 in.]

Figure 110 Caer-lem, Pembrokeshire.
Pencil sketch 254 × 304 mm [10 × 12 in.]

John Blockley.

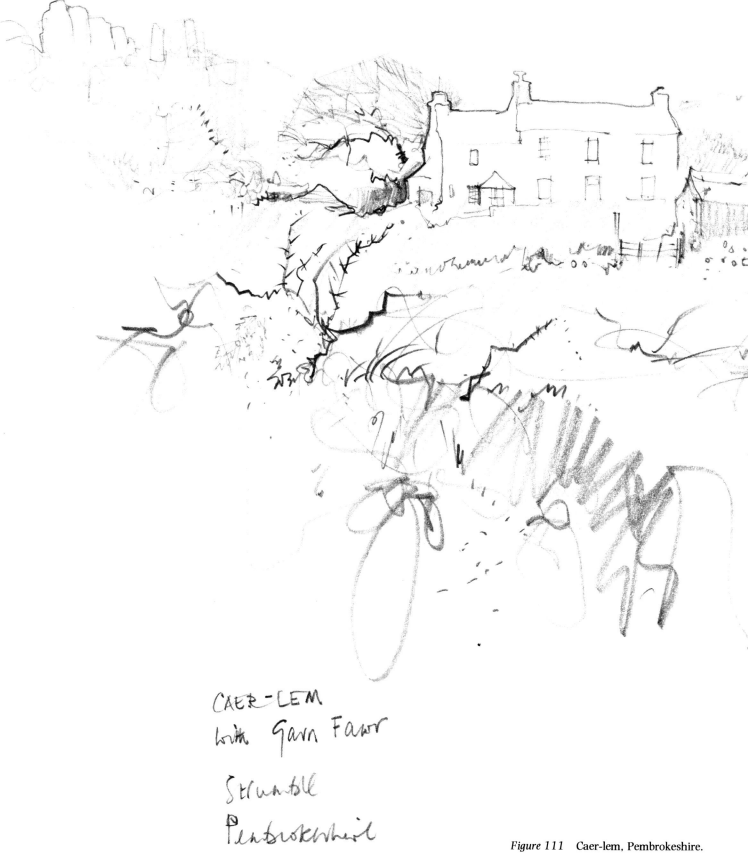

CAER-LEM
with Garn Fawr

Strumble
Pembrokeshire

Figure 111 Caer-lem, Pembrokeshire.
Pencil sketch 254 × 381 mm [10 × 15 in.]

John Blockley

Figure 112 Strumble Head. Pencil sketch,
75 × 250 mm [3 × 10 in.]

6
Portfolio

To round off the book I have collected some paintings together and added a few notes in which I have tried to concentrate on the important points about each painting. The paintings were picked at random and they are not arranged in any particular order. They are intended as a sort of summary of the thinking and the processes described throughout the book.

One form of selection was exercised in picking out these paintings. Like all those illustrated in this book, they are small in size. This is a deliberate choice because large paintings if reduced to fit the page would tend to lose too much of their textural quality.

In any case, the intimacy of the small scale appeals to me and so I like to paint small pictures. Obviously a small size is suited to such subjects as the dandelion which I discuss in the Introduction to this book, but I also have a personal feeling that a big subject can be expressed effectively when painted to a small size. I do not think this is necessarily because of some pig-headed streak; I often find it is useful to question the obvious. Sometimes a subject which immediately suggests a horizontal picture will look more interesting when designed into a vertical format, or the questioning might reveal other interesting qualities about the subject.

There is a counter-argument that small paintings can flatter the artist

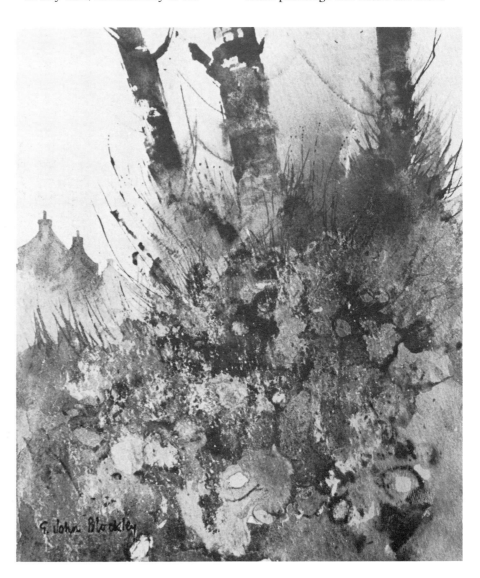

Figure 113 **Trees and Crumbled Wall.**
240 × 200 mm [9½ × 8 in.]

and so as an insurance against complacency I sometimes do paintings, which are large by watercolour standards, 760 × 510 mm (30 × 20 in.) and even 1020 × 760 mm (40 × 30 in.). I paint these mostly on an easel, and with big brushes held at arm's length, walking up to the easel only for small brushwork. However, I only work this size occasionally, as I really feel that the watercolour medium is better suited to smaller paintings.

Trees and Crumbled Wall

The painting is concerned with the textures of tree bark and the random-sized stones in the wall. The textured quality in the foreground was obtained by a combination of washing colour over candle wax resist and pouring ink into it and washing away when partly dry. The trees were painted with side-strokes of a flat brush.

Trees on a Bank

Below is another painting concerned with textures. I painted it by adding ink to wet colour and washing out when partly dry. It is painted on a very rough paper and I found that the edge of a razor blade would scrape wet paint from the paper surface to reveal white paper but without damaging its surface. This treatment adds a further textural effect.

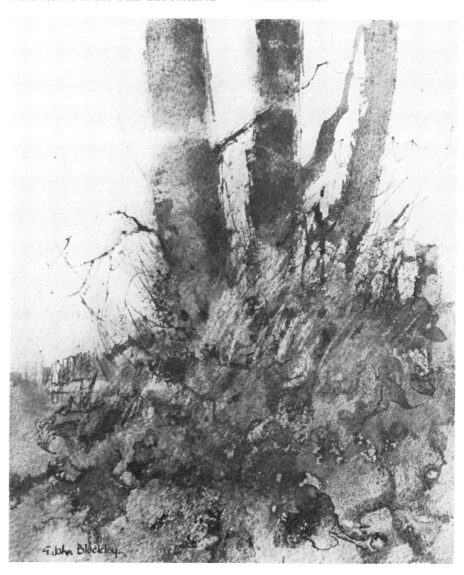

Figure 114 **Trees on a Bank.**
250 × 215 mm [10 × 8½ in.]

Figure 115 **Trees and Cotswold Wall.**
250 × 355 mm [10 × 14 in.]

Trees and Cotswold Wall
More wax resist work, especially on the vertical stones at the top of the wall. I wanted them to sparkle. The light parts of the wall are raw sienna, golden, and emphasized by the neighbouring dark tone made with French ultramarine and burnt umber.

Bridge, North Wales
This is another version of my bridge demonstration painting shown in Figures 74-77. I found that I had painted the first one on the back of another painting, so now someone has two paintings in one frame but does not know.

Mountains and Sky
On the site I recorded the profile of the mountains with a pencil line on an old envelope. The rest is a combination of imagination and memory. The mountain is blue-black, almost black, and I painted it crisply against the sky except at the right, where I continued the brushstroke to melt the mountain into the sky.

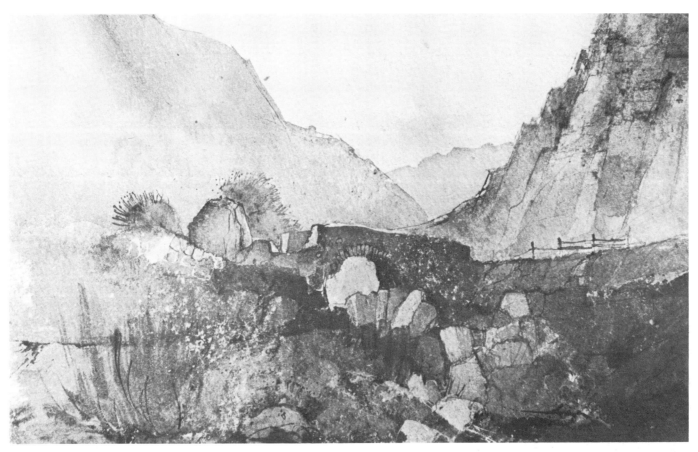

Figure 116 **Bridge, North Wales.** 250 × 380 mm [10 × 15 in.]
Figure 117 **Mountains and Sky.** 150 × 250 mm [6 × 10 in.]

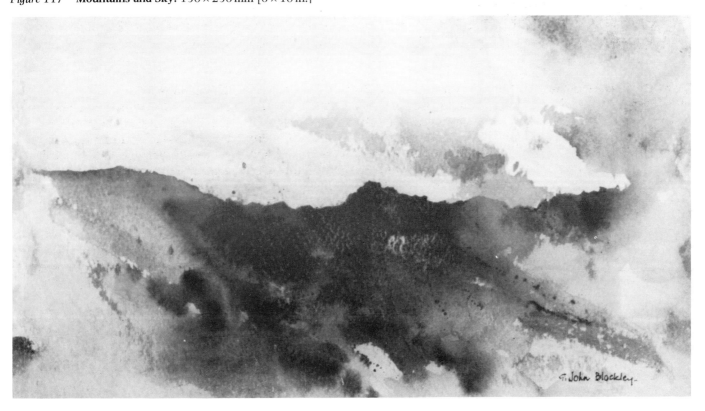

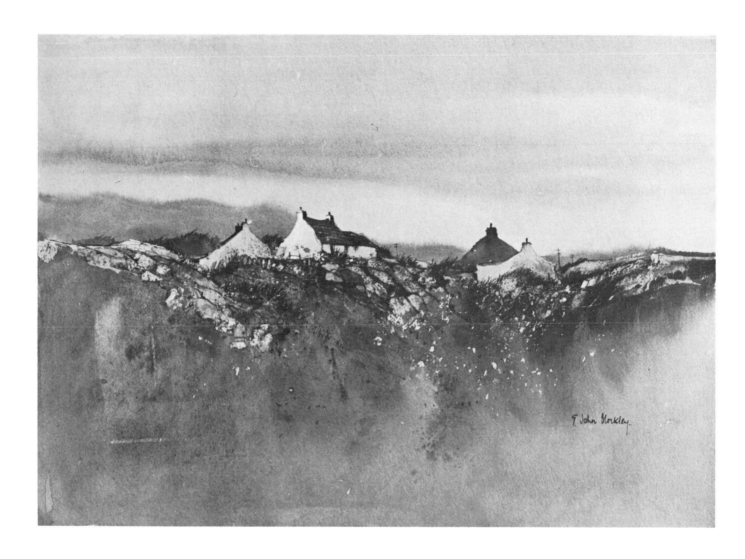

Figure 118 **Mountain Cottages, Wales.**
200 × 300 mm [8 × 12 in.]

Mountain Cottages, Wales
I liked the repetitive shapes of the
buildings and the repetition of light
tones on the buildings and the rock-
strewn ground. These light parts were
obtained by using masking fluid. The
rest of the painting was done by
traditional wet into wet watercolour
processes.

Mountain Cottages
Some more cottages in the Welsh
mountains. Here again masking fluid
was combined with traditional washes.

Welsh Farm
A straightforward landscape view as a
change from textured foreground. I
painted it some years ago, in
traditional washes to which I added a
little drawing with a pen dipped in
watercolour.

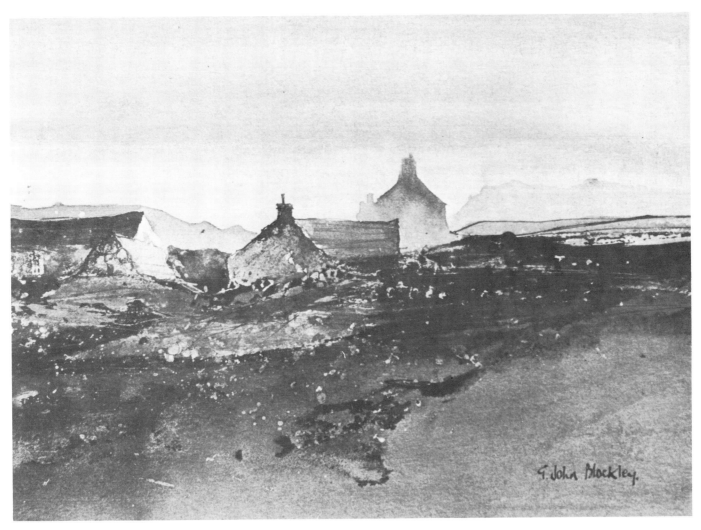

Figure 119 **Mountain Cottages.** 250 × 355 mm [10 × 14 in.]

Figure 120 **Welsh Farm.** 200 × 400 mm [8 × 16 in.]

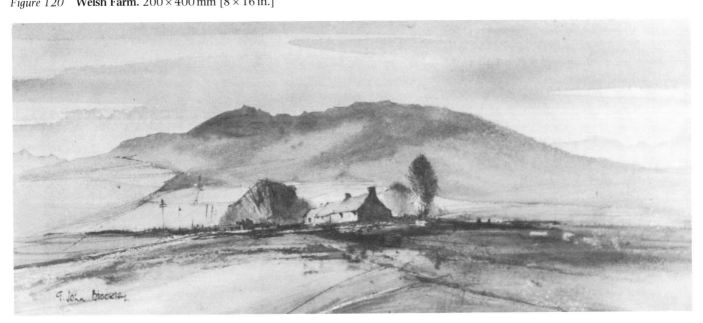

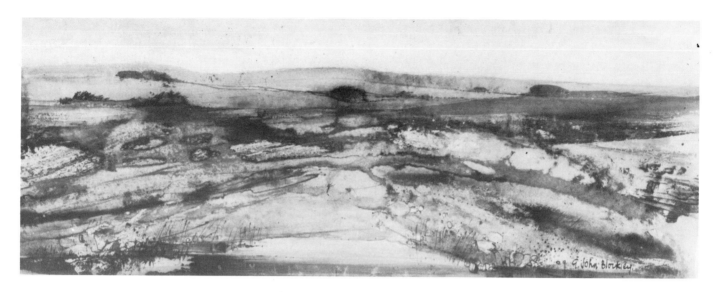

Figure 121 **Moorland Textures.**
200 × 460 mm [8 × 18 in.]

Figure 122 **Moorland Farm, Yorkshire.**
150 × 275 mm [6 × 11 in.].
This painting is also reproduced in colour,
in Plate 16.

Moorland Textures
I like the marbled pattern of the foreground against the gentle distant curves. I painted the sky and continued it to the bottom of the paper with changing colours of very pale pink, hints of cobalt and grey. I added ink to the foreground, tilted the paper to induce ink runs, partly dried it, and then washed out the bits which were still wet. I dotted pigment into it with the wrong end of the brush and drew lines with pen and watercolour, some of them meandering loosely across the surface and some short and taut to represent the coarse moorland grass. The distance was painted with horizontal sweeping brushstrokes.

Moorland Farm, Yorkshire
The buildings in this part of the country have vermilion-coloured

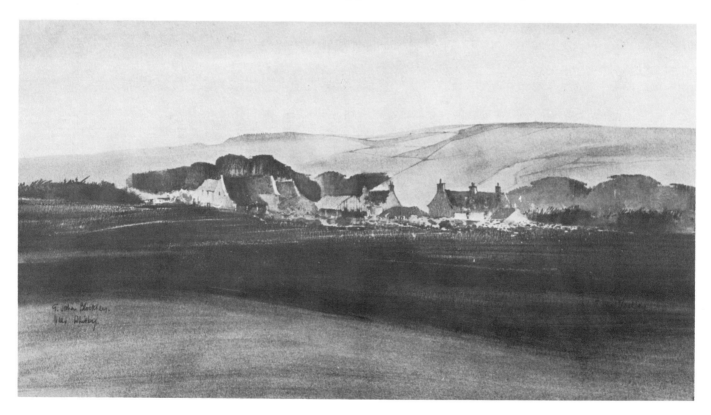

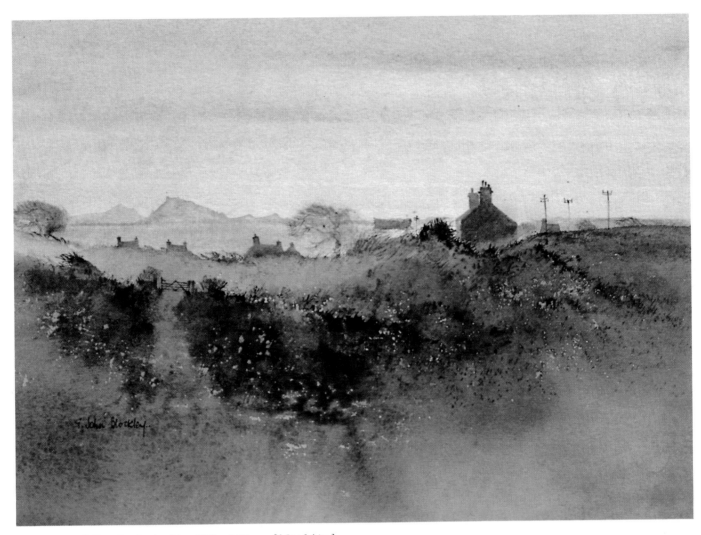

Plate 13 **Trehillin, Pembrokeshire.** 250 × 355 mm [10 × 14 in.]

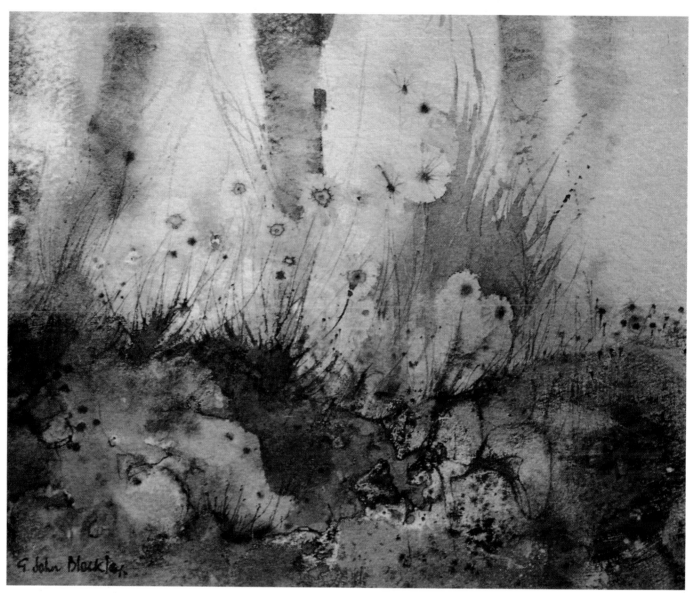

Plate 14 **Woodland Fantasy.** 175×210 mm [$7 \times 8\frac{1}{4}$ in.]

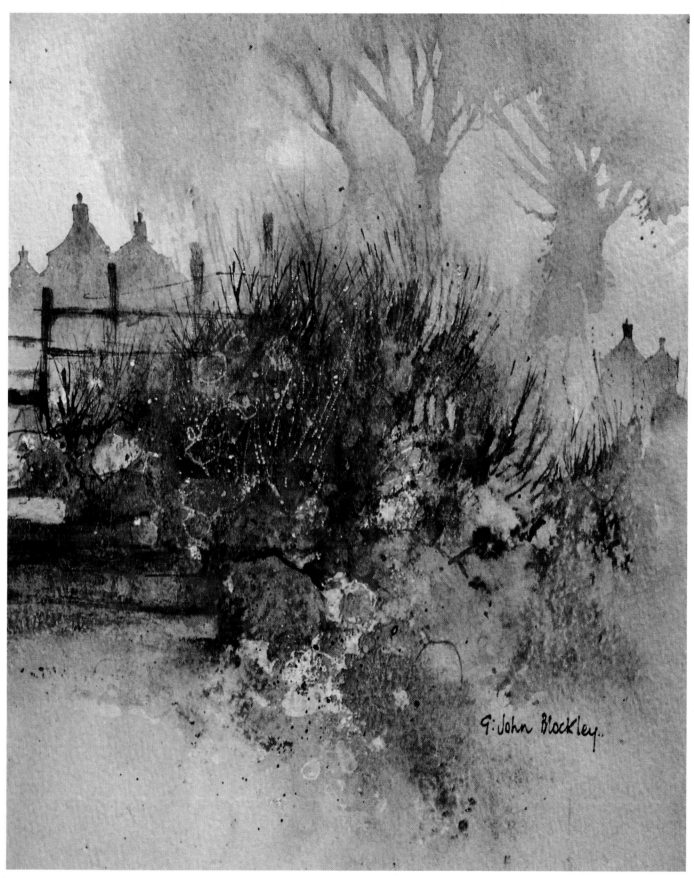

Plate 15 **Morning Light, Cotswolds.** 150 × 190 mm [6 × 7½ in.]

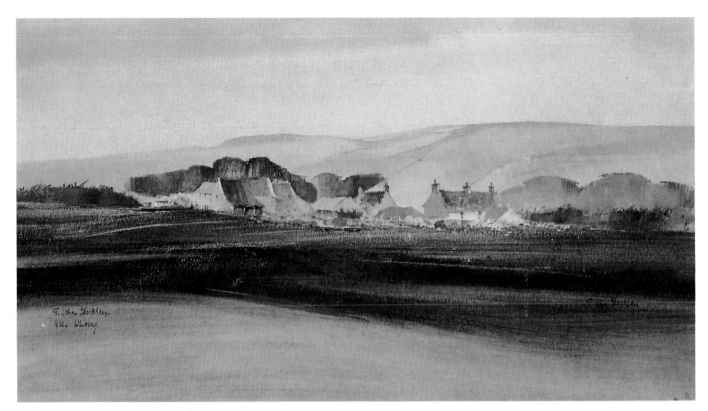

Plate 16 **Moorland Farm, Yorkshire.** 150 × 275 mm [6 × 11 in.]

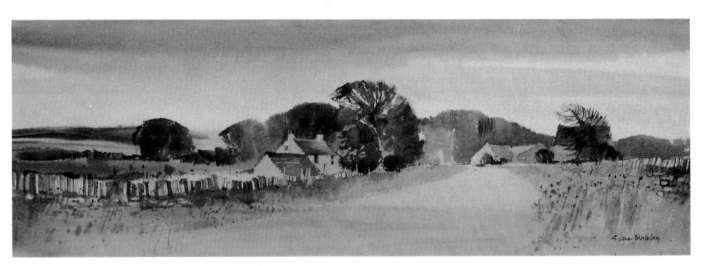

Plate 17 **Cotswold Landscape.** 150 × 275 mm [6 × 11 in.]

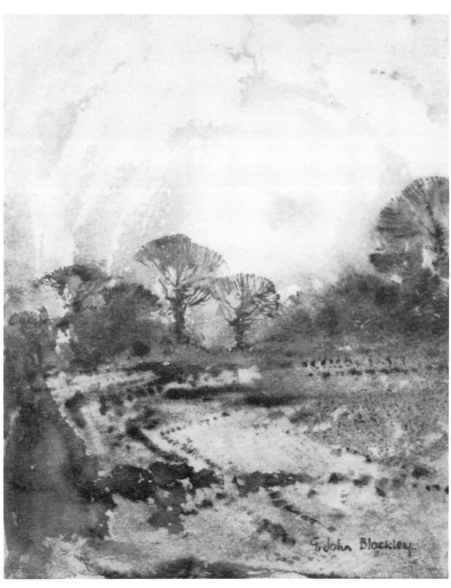

Figure 123 **March Textures.**
150 × 125 mm [6 × 5 in.]

pantile roofs. The trees and foreground are in warm, dark tones, burnt umber with a little French ultramarine. The hills are palest blue-green. I used traditional processes, except that I painted the dark foreground with an oil painter's hog-bristle brush to give horizontal brushmarks showing across the foreground paint.

March Textures

This is a favourite month with me. Not winter, not quite spring. A time of promise. Trees are black and a winter's weathering has crumbled the earth ridges made by the plough into clods of earth glistening on top and shaded underneath. I have tried to suggest the mottled light on this crumbling surface and the crude darks of the earth lumps. Some of these dark blotches join together to indicate the original ploughed furrow, then disintegrate into blotches again before re-forming as the black tree mass. I obtained the effect of this surface by pouring colour over the paper and rocking the paper so that the wash swilled backwards and forwards. The pigment separated out as dark granules in the tooth of the paper. The top surface of the paper stays only slightly stained, almost white, or, as I would like to think, silver, in relation to the sombre tones elsewhere.

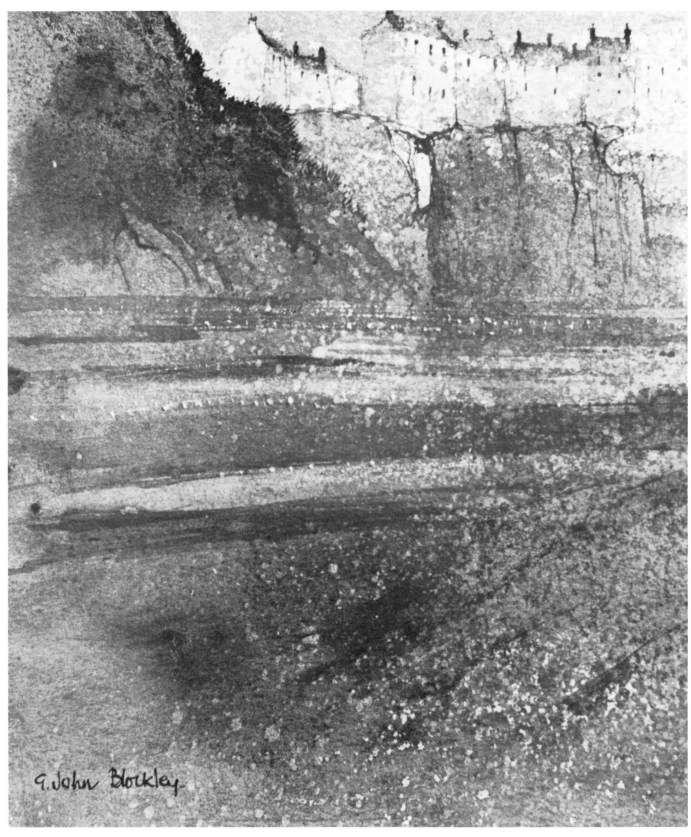

Figure 124 **Coastal Textures.** 175 × 150 mm [7 × 6 in.]

Coastal Textures

This is an imaginary subject. I wanted to integrate the cliffs, houses and sea by giving them a speckled effect all over. I rubbed a little wax on the place occupied by the houses, but without carefully shaping them. Colour poured over the cliff and sea area precipitated out to give the fine speckled finish. A few dark reflections were brushed across the paper, leaving the original wash to suggest rippled surface reflecting the sky. The white house shapes were created by the resistance of the wax to the sky wash. I added chimneys, roof and windows to confirm the shapes as houses.

Staithes, Yorkshire

This was painted basically in three washes, each wash having its own modulations of tone. The sky wash was taken to the bottom of the painting. The distant buildings were formed by another wash, the top of the wash shaped to represent roofs and chimneys. The nearer dark house was painted as part of the third, foreground wash. This wash was painted soft-edged into redampened paper. Finally I drew a few details in the houses and foreground.

Wharfedale

Some of the hard-edged white parts of the water were masked out and a little wax was rubbed over the bottom part of the painting. The water was brushed in quickly with horizontal strokes. I kept the buildings and background hill similar in tone so that the emphasis is on the water. Rubbing the masking fluid away exposed the movement of light in the water and lower down the wax resist gives a sparkle.

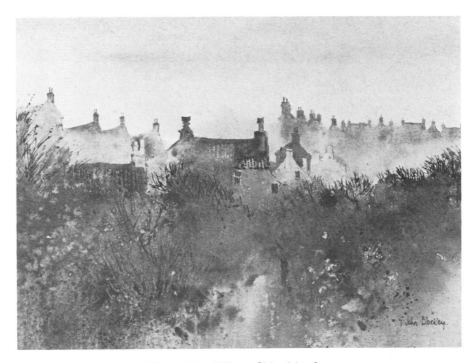

Figure 125 **Staithes, Yorkshire.** 250 × 355 mm [10 × 14 in.]

Figure 126 **Wharfedale.** 175 × 250 mm [7 × 10 in.]

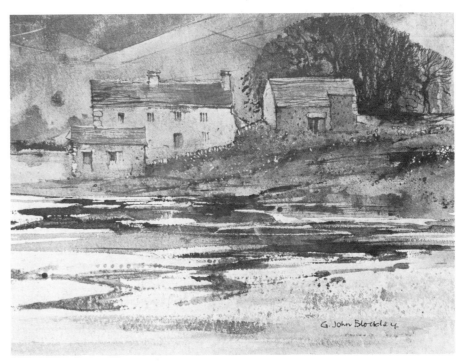

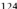

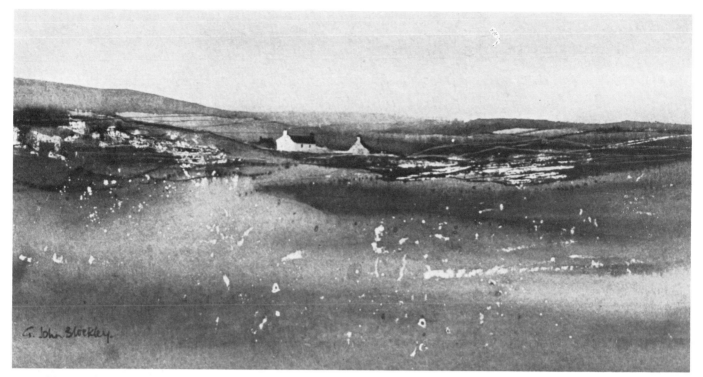

Figure 127 **Yorkshire Moorland.** 100×200 mm [4×8 in.]

Figure 128 **Derbyshire Cottages.** 250×355 mm [10×14 in.]

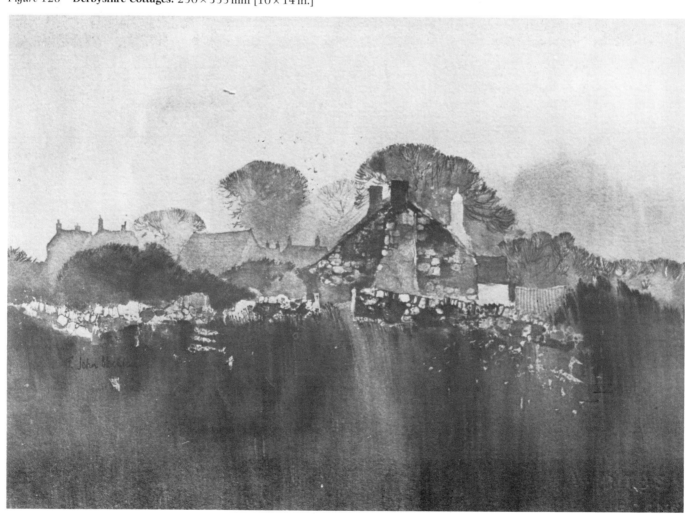

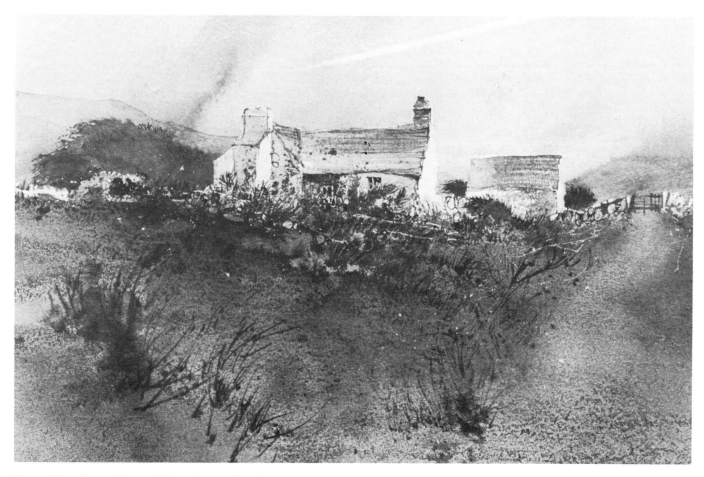

Figure 129 **Stone Cottage.** 225 × 355 mm [9 × 14 in.]

Yorkshire Moorland

A quick watercolour sketch to record the sweep of the moorland. The foreground was kept featureless to contain the interest in the distance.

Derbyshire Cottages

I masked out the details of the cottages and stone wall before painting a preliminary wash over the sky and foreground. The trees were painted into the damp sky wash, first as a soft-edged smudge of tone and then with fine brush drawing. I painted vertical brushstrokes with a flat 50 mm (2 in.) wide brush into the damp foreground to give some vertical direction as a foil to the horizontal arrangement of buildings and wall.

Stone Cottage

I used masking fluid to obtain the white parts of the cottage and the nearby rocks and ground textures. The rest was painted in traditional washes of colour, wet into wet with finally a little line drawing with pen and watercolour, especially in the long foreground grass.

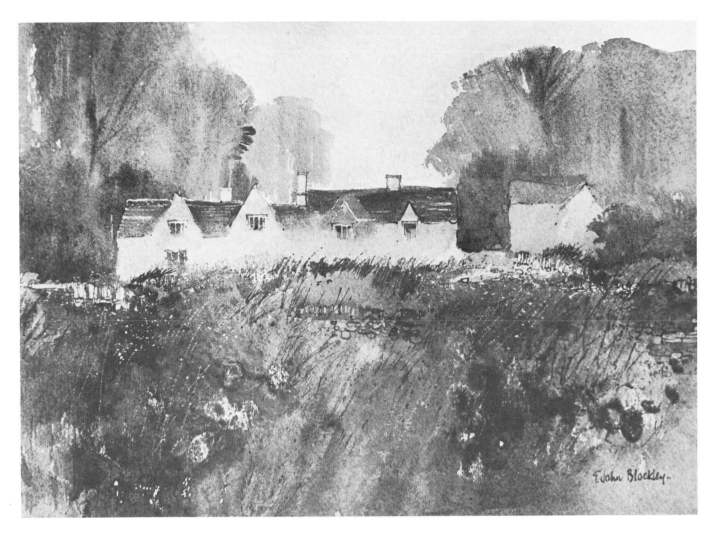

Figure 130 **Cotswold Cottages.**
225 × 355 mm [9 × 14 in.]

Cotswold Cottages
I painted raw sienna over the paper, and this represents the sky and the buildings in the final painting. I merely added the roof and windows to explain the first wash as houses. The trees were painted as flat shapes of blue-grey into which I brushed moist pigment to suggest some branches. The foreground is deeper raw sienna, with burnt umber floated in while wet and some grasses drawn with a pen.

Abandoned Cottage
The texture of the cottage is repeated in the ground and trees. I aimed to reproduce this similarity of texture throughout. I obtained it by working with very wet colour mixtures on a rough-surface paper lying flat on the table. Under these circumstances the pigment precipitates out of the wash to give the granulated finish. The cottage, trees and foreground were painted all as one shape, in one granulated wash of varied colour over a previously painted dry sky. Darker tones were added into this damp wash to define the various features.

Cotswold Farm Cottages
The main interest is in the trees and foreground. Each tree started with very pale colour painted the over-all shape of the tree into a damp sky. The branches were drawn with moist pigment into the first damp wash, using a finely pointed brush. The foreground textures were obtained by painting over masking fluid, some wax resist, and wet into wet painting.

Figure 131 **Abandoned Cottage.** 225 × 355 mm [9 × 14 in.]

Figure 132 **Cotswold Farm Cottages.** 225 × 535 mm [9 × 21 in.]

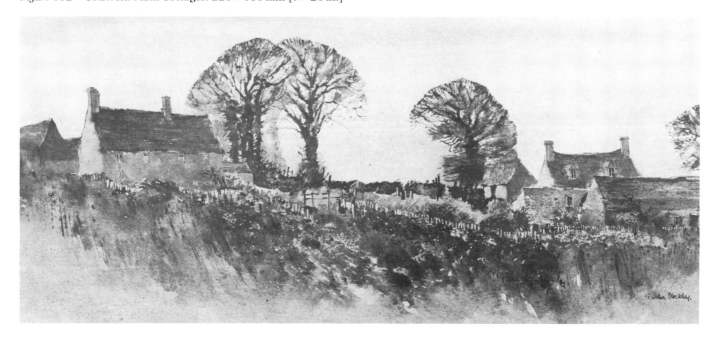

Figure 133 **Newspaper Seller.**
115 × 100 mm [4½ × 4 in.]

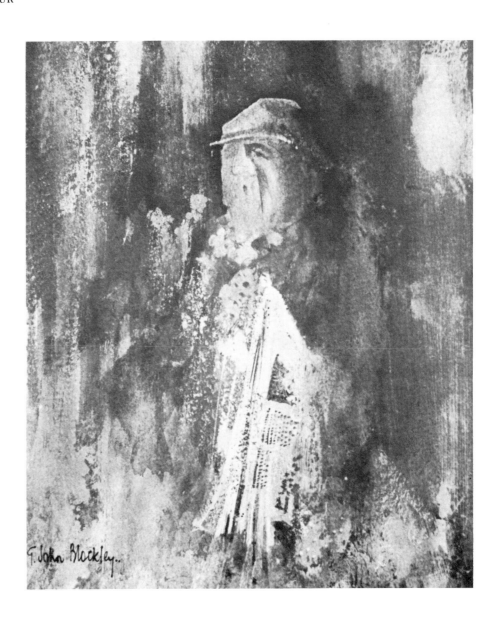

Newspaper Seller
The important thing here is that I
began by painting the background,
crisply around the shape of the head,
starting with light colour and painting
darker tones into it. I continued this
treatment into the body without
special definition. This background
wash defines white paper shapes for
the head and newspaper. I added
brilliant vermilion for a knotted
neckerchief, touched in the face colour
and indicated features. The newsprint
was dotted in with a fine brush.

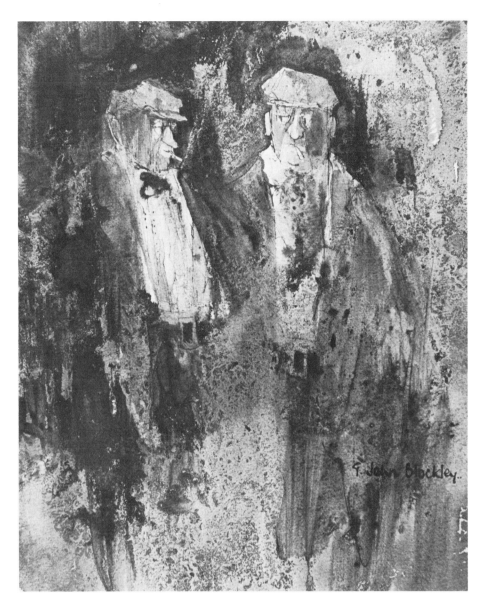

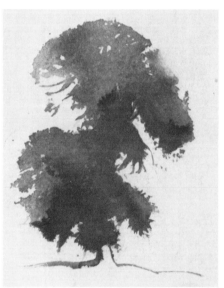

Figure 134 **Conversation.**
225 × 190 mm [9 × 7½ in.]

Figure 135 Tree. Pencil sketch,
90 × 75 mm [3½ × 3 in.]

Conversation
I again started with the background
wash, leaving the head and shirt fronts
as white paper. I added darks into the
background and then added ink, partly
drying and washing away to create a
mottled effect. The faces were put in
last.

Tree
This sketch-note was produced by the
simplest watercolour processes. The
tree shape was painted in one flat
wash which I immediately darkened in
places with additional colour.

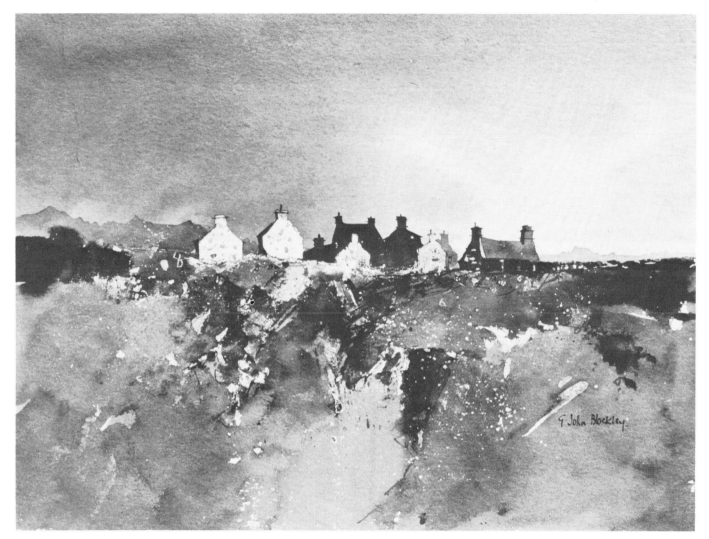

Figure 136 **Welsh Skyline.** 355 × 250 mm [14 × 10 in.]. This painting is also reproduced in colour, in Plate 12.

Welsh Skyline

I wanted to paint a personal impression of the mountainous country of North Wales, with dark stone or white-painted cottages in a surround of blue-green slate, and flickering lights on splintered stone. The cottages are solid and chunky, built to withstand the weather, without ornamentation but completely satisfying in their simple proportions. The cottages in this painting are exactly as I saw and recorded them in a pencil sketch; but the foreground is a personal interpretation derived from long experience of working in this part of the country. The darks in the foreground relate with the black cottages, but I avoided competition by keeping them soft in comparison with the crisp shapes of the buildings. As a foil to the activity in the landscape the sky is seen as a simple over-all blue-black wash relieved by the soft pink light at the horizon.

I masked out the white buildings with masking fluid and allowed them to dry before washing in the sky. I used dilute cadmium red to give a pink light in the lower sky and then washed a mixture of French ultramarine and lampblack over the remaining sky and continued this down the paper, adding green modified with black. While the ground was damp I brushed in moist lampblack, tending to make downward brushstrokes to hint at a change from the horizontal line of houses. The masking fluid enabled me to brush the wash over the cottages instead of having to paint carefully around them.

When the paper was dry the black silhouetted cottages were painted in and black was added to the shaded side of the white cottages. Using a pen dipped in watercolour I added a little descriptive drawing to the chimneys. Finally, I rubbed away the masking fluid to reveal the paper for the white cottages.

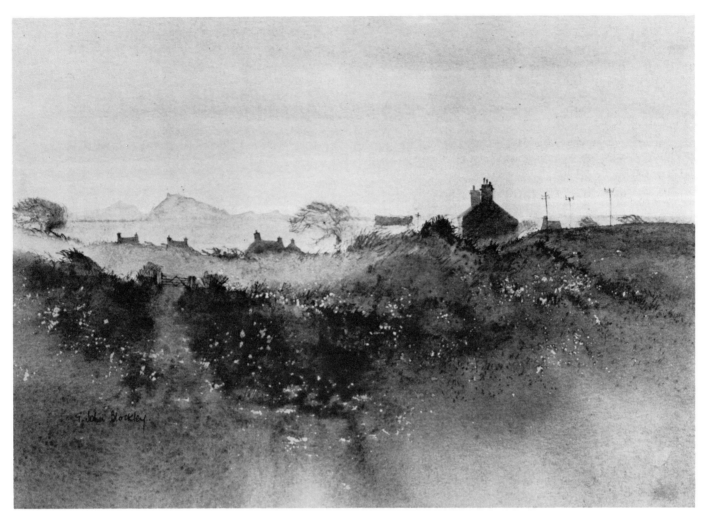

Figure 137 **Trehillin, Pembrokeshire.** 355 × 250 mm [14 × 10 in.]. This painting is also reproduced in colour, in Plate 13.

Trehillin, Pembrokeshire

I saw this subject as I looked sideways through the car window when driving along a main road. And so I stopped to make a quick pencil note, simply concentrating on essentials. I liked the cottage dark against the sky and the echoing distant cottages peeping over the expanse of foreground grasses.

Back in the studio I painted from the sketch. The paper was given an over-all wash of raw sienna slightly greyed with a touch of lampblack. I mixed French ultramarine with a little black and brushed blue-grey horizontal clouds into the sky, taking care that the brush was only just moist with colour. The relationship of moist brush to wetter wash ensured the soft cloud

edges. The mixture left over in the palette was then added to the still-damp ground in random shapes. I let the paper dry and flicked spots of masking fluid over the foreground. When these were dry I dampened the paper with a clean wet brush and added further soft-edged tones into the foreground with burnt umber and mixtures of burnt umber and French ultramarine. I made no attempt to model these darks but allowed them to spread almost uncontrolled into the damp paper. While the paper was still damp short pen-strokes of burnt umber watercolour were flicked in to suggest grass textures. I also added blots of burnt umber and French ultramarine and teased their upper edges with a

pen to suggest spiky bushes. The paper was allowed to dry and the spots of masking fluid were rubbed away to leave sparkling lights in the foreground. Then I added the water and the hills with washes of diluted French ultramarine, and the cottages with French ultramarine greyed with raw sienna. Finally, I flicked in the telegraph poles and the gate with a pen and watercolour.

In this painting I followed my normal process of leaving the precisely identifiable features to the last. Until this final stage of explanation the aim was to hint and suggest the character of the surroundings.

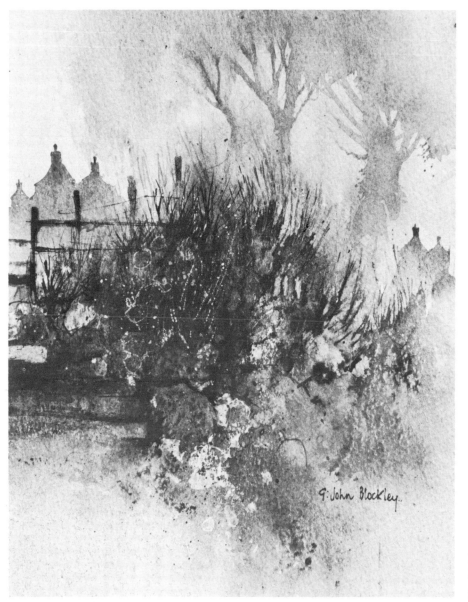

Figure 138 **Morning Light, Cotswolds.**
190 × 150 mm [7½ × 6 in.].
This painting is also reproduced in colour, in Plate 15.

Figure 139 (right) **Woodland Fantasy.**
210 × 175 mm [8¼ × 7 in.].
This painting is also reproduced in colour, in Plate 14.

Morning Light, Cotswolds

I covered the whole of the paper with a wash of raw sienna and floated hints of cadmium red into it. Just before this dried I poured a pool of blue-grey mixture into the middle of it to create a misty soft central area of tone and drew into this with a pointed brush and stiffer pigment to hint at details of stone and grass. I allowed the paper to dry. Then I dampened parts of it and with my fingers squeezed paint droplets from a brush to fall partly on the damp and partly on the dry paper. Using a fingernail I teased this paint over the dry paper to represent long grasses. The misty trees were painted into paper dampened locally, and the houses were painted crisp and edgy on dry paper. Notice that I darkened the chimneys against the light sky. Finally, I scratched in a few sparkling lights, scraping pieces of paper surface away with a razor blade.

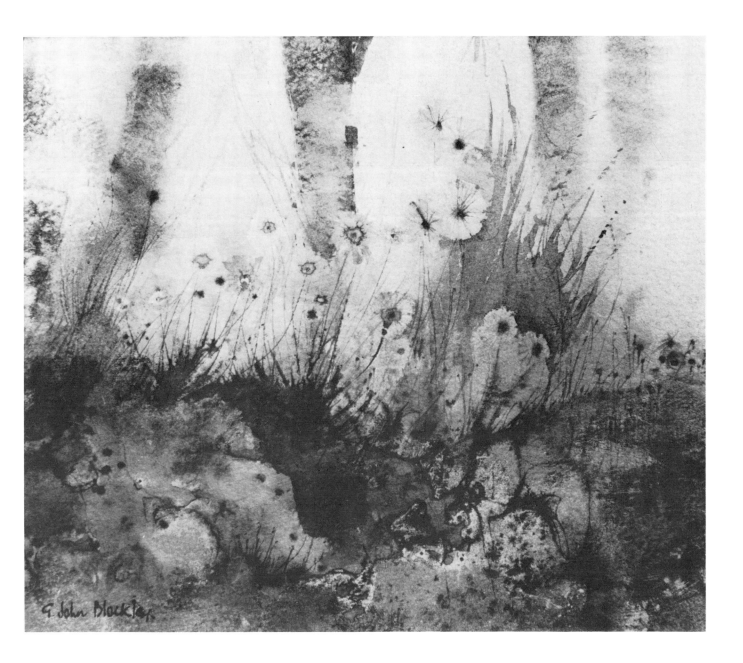

Woodland Fantasy

This is an imaginary subject painted in the studio. I had an idea to paint woodland flowers and plants, but in a manner not quite factual, perhaps whimsical, yet almost convincing. Are these real flowers? I wanted a feeling of light and airiness and a hint of almost prettiness in delicately tinted flowers. I wanted some of them to be light and filmy, almost floating but some almost geometrically precise, and so I painted them as round shapes in the sharp clarity of aureolin, with some edges crisply defining the round shapes and some edges disappearing and merging into the light background. A mischievous thought passed through my mind of circular pineapple slices with serrated edges. I picked up neat pigment with the wrong end of the brush and touched the damp centres of the flowers and with the lightest touch flicked, with a pen, lines of pale colour radiating from those soft centres.

I poured pools of colour on to the lower half of the paper, and tilted the paper to create paint runs. I accelerated the drying in parts with a hairdrier and slowed down the drying in other parts by floating in clean water. Dots of pigment were stippled with the wrong end of the brush into the damp paper, the soft-edged tree trunks were painted in and the long grasses were flicked with my fingernail from wet pools of colour on the paper.

7 Materials

So as not to repeat the discussions on materials in other books I have confined these notes to a few essential requirements in terms of my own experience and methods.

Water

I am constantly amazed at the small water containers that students use. One dip of the brush and the water is dirty. Use the biggest jar you can get, or a bucket. This message goes for all your materials really. Work generously, always use the biggest brush you can, have lots of water in the jar, lots of paint squeezed out.

Brushes

The best-quality brushes are the red sable, made of selected hair from the tail of the kolinsky, a wild species of Asiatic mink. The hair makes up into a brush which is springy, strong, and comes to a fine point—even the larger brushes taper to a remarkably sharp tip. The production of these brushes is highly skilled. Ox-hair is also used for brush-making. It is strong and springy, and although ox-hair brushes lack the point and colour-holding quality of red sable they are a good and relatively economical substitute. Squirrel hair is very soft and lacking in spring, but squirrel-hair brushes are cheaper and very useful for covering the paper with colour washes. Brushes are also made from various blends, including a mixture of red sable and ox-hair.

The very best brushes are expensive, and in the large sizes they are sometimes difficult to obtain because of the scarcity of the natural material. It is wise to buy the best brush you can afford. A good art materials shop will have a glass of water available for you to test the brush. Dip the brush into the water, give it one strong flick and the hair should instantly form a fine point.

I have described how I like to start painting with washes over all the paper and then progress towards final detail. The main requirement for the first stage of the painting is that the brush should hold a lot of colour, and then for the more detailed work a smaller, more springy brush is needed. I often start with a big flat squirrel-hair wash brush, 50 mm (2 in.) wide. For the next stages of the painting I use best-quality sable brushes, usually No.12, No.8 or No.4. I sometimes use an oil painter's hog-bristle brush to apply watercolour. The stiff bristles create distinct lines of paint along the direction of the brushstroke, but with the fluidity of the paint these lines tend to merge together, resulting in a subtle striated paint surface.

Take care of your brushes. Wash them under a running tap after use, shake out the surplus water, and shape the brush to a point between the fingers. I have been sucking brushes and shaping them with my lips for a good many years, but manufacturers do advise that some paints might be toxic. I lay my brushes flat on the table and allow them to dry naturally. They should never be put away damp in an airtight container, and they should be stored in such a way that there is no risk of the hairs being bent by pressing against a container wall.

Paint marks may also be made by pressing the edge of a piece of cardboard loaded with paint on the paper. I frequently make lines by pressing paint from the sharp edge of a painter's knife into the paper. The sharp-edged steel blade produces a beautifully taut, immediate line, whereas the thicker, absorbent cardboard produces a soft line, varying in density along its length.

Papers

Papers are either handmade or mould-made. The handmade sheet is individually made by a highly skilled process, and each piece has its own unique and subtle differences of surface. Mould-made papers are made by machine and so have a more uniform surface.

Watercolour papers are made in a range of thicknesses and are categorized by weight. The thinnest paper is about 72 lb. per ream (145 gsm) and the heaviest 400 lb. (850 gsm). I use 140 lb. (295 gsm) paper for small sketches, but for serious work I prefer 200 lb. (425 gsm).

Papers are made in three surfaces.

Hot-pressed (HP)

This paper has an extremely smooth surface which is very suitable for drawing, but can make washes difficult to control. The colour lies on the paper with a look of immediacy and sharpness which is suitable to some subjects.

NOT

Meaning not hot-pressed. In the USA it is called Cold-pressed (CP). This has a slightly rougher surface. It is my favourite surface, as it receives both colour washes and line drawing well, and so enables me to combine detail with broad washes of colour.

Rough

This has a very pronounced surface texture which is best suited to a broad, direct treatment. Paint may be dragged quickly over the surface to produce a broken, sparkling look. The effect of granulation where pigments precipitate out of a wash is very noticeable with this paper. The pigment settles in the tooth of the paper to give a speckled effect. Some pigments are more prone to this than others. A mixture of light red and French ultramarine will separate out into particles of red and blue. I dislike the mauve effect resulting from this particular combination, but I like the subtle warm grey which comes from the granulation of burnt umber and French ultramarine. This is just a personal whim.

Paints

The choice between tube and pan colours is a personal one, I think. Pans

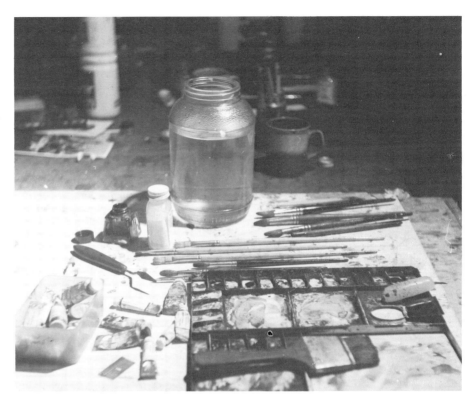

Figure 140 Studio workbench. Large paint-box, wash brush, wax candle, tubes of paint, bottles of ink and masking fluid, small painting knife, hog-bristle and sable brushes, jar of water.
Figure 141 Studio sink. Paint-box, brushes, water jar, ink, masking fluid, tubes of paint, painting knife, hairdrier. The rubber spout on the tap is very useful, as I can bend it to control the washing out of parts of a painting.

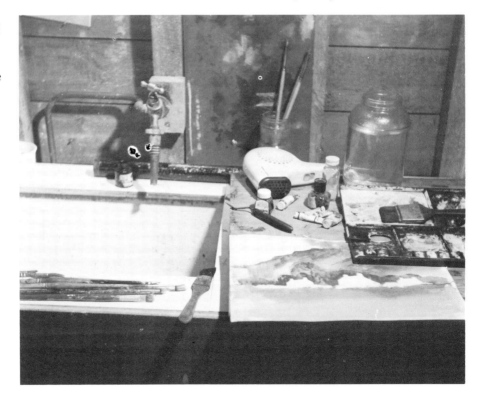

in a box make a compact unit compared with tubes and a separate palette. Tube colours stay moist if the cap is replaced each time, whereas pans tend to dry hard if they are not used frequently. However, some painters find the stiffer consistency of the pan paint easier to control. I use tubes of paint, squeezing out fresh paint into my paint-box as I require it. I would recommend artists' quality paint, but lower-priced paints of good quality are available.

I like to experiment by trying a colour unfamiliar to me, but my basic palette is: raw sienna, aureolin, cadmium red, brown madder alizarin, burnt umber, phthalo blue, cobalt, lampblack. Occasionally I use French ultramarine and sepia. Raw sienna is a lovely earth colour, more transparent than yellow ochre. Aureolin is a sharp bright yellow. Cadmium red is a bright red and brown madder alizarin is a lovely low-toned red, a cool relative of cadium red. I dislike light red, which seems to be a favourite colour with many watercolour painters. I do not like its slight opacity, but my chief aversion is to the plum colour it produces when mixed with blue. I prefer to mix my own greens. Black diluted makes a pleasing grey which can be adjusted by adding a touch of blue or red. I like the subtle grey-green produced by combining black and raw sienna. Burnt umber mixed with any of the blues produces very pleasant greys.

Paint-box

I use a metal box, with divisions for holding paint and deep wells in the lid for mixing washes. It also has a large flat area which I find useful for mixing less diluted paints. I have developed an instinctive painting sequence in which I first moisten the brush in the water pot, then pick up the paint from the box, try out the colour for strength and consistency on the flat lid, and then apply it to the paper. My big metal palette is ideal for this. I only wash one

well of my paint-box. The rest is rarely cleaned. I would feel I was working in my best suit. And in any case, yesterday's mixture of paint often provides just the subtle tint needed for a part of the painting.

Masking fluid

I use masking fluid for masking out shapes. This is a rubber latex in liquid form which is brushed over the area to be protected. It dries on the paper quite quickly and watercolour can be washed freely over it. When the colour wash is dry the rubbed skin is peeled or gently rubbed away with the finger or a rag. There is a risk of rubbing away the surface of very soft, absorbent papers, but if you rub gently you should not have any trouble.

I have used Process White as a variation of masking medium, painting it over the area to be protected, allowing it to dry and then overpainting with watercolour. When this is dry the painting is thoroughly immersed in water and the dry Process White, being solvent, softens and disperses to leave white paper with fairly soft edges. Sometimes the white needs a little coaxing with a brush to come away.

Drawing inks

I use black drawing ink in combination with my watercolour washes. The inks may be diluted with distilled water. There are brilliant-coloured inks and also some lovely subtle peat-browns, but only black and white inks are light-fast, the coloured ones are likely to fade. If I want to draw a line in colour I use watercolour on a pen or piece of stick rather than coloured ink.

Easel

I always use an easel for outdoor working. Many painters scorn outdoor folding-type easels and say that they are likely to collapse at the most inconvenient time, and that folding

them at the end of the day is something of a music hall performance. My easel is sturdy, very reliable, folds compactly and has a carrying handle. It can be arranged to carry a board flat for watercolour painting, but will also support a board vertically. I have two such easels; one which is still in use is many years old and the other I bought a year or so ago as an insurance.

The advantage of an easel is that it holds the paper and leaves both hands free. Alternatively, the painting can be rested on one's knees when sitting down, but I always stand to work so that I can step back to look at the work and generally have more freedom.

In the studio I work mainly with the paper lying flat on a table but occasionally I choose to work with the paper vertically, particularly when demonstrating, and then I stand at a traditional radial easel. I also have a big old studio easel which is operated up and down by turning a large screw with a handle. This is mainly used for oil or pastel painting, but occasionally I use it when working with broad, vigorous treatment on large watercolours.

Picture-framing

At one time I made nearly all my own frames, but, although I am intensely interested in framing, I now have most of my paintings professionally framed so that I can concentrate on painting.

Good presentation is important and it seems entirely contradictory to lavish care on a painting and then put it in an unsuitable frame. I am fussy about presentation and spend time with the framer selecting individual mounts and frame for each painting.

The frame has the practical purpose of protecting the painting and the aesthetic purpose of creating a gradual transition from the picture to its surroundings. This means that the colouring and tones of the frame and mount need to be considered just as carefully as the tones and colours of

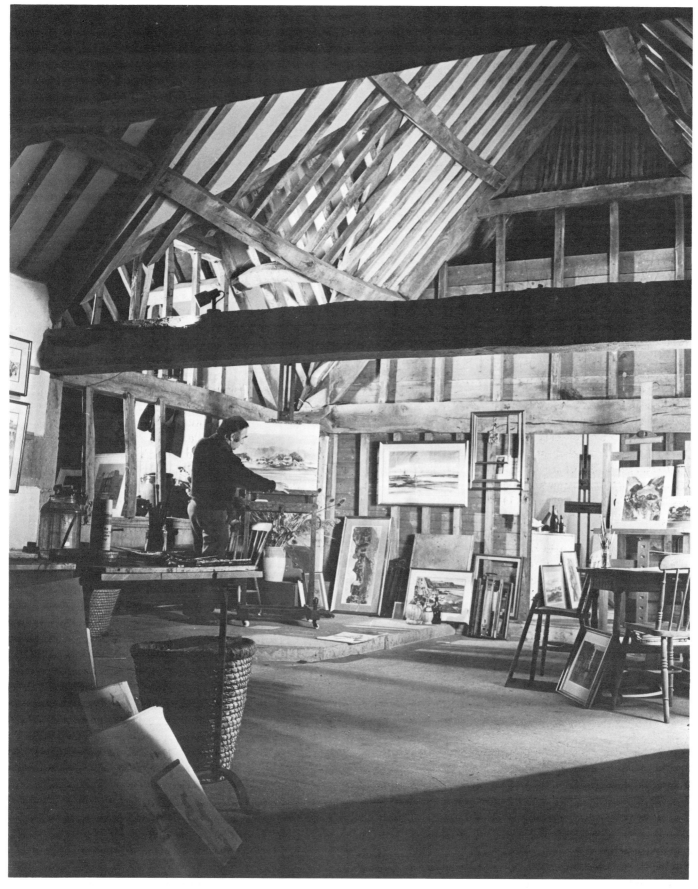

Figure 142 Photograph of the author's studio, which is a converted 16th century stone barn, situated in the Cotswolds.

the painting and so, in this book, I have sometimes included the framing in my description of a painting.

I like to have a double mount. This consists of a wide outer mount and a narrow inner mount, or slip, of a contrasting but sympathetic colour. It is interesting to look in the painting for a colour which is subtle and pleasing in itself but not necessarily a major factor in the painting, and then use it, or a near colour, in the narrow slip mount. As an example, a background colour in the painting could be repeated in the slip. The surface of the mount is important also. A slightly textured surface might sympathize with textures in the painting. Some of the fine linen- or silk-faced mounts are delightful with certain pictures, such as flower painting.

For some traditional watercolours a wash-lined mount looks well. In this treatment, parallel lines, filled with watercolour wash, surround the picture opening.

The essential requirement is that the framing is appropriate to the picture. It must not dominate the painting, and it must not be too weak. The components of the frame need careful judgement so that they integrate with the picture.

A lot has been written elsewhere for those who wish to make their own frames and so I will say just enough to complete the outline of the materials and equipment that I like to have.

Mitring the frame corners

To mitre the corners of the picture frame moulding I use a Morso foot-operated guillotine. It has two guillotine blades set at an angle to each other so that they cut two perfectly matching mitres in one operation. The guillotine blades are so sharp that they cut through the moulding without damaging its decorative surface. This type of machine is widely used by professional frame-makers, who require a robust machine to stand up to continuous use without losing accuracy.

Joining the corners

I use a heavy duty cast iron corner cramp to join the corners. The four corners are joined in rotation using woodworking glue, reinforced with panel pins. I drill holes in the moulding to receive the panel pins to avoid splitting the wood by hammering through it.

Cutting the mount

I used to cut bevelled openings in the mount (mat) with a craft knife held at an angle against a steel rule, but I now have a sophisticated type of mount-cutter in which the cutting blade is held in a block which slides along a polished rail. It is extremely accurate and is adjustable to cut different sizes of mounts.

Backs

I use lightweight hardboard to back the paintings.

Glass

I am told that cutting glass is easy, but I find it easier to buy sheets cut to picture sizes.

Conclusion

Dégas said that 'Painting belongs to one's private life'. This is good advice. Paint what you want to paint and enjoy it. Painting is a personal process and I have often thought that it is a selfish pursuit. We are not asked to paint, we do it because we want to, and very often almost to the exclusion of other interests. It is presumptuous to think that the rôle of the painter is to educate others. Basically he paints only because he wants to, and he finds ways of painting that suit him and express the things he feels about. So, go ahead and paint for yourself and don't be too upset by what the pundits say. I have often stood on the fringe of discussions at exhibitions and heard that this painting is well designed, but that painting is contrived and I am not sure what the difference is and what it all meant.

In writing this book I have been mainly concerned with describing the thinking leading to the pictures, and why and how I painted them. I have also tried to give an accurate account of my thinking during the act of painting and how the processes and techniques evolved from my reactions to the mood and nature of the subject. At the same time I have suggested some practical ideas for organizing the picture components. I have discussed patterns, shapes and tonal arrangements as basic guide rules from which personal experiences can be developed. I have found it reassuring to have these starting points to build on.

I would be content to know that the ideas here might stimulate new ways of thinking and new ways of looking at the surroundings, from which the reader might develop his own ways of painting, and of thinking about watercolour painting. It is a wonderful medium to work with and it is capable of a wide range of expression from quick impressions to considered and developed work. For me, it amounts to a way of life. I look at the landscape in terms of watercolour and the search for ways of painting is a continuing one. The traditional way of working, with pure colour only, is fiercely upheld by many painters. At the opposite end of the scale other painters argue that we should advance with time and that the traditional way of working is old-fashioned. The two schools of thinking seem to be entirely opposed. I enjoy the advantage of both ways of working. I find that I am more likely to say what I want to say by combining the two ways of painting, and the possibilities are endless.

Dégas also said that he spent his life experimenting, and to me this seems an exciting and satisfying way of life to choose.

Exhibiting

Information may be obtained in the UK from The Federation of British Artists 17 Carlton House Terrace, London.

Associated Societies include:

Royal Institute of Painters in Watercolours—March

Royal Society of British Artists—May

New English Art Club—October

Royal Society of Marine Artists—September

Other Exhibitions:
Royal Academy of Arts—Sending in days end of March

Royal Water Colour Society—Members only

Art Magazines:
The Artist

Leisure Painter and Craftsman

Arts News and Review

Norman Battershill: *Light on the Landscape* (Pitman, London, 1977; Watson-Guptill, New York, 1977)

Bernard Dunstan: *Paintings in Progress* (Pitman, London, 1976; Watson-Guptill, New York, 1976)

Jacquetta Hawkes: *A Land* (Pelican Books, London, 1959)

Colin Hayes: *The Complete Guide to Painting and Drawing Techniques and Materials* (Phaidon Press, Oxford, 1978)

Rowland Hilder: *Starting with Watercolours* (Studio Vista, London, 1966; Watson-Guptill, New York, 1966)

W. G. Hoskins: *One Man's England* (British Broadcasting Corporation, London, 1978)

Thomas Hoving: *Two Worlds of Andrew Wyeth* (Houghton Mifflin Company, Boston)

Lewis John: *Rowland Hilder, Painter and Illustrator* (Barrie & Jenkins, London, 1978)

Ralph Mayer: *The Artist's Handbook of Materials and Techniques* (Faber & Faber, London, 1972)

Jack Merriott: *Discovering Watercolour* (Pitman, London, 1973)

John & Jane Penyre: *Houses in the Landscape* (Faber & Faber, London, 1978)

Graham Reynolds: *A Concise History of Watercolours* (Thames & Hudson, London, 1971)

Graham Reynolds: *The Watercolour Drawings of John Sell Cotman* (The Studio, 1923)

Zoltan Szabo: *Creative Watercolour Techniques* (Watson-Guptill, New York, 1974; Pitman, London, 1974)

Zottan Szabo: *Zoltan Szabo Paints Landscapes* (Watson-Guptill, New York, 1977; Pitman, London, 1977)

Gerald Wilkinson: *Turner's Sketches 1789–1820; Turner's Colour Sketches 1820–1834; Turner's Early Sketchbooks 1789–1802; The Sketches of Turner R.A. 1802–1820* (Barrie & Jenkins, London 1977)

Leslie Worth: *The Practice of Watercolour Painting* (Pitman, London 1977; Watson-Guptill, New York, 1977)

Index